THE ZOMBOOK

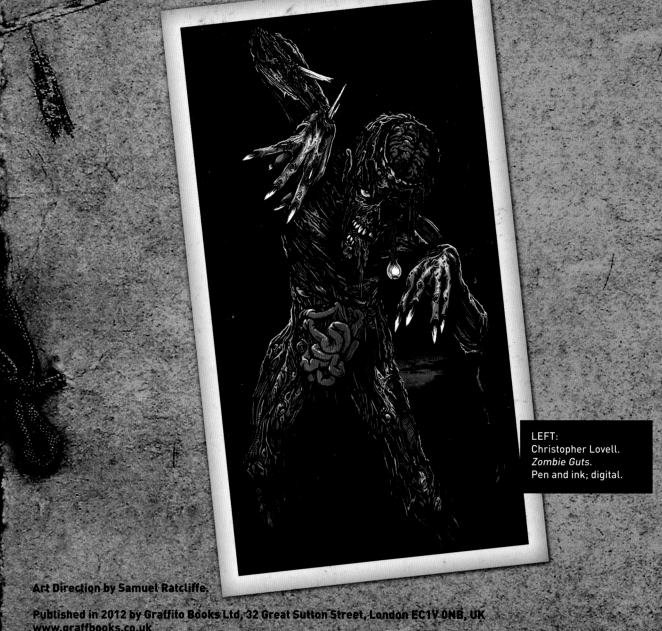

LEFT:
Christopher Lovell.
Zombie Guts.
Pen and ink; digital.

Art Direction by Samuel Ratcliffe.

Published in 2012 by Graffito Books Ltd, 32 Great Sutton Street, London EC1V 0NB, UK
www.graffbooks.co.uk
© Graffito Books Ltd, 2012.
ISBN 978-0956028-45-7

British Library cataloguing-in-publication data:
A catalogue record of this book is available at the British Library.

Printed in China.

THE ZOMBOOK

ALLAN GRAVES

GRAFFITO

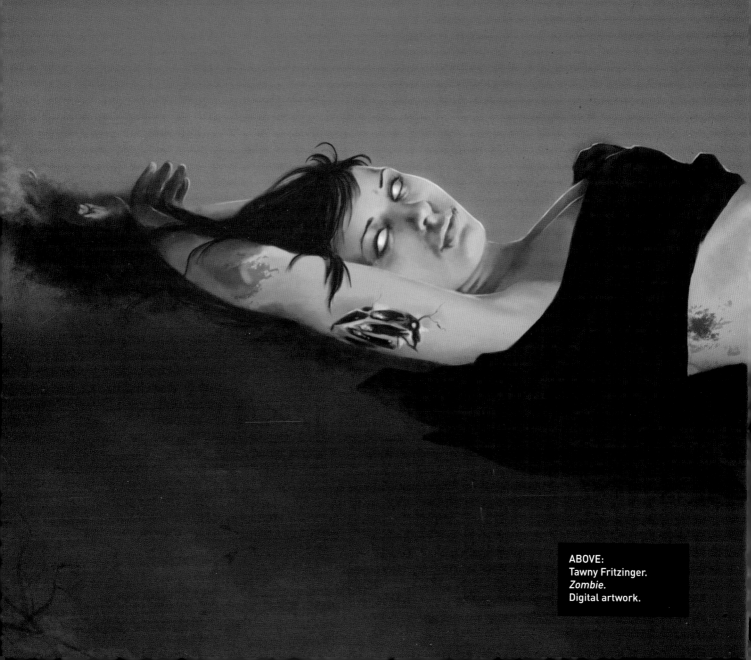

CONTENTS

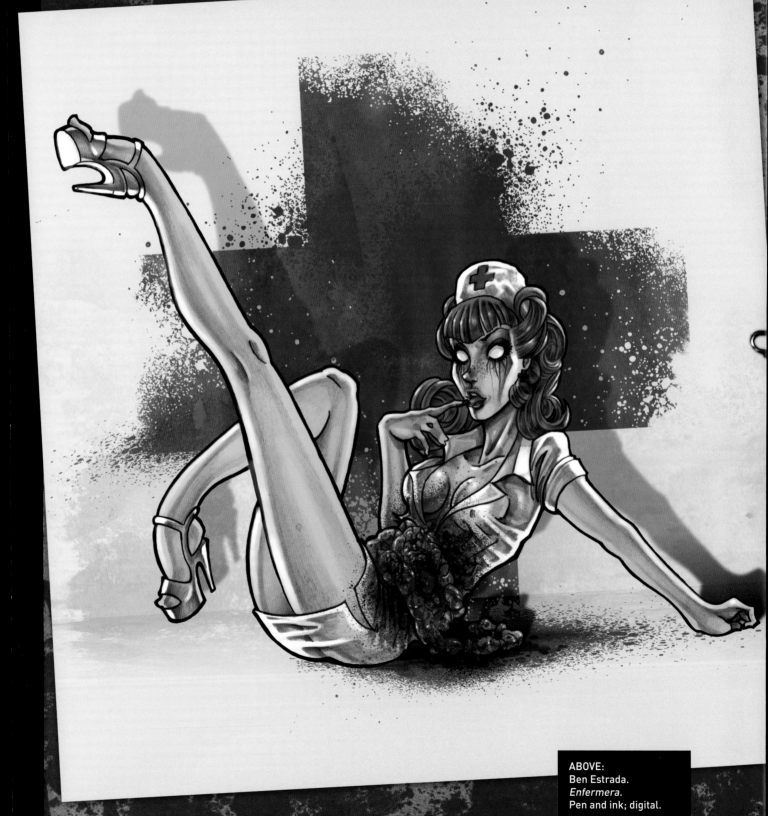

ABOVE:
Ben Estrada.
Enfermera.
Pen and ink; digital.

THE CALL OF THE ZOMBIE

Responding to the zombie's call is how my girlfriend described what I've been doing obsessively for the past eight months. I would have never imagined that I'd be doing this right now and certainly not on this scale: gathering some of the best artists from around the world to make the ultimate zombie book!

I have been a horror fan, and specially a zombie fan, probably since my mum went to see a late-night screening of *Night of the Living Dead,* while pregnant, with me. You could say my long time love for all things (un)dead was triggered even before I was born.......

But, as so often with books born of enthusiasm, this project happened unexpectedly. I'm a tattoo artist by day and last year I was toying with the idea of putting out a sketch book of some of my designs. Whilst researching potential publishers, a friend introduced me to the people at Graffito – it was love at first bite! – their vision and enthusiasm really grabbed me. As we were talking they asked why I had so many zombies among my tattoo sketches (I guess my tattoo sketches weren't that tattoo related...).

So we talked some more about our slow (or fast – depending on who you ask these days –) moving, rotting, gnawing friends and about their resuscitation on the scene in the last few years....and then it suddenly hit us that whilst there were tons of zombie books out there, there were none about the art as a whole, none focused on the best undead art by artists from all over the world.

So, I decided I should park my sketch book for a while and the idea of the ultimate zombie art book was born. The result is the book you're holding in your hands right now.

Having had the idea, my quest really started: a quest to gather up the best zombie makers out there. It turned into a kind of ritual. Every time I sent an email to make contact with someone new, it was like casting a voodoo spell to add a new member to The Zombook family. Many months of intense voodoo later, we managed to craft a brilliant resource of images to feast your eyes!

So, sit back, relax and get lost inside the pages of this fantastic tome of many, many amazing artists' work. Hopefully you will have as much fun flipping through it as I did putting it together, and, who knows, maybe it will even be of help in coping with the imminent zombie apocalypse!

ALLAN GRAVES, LONDON, 2012

OUTBREAK

BELOW:
Bryan Baugh.
Drippy Zombie.
Acrylic.

UGH 2010

"HE'S DEAD? NOT ANYMORE."

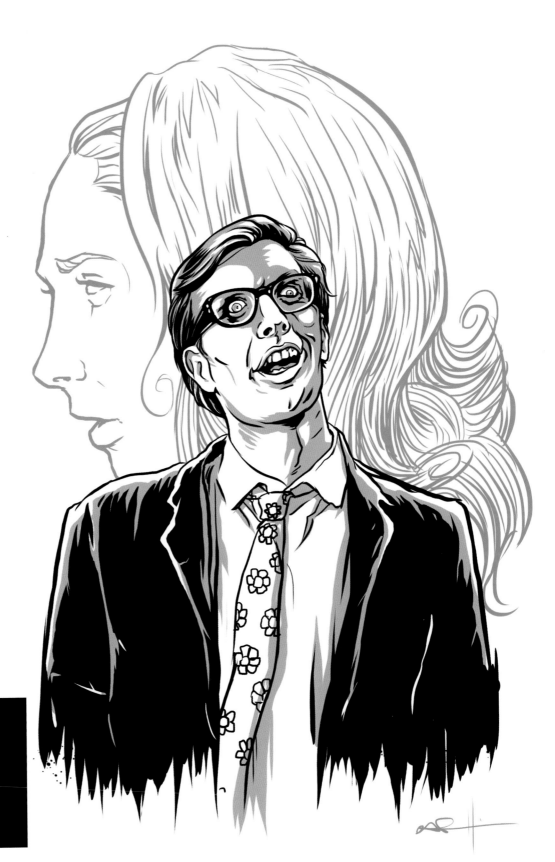

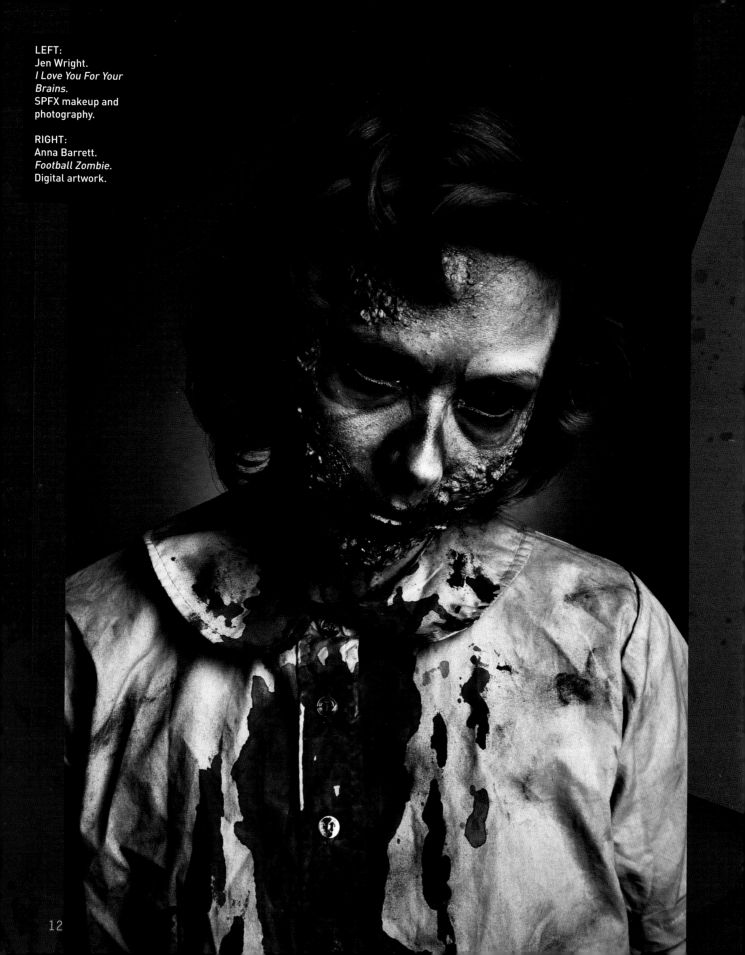

LEFT:
Jen Wright.
I Love You For Your Brains.
SPFX makeup and photography.

RIGHT:
Anna Barrett.
Football Zombie.
Digital artwork.

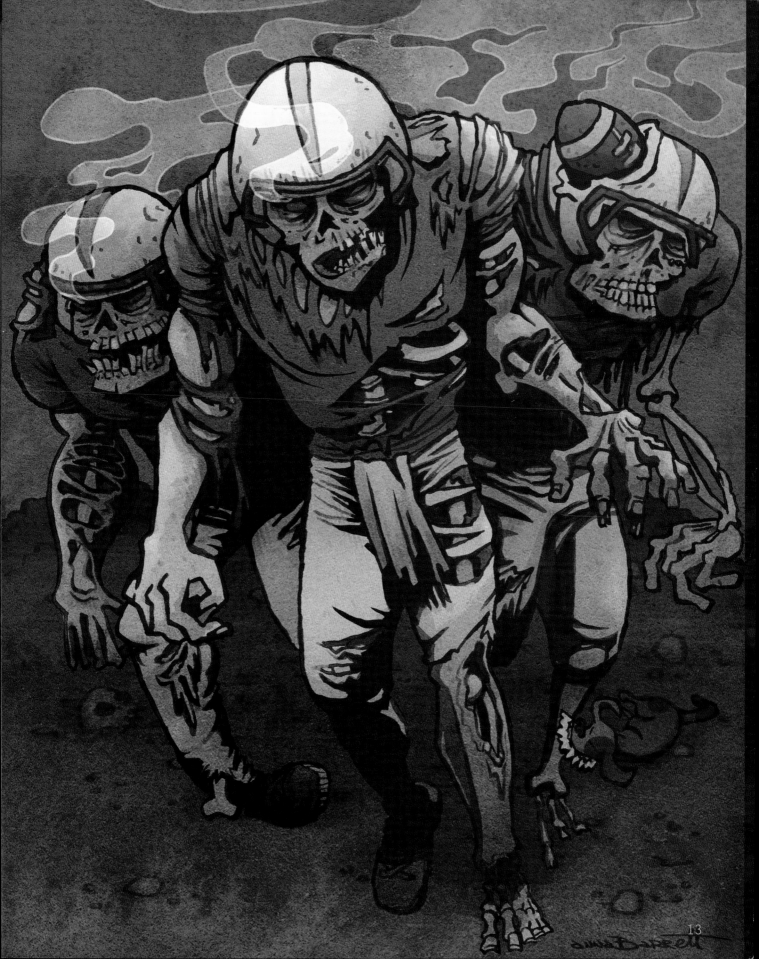

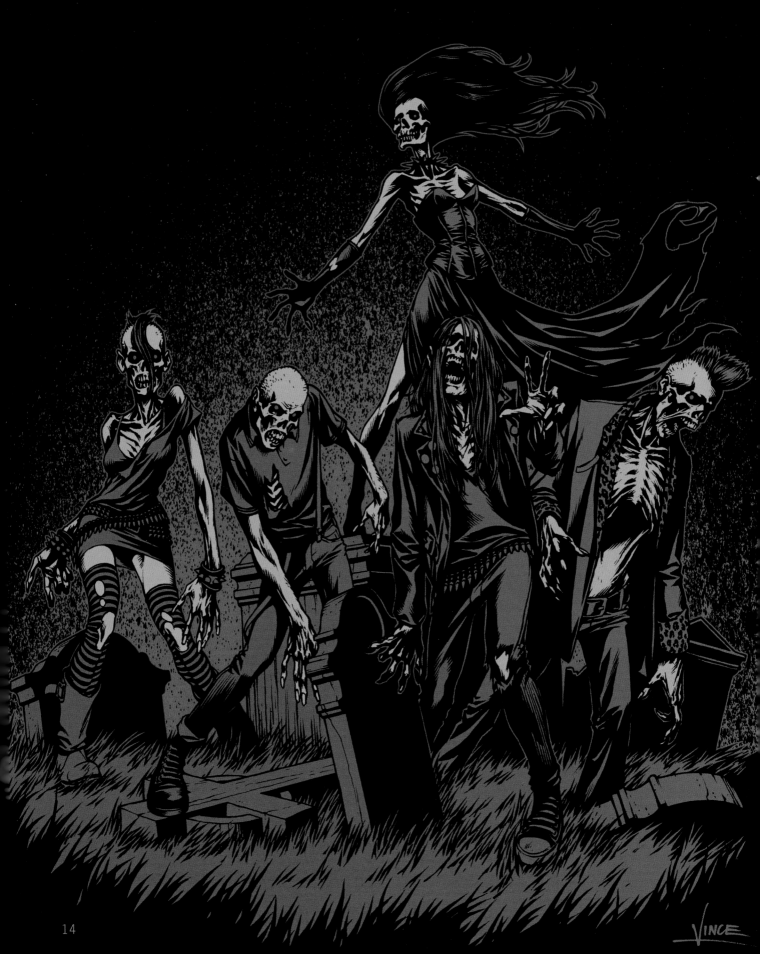

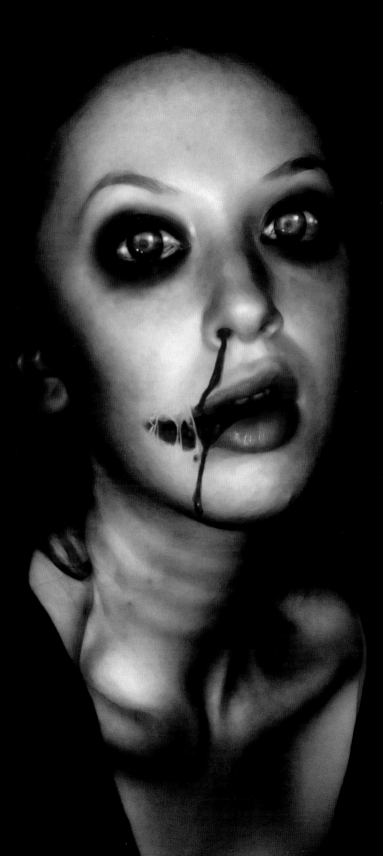

LEFT:
Vince Ruarus.
Subcultures.
Pen and ink; digital

RIGHT:
April McGuire.
Something's Wrong With April.
Digital artwork.

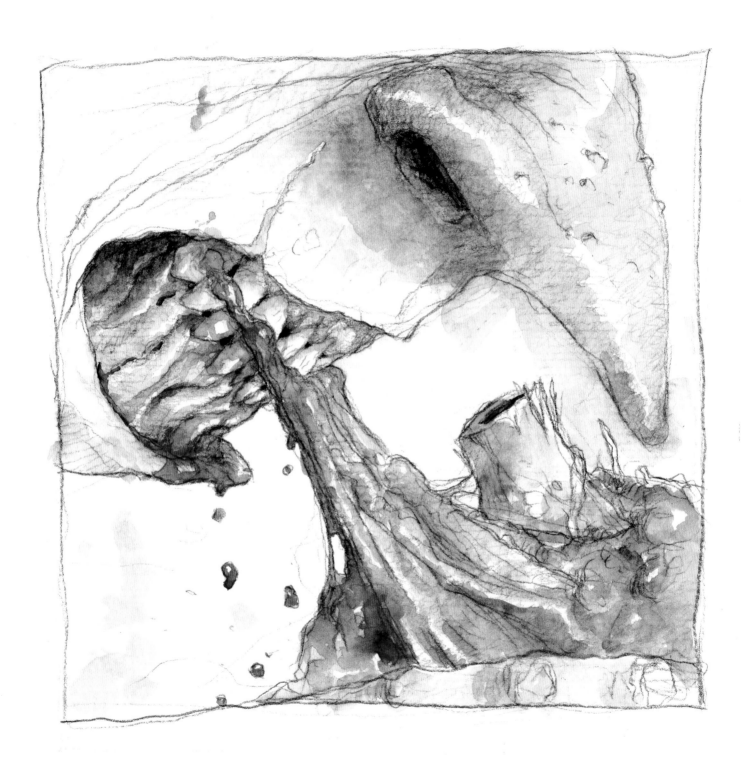

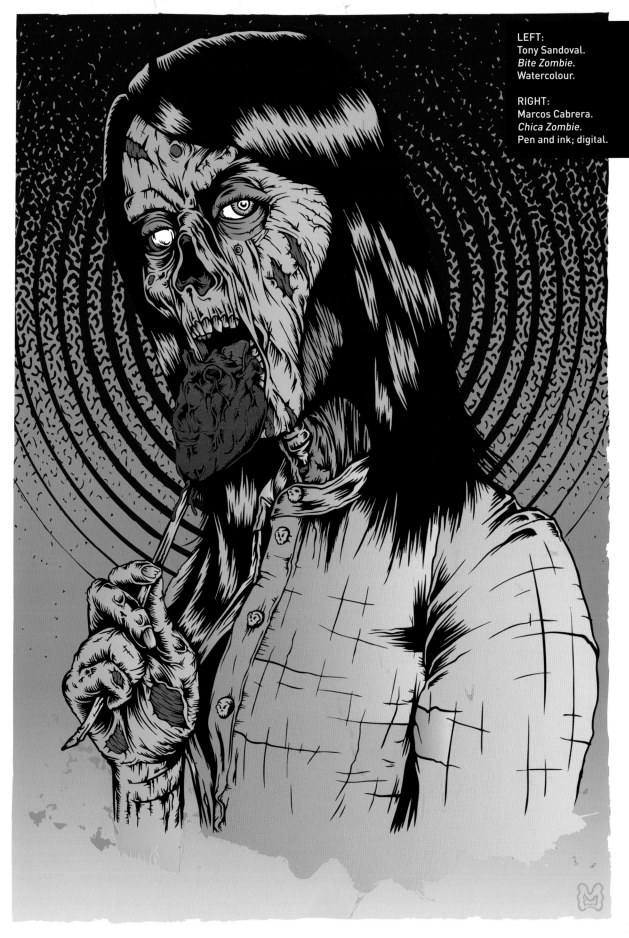

LEFT:
Tony Sandoval.
Bite Zombie.
Watercolour.

RIGHT:
Marcos Cabrera.
Chica Zombie.
Pen and ink; digital.

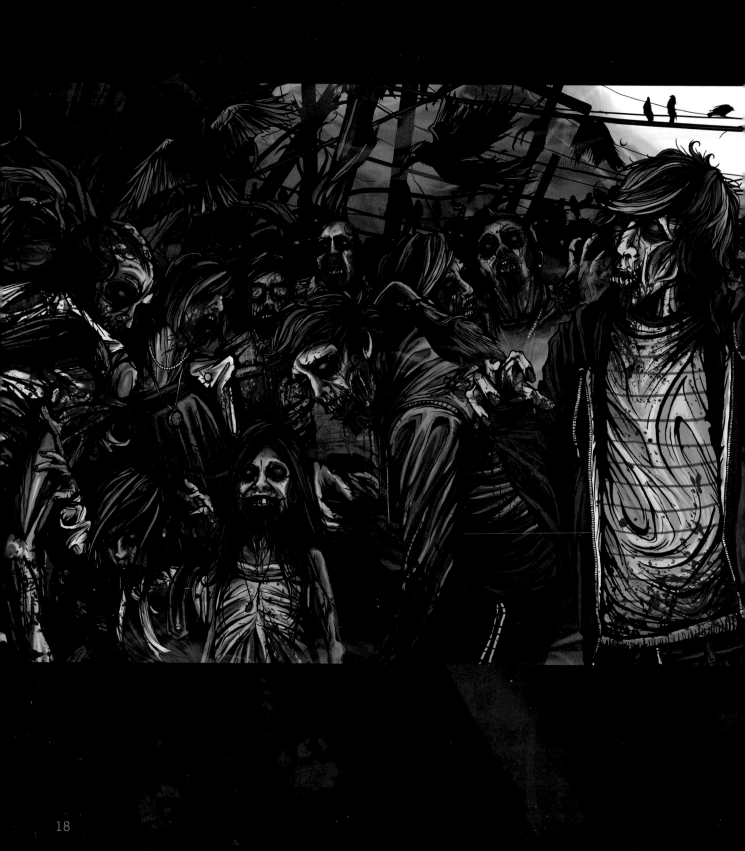

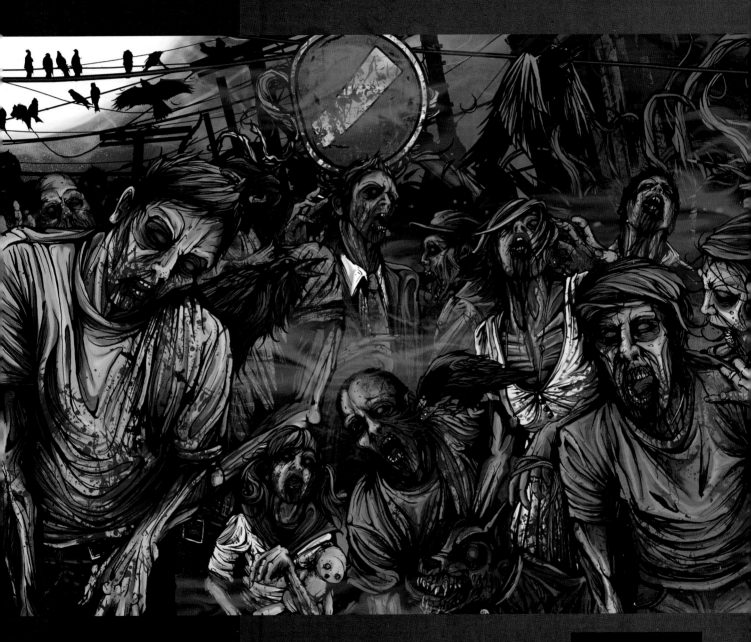

ABOVE:
Dan Mumford.
Evil 9.
Pen and ink; digital.

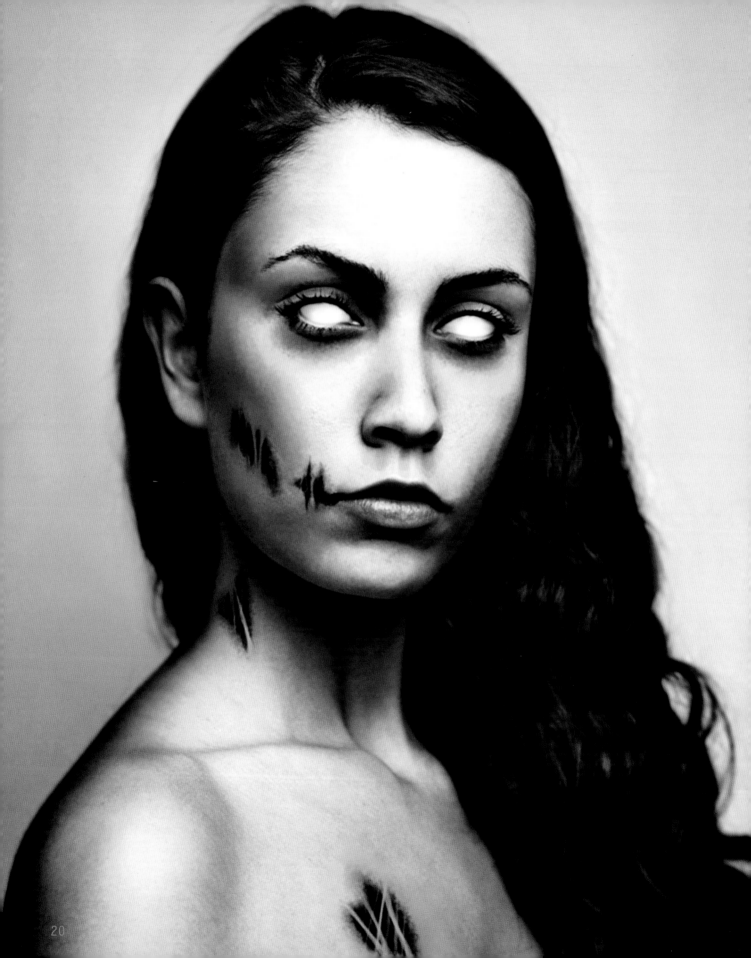

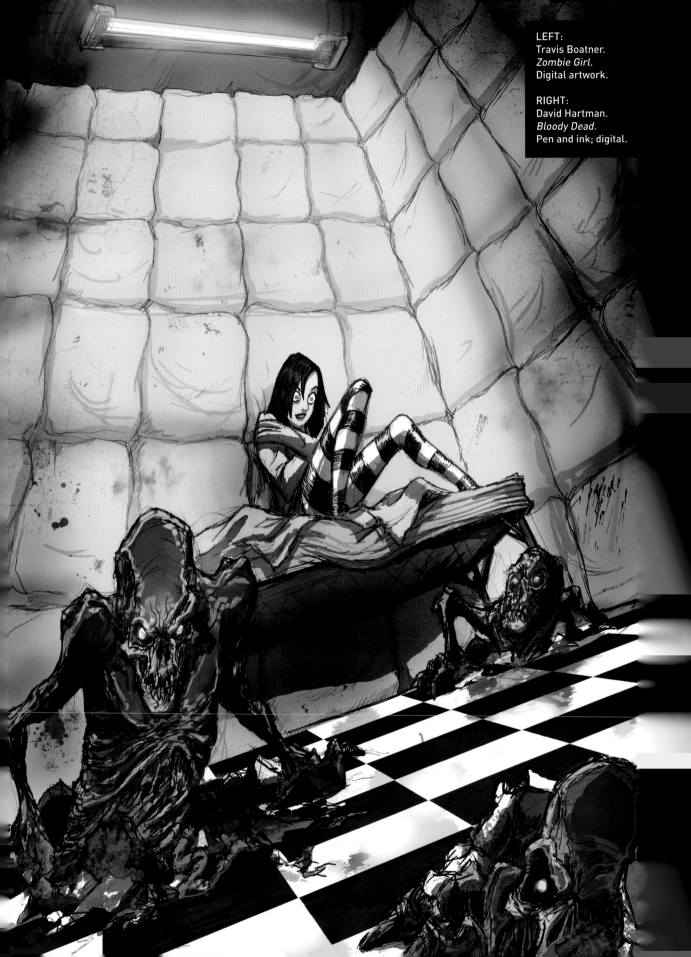

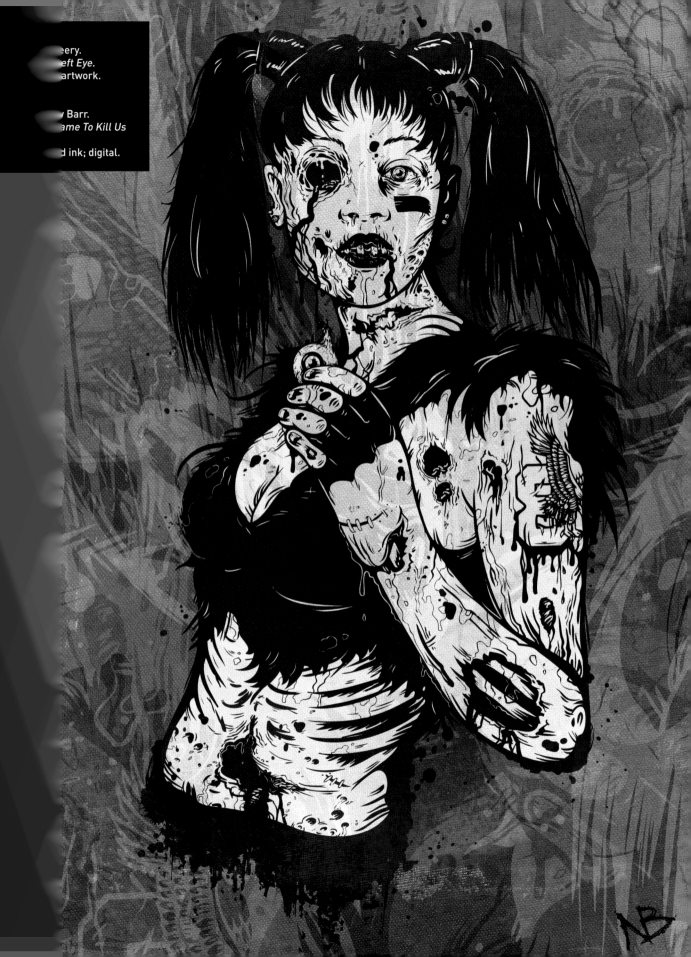

eery.
eft Eye.
artwork.

Barr.
ame To Kill Us

d ink; digital.

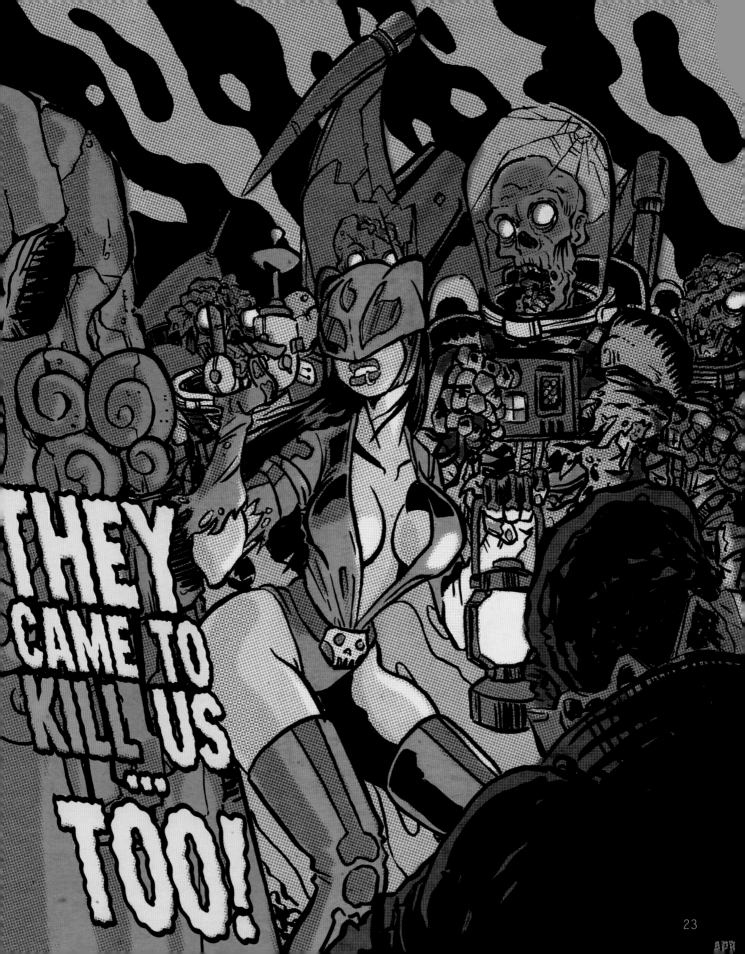

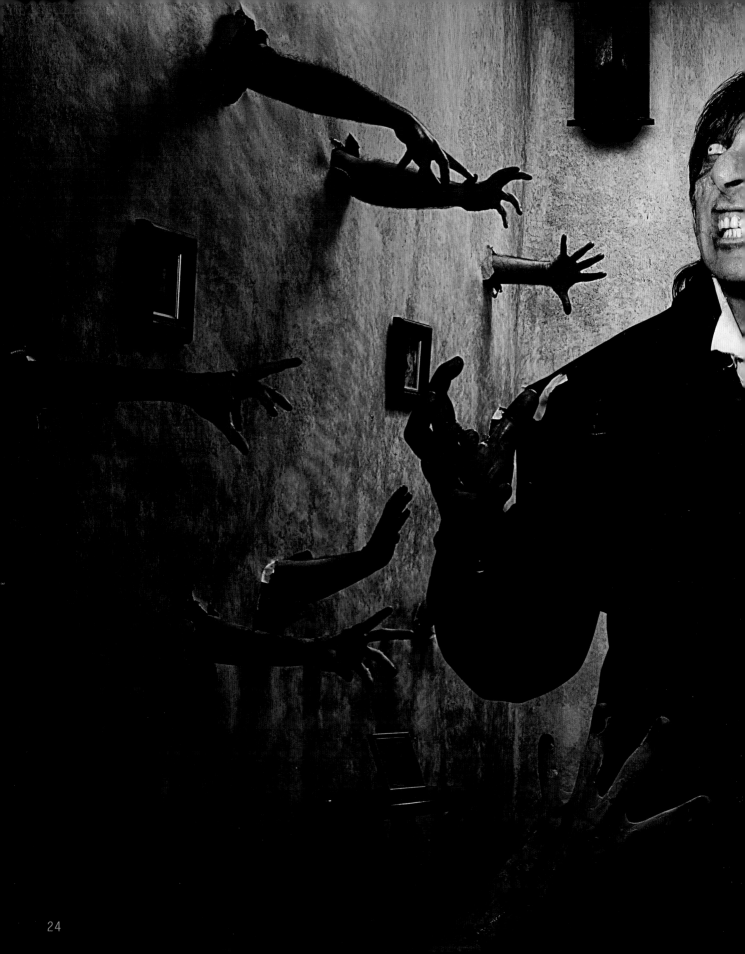

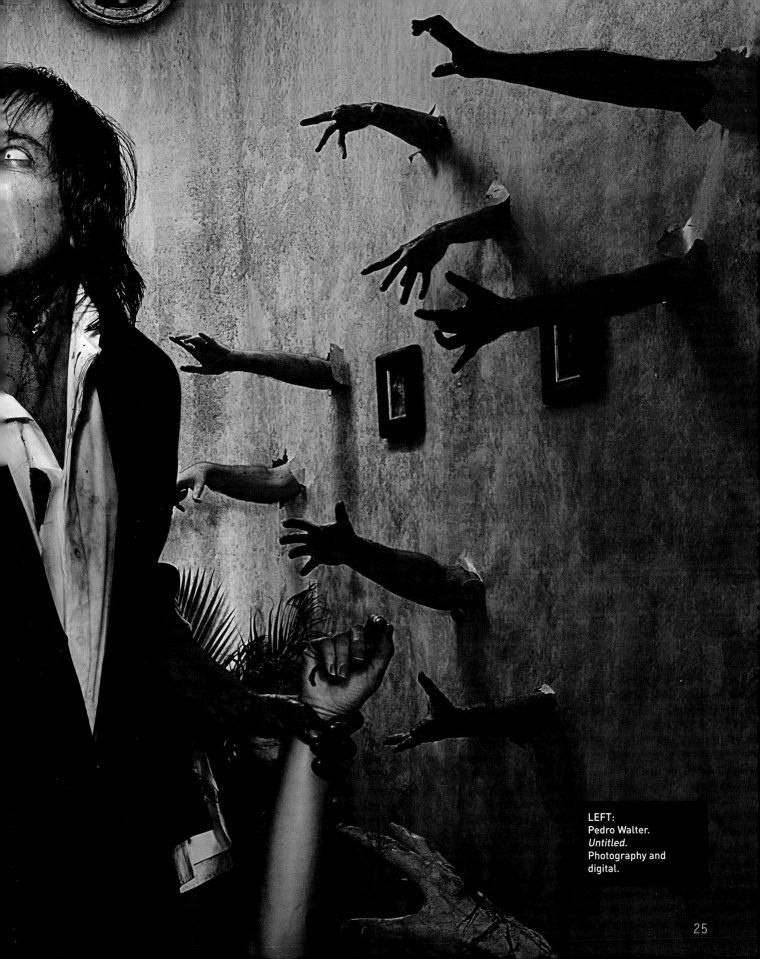

LEFT:
Pedro Walter.
Untitled.
Photography and
digital.

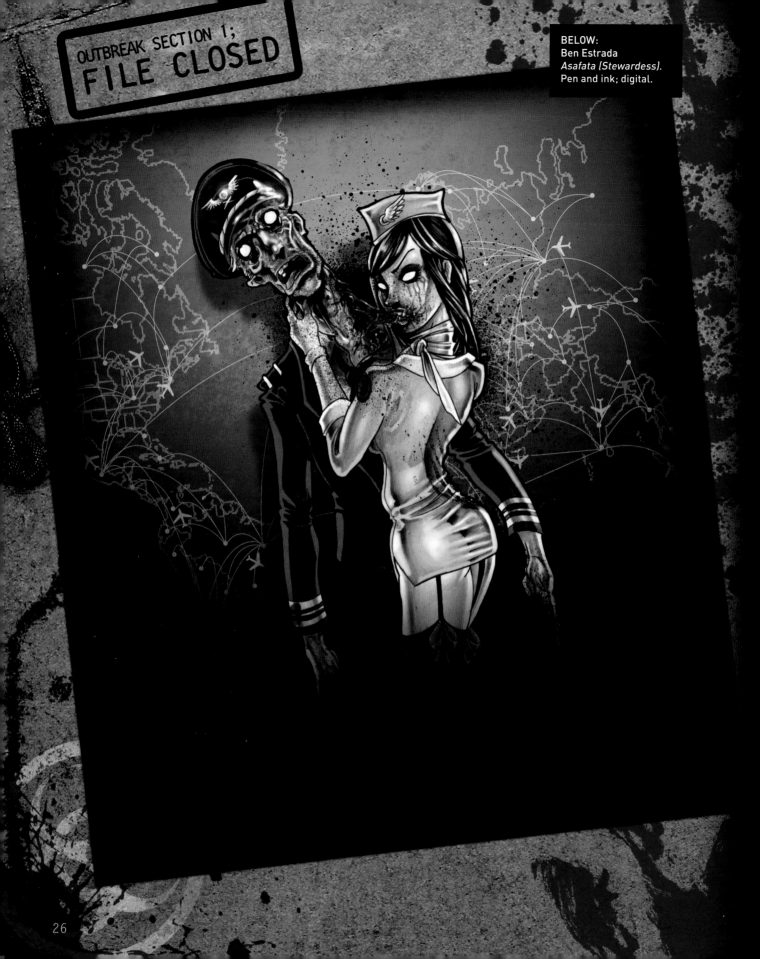

BELOW:
Ben Estrada
Asafata (Stewardess).
Pen and ink; digital.

CONTAMINATION

ABOVE:
Johanna Skarfelt.
I Was Such a Monster Back Then.
Digital artwork.

"THE FIRST GIRL I LET INTO MY LIFE AND SHE TRIES TO EAT ME."

TOP SECRET

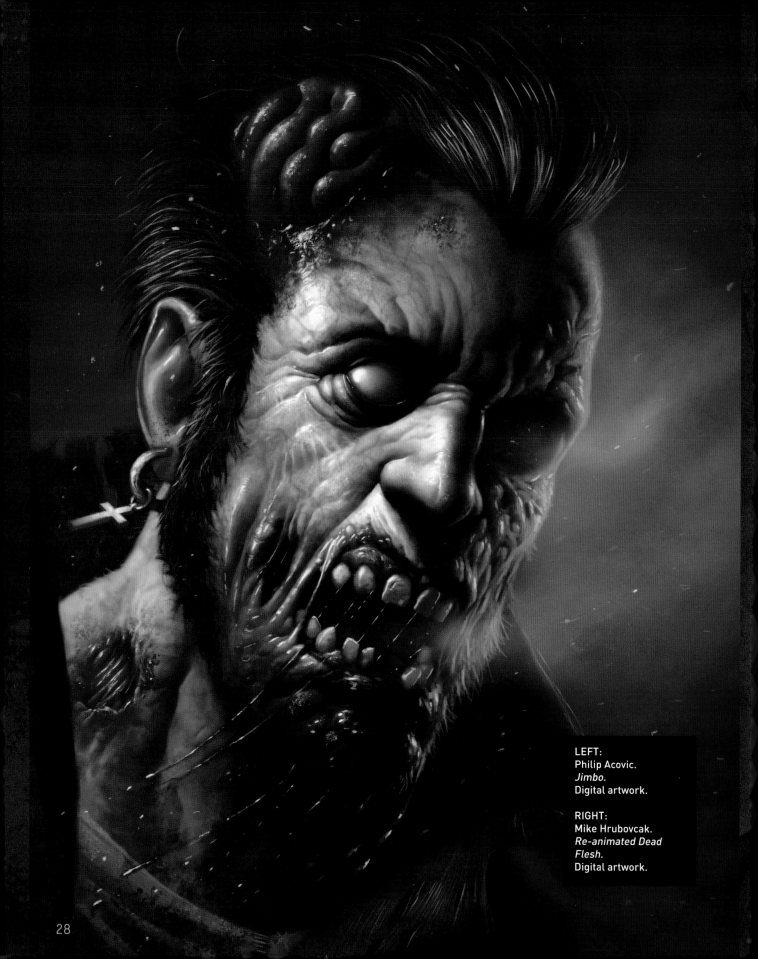

LEFT:
Philip Acovic.
Jimbo.
Digital artwork.

RIGHT:
Mike Hrubovcak.
*Re-animated Dead
Flesh.*
Digital artwork.

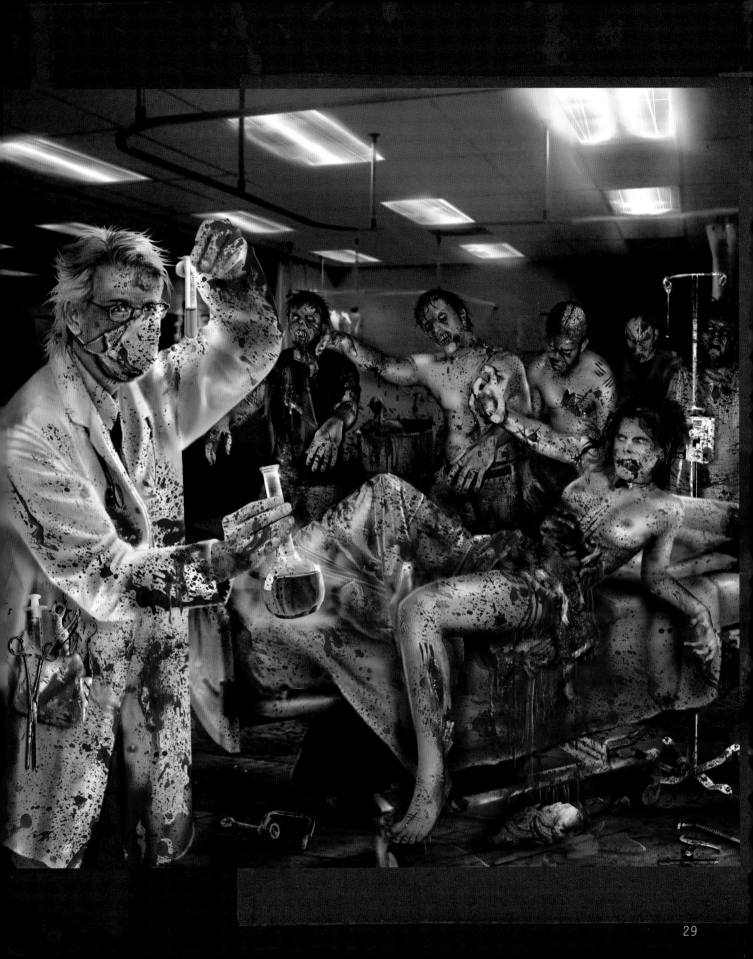

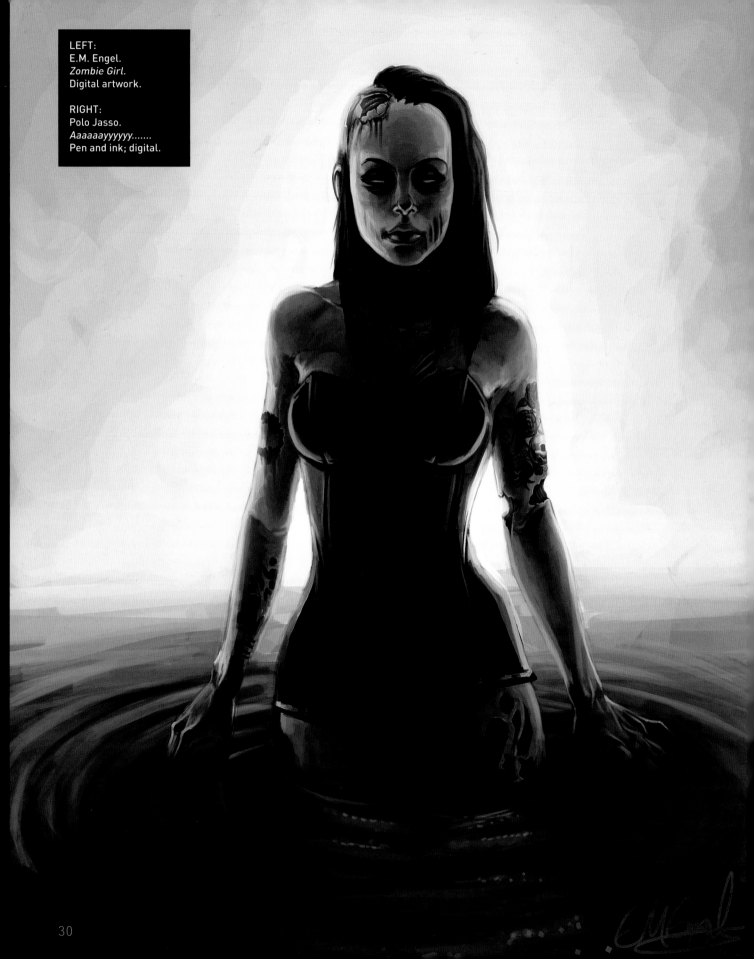

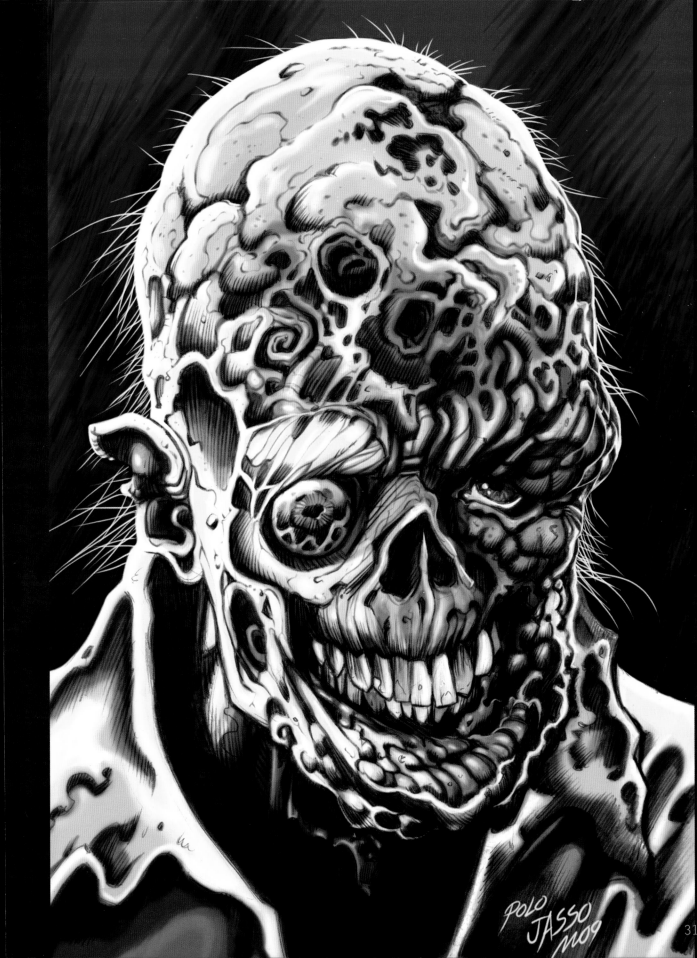

POLO
JASSO
M09

33

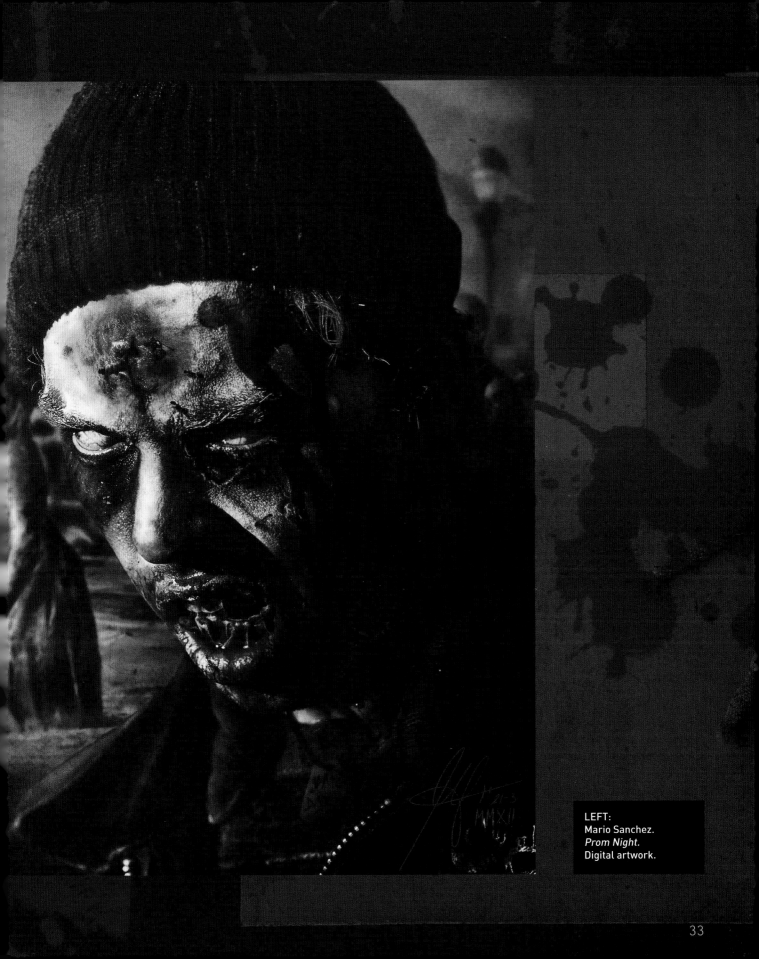

LEFT:
Mario Sanchez.
Prom Night.
Digital artwork.

LEFT:
Jay Serra.
Untitled.
Digital artwork.

RIGHT:
Paul Garner.
The Rot Pack.
Pen and ink; digital.

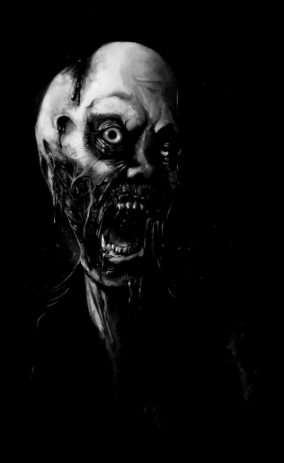

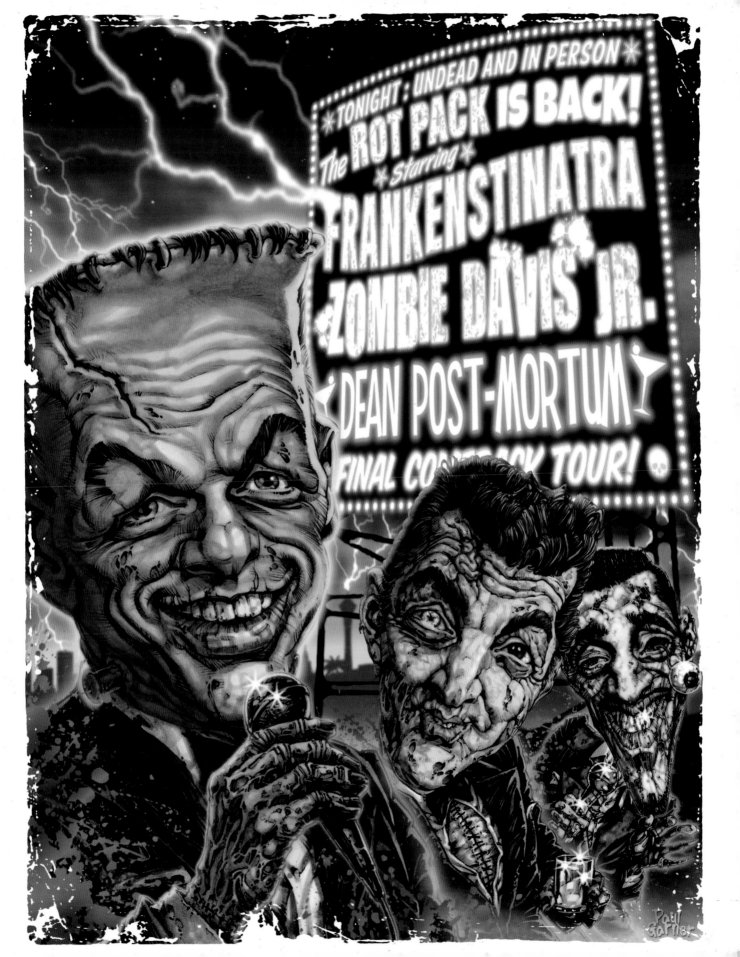

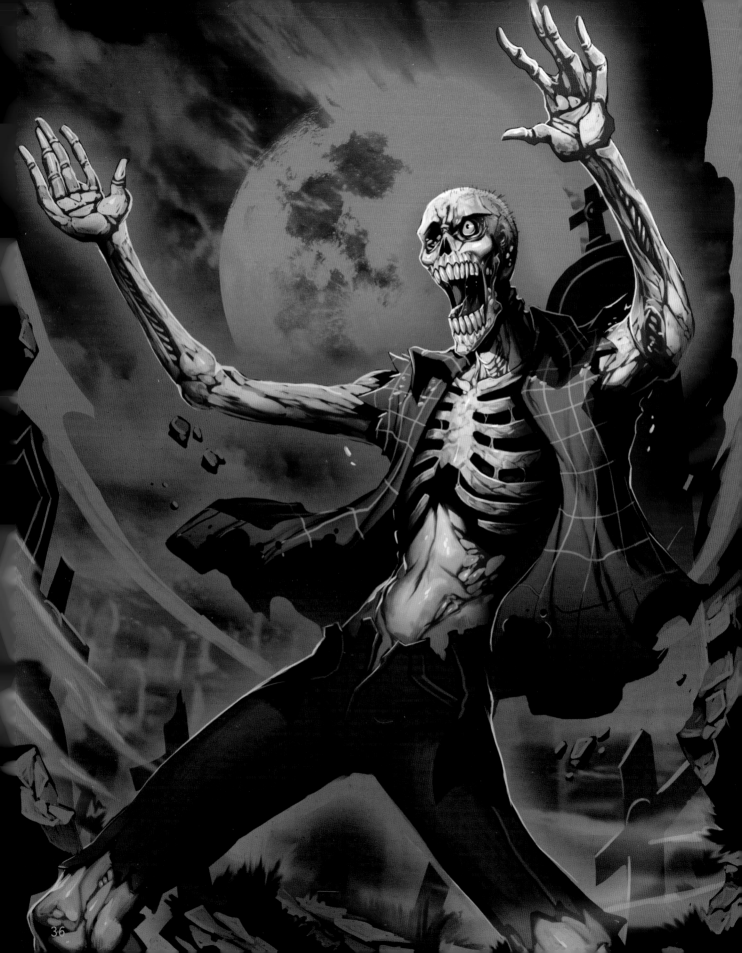

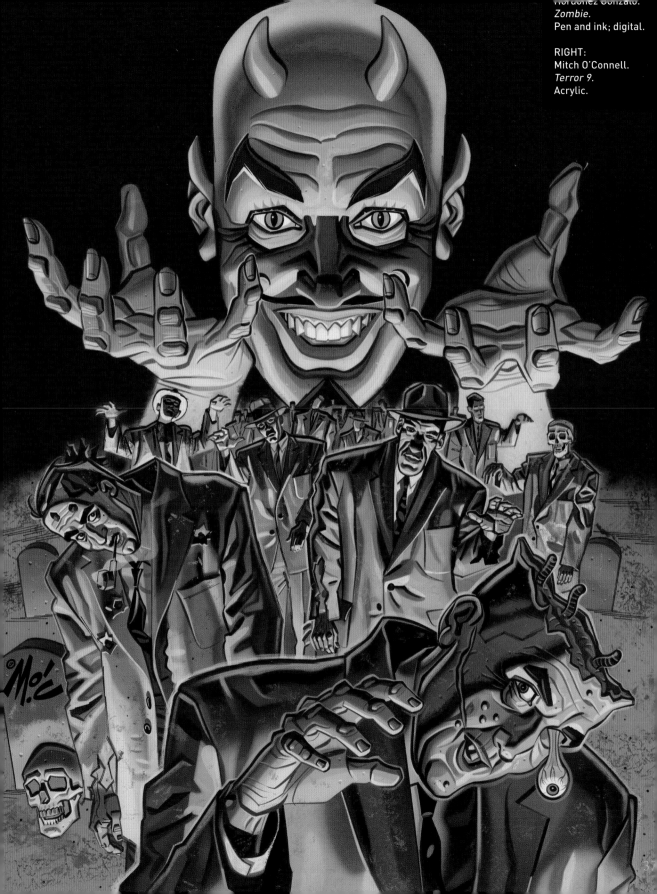

Nordoñez Gonzalo.
Zombie.
Pen and ink; digital.

RIGHT:
Mitch O'Connell.
Terror 9.
Acrylic.

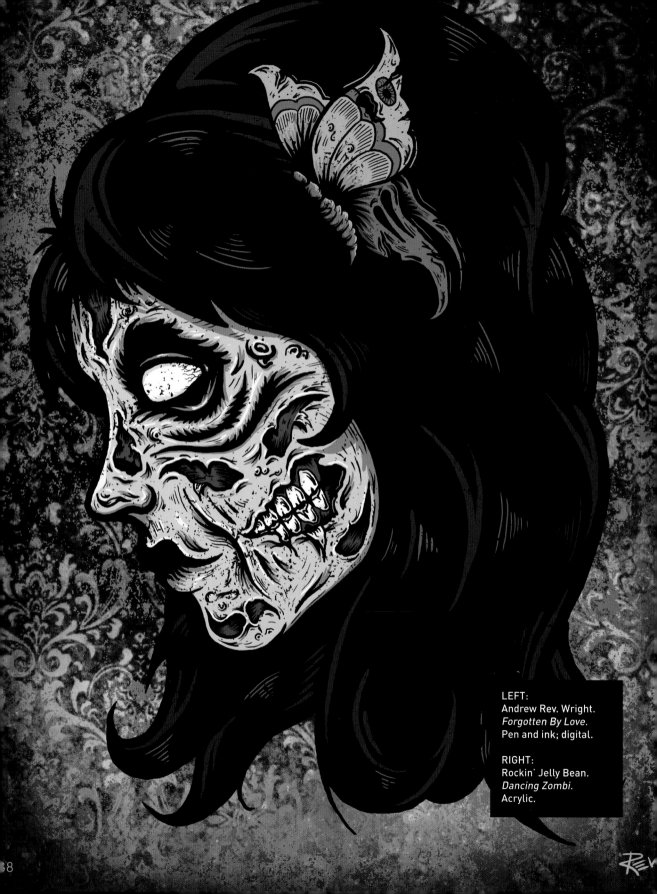

LEFT:
Andrew Rev. Wright.
Forgotten By Love.
Pen and ink; digital.

RIGHT:
Rockin' Jelly Bean.
Dancing Zombi.
Acrylic.

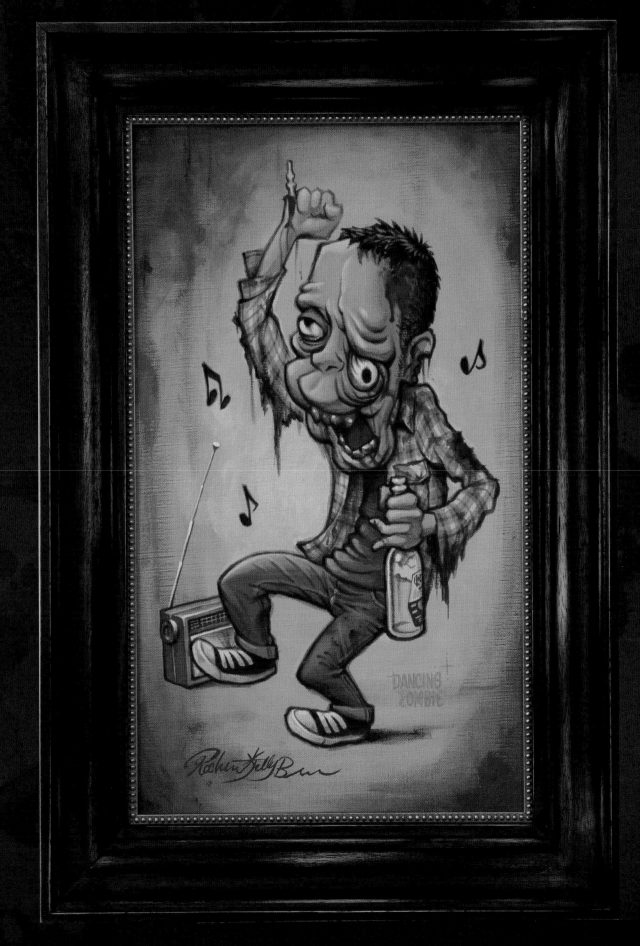

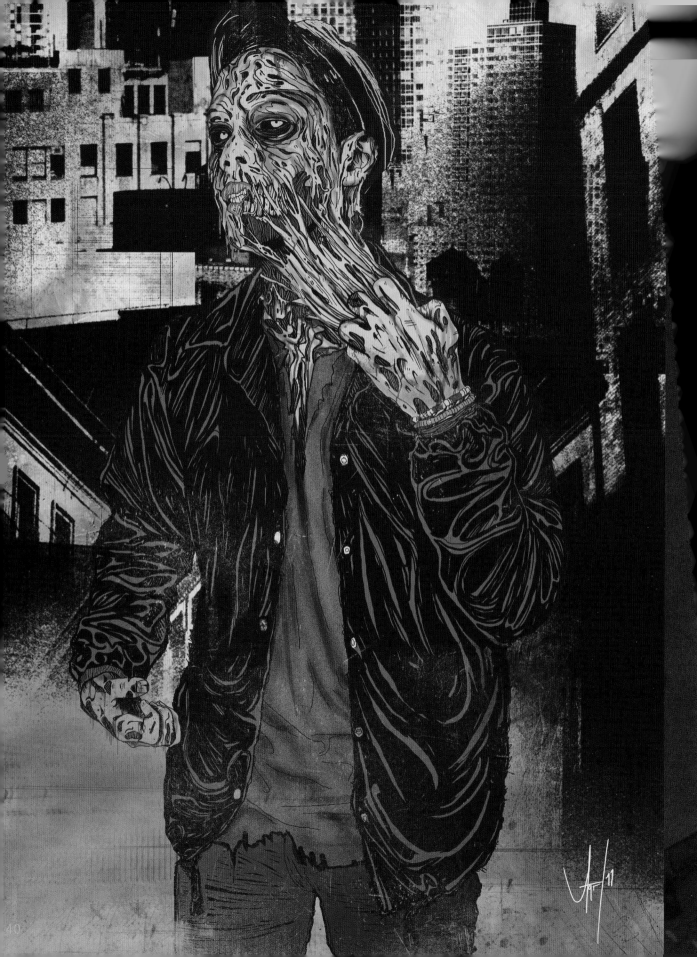

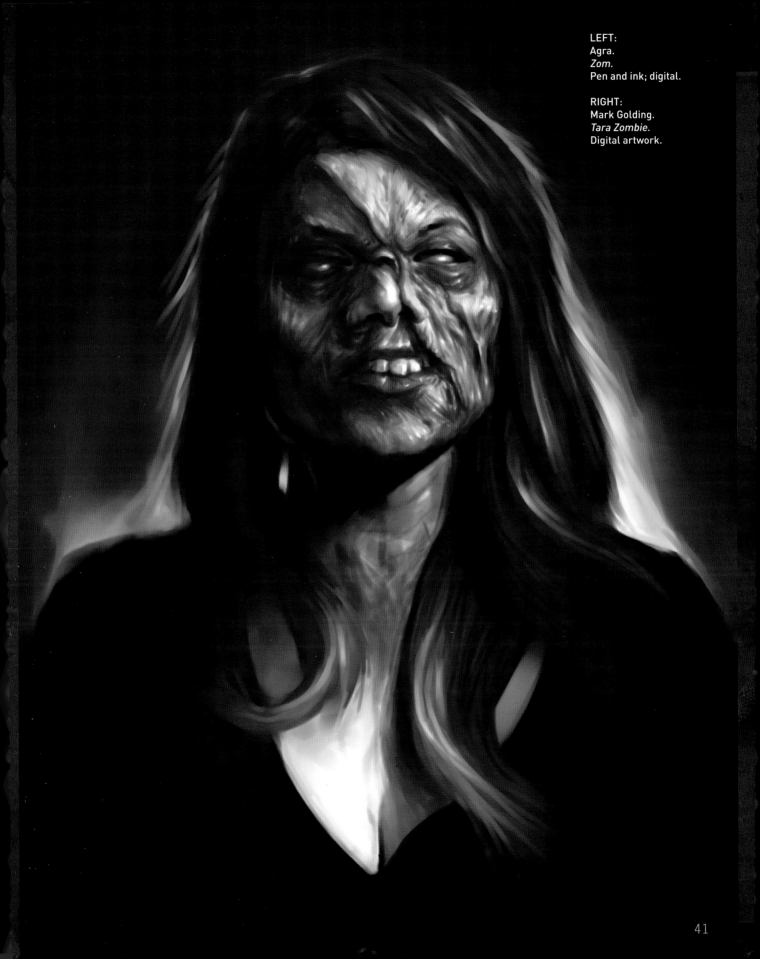

LEFT:
Agra.
Zom.
Pen and ink; digital.

RIGHT:
Mark Golding.
Tara Zombie.
Digital artwork.

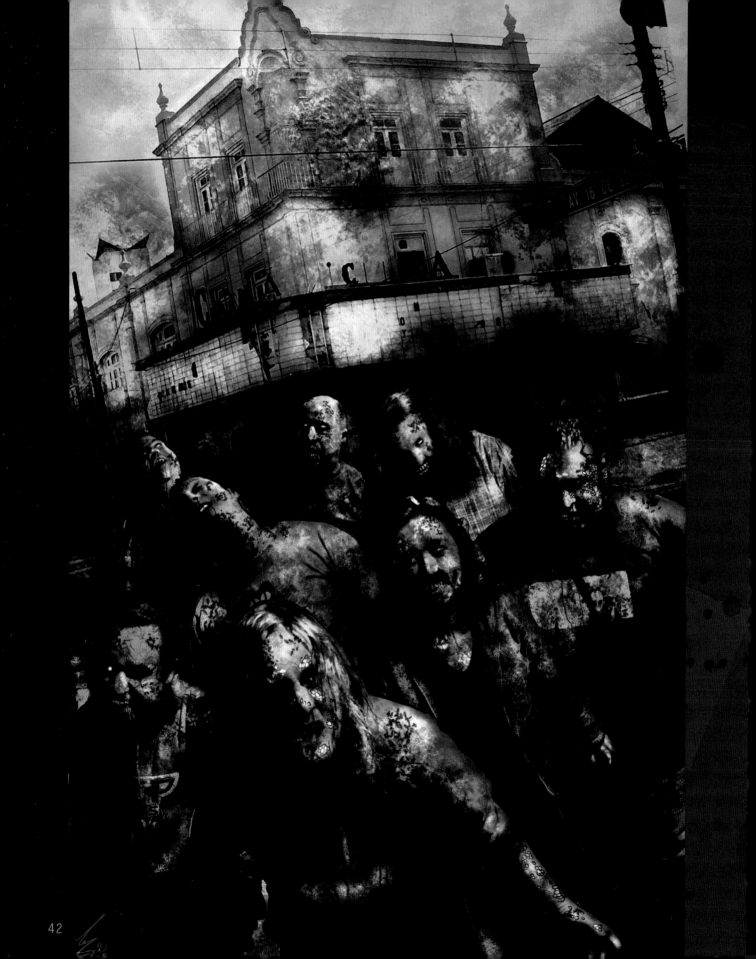

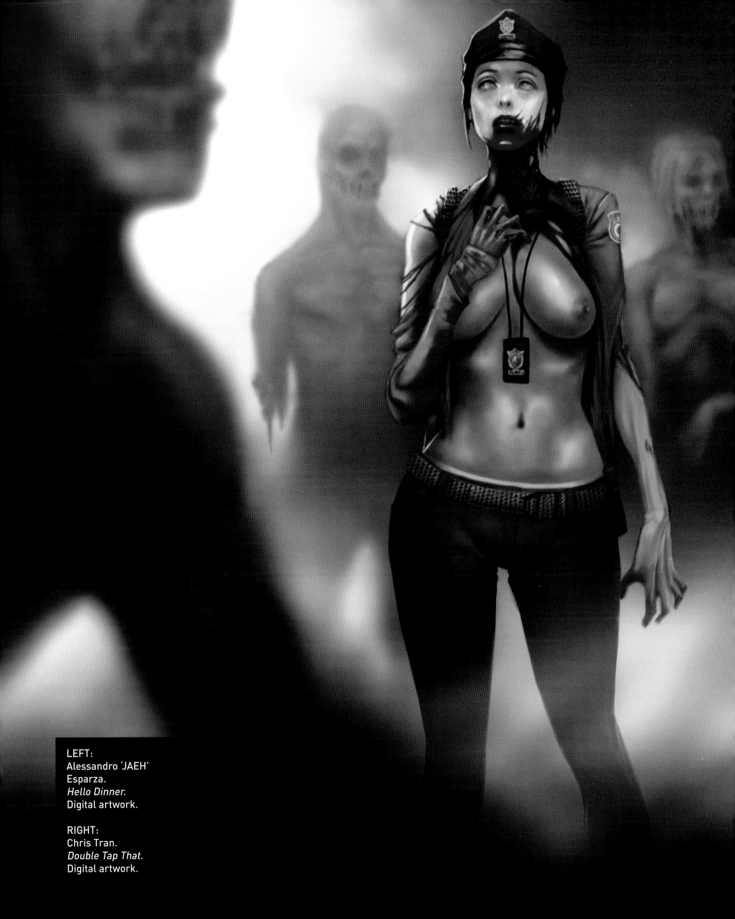

LEFT:
Alessandro 'JAEH'
Esparza.
Hello Dinner.
Digital artwork.

RIGHT:
Chris Tran.
Double Tap That.
Digital artwork.

ABOVE:
The Gurch.
Zombob Likes Garlic.
Pen and ink; digital.

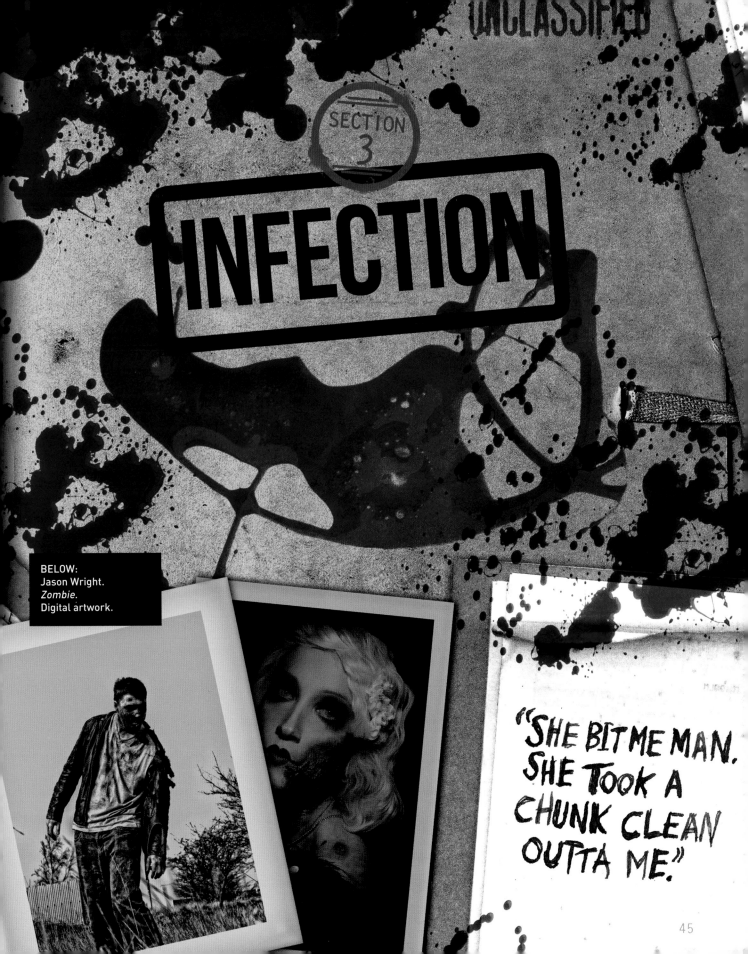

SECTION 3

INFECTION

BELOW:
Jason Wright.
Zombie.
Digital artwork.

"SHE BIT ME MAN. SHE TOOK A CHUNK CLEAN OUTTA ME."

45

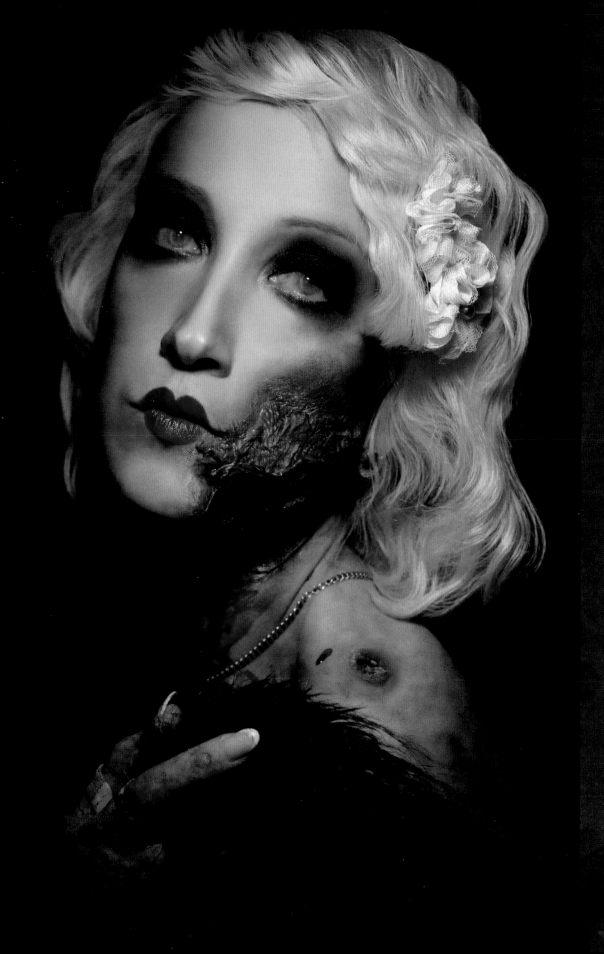

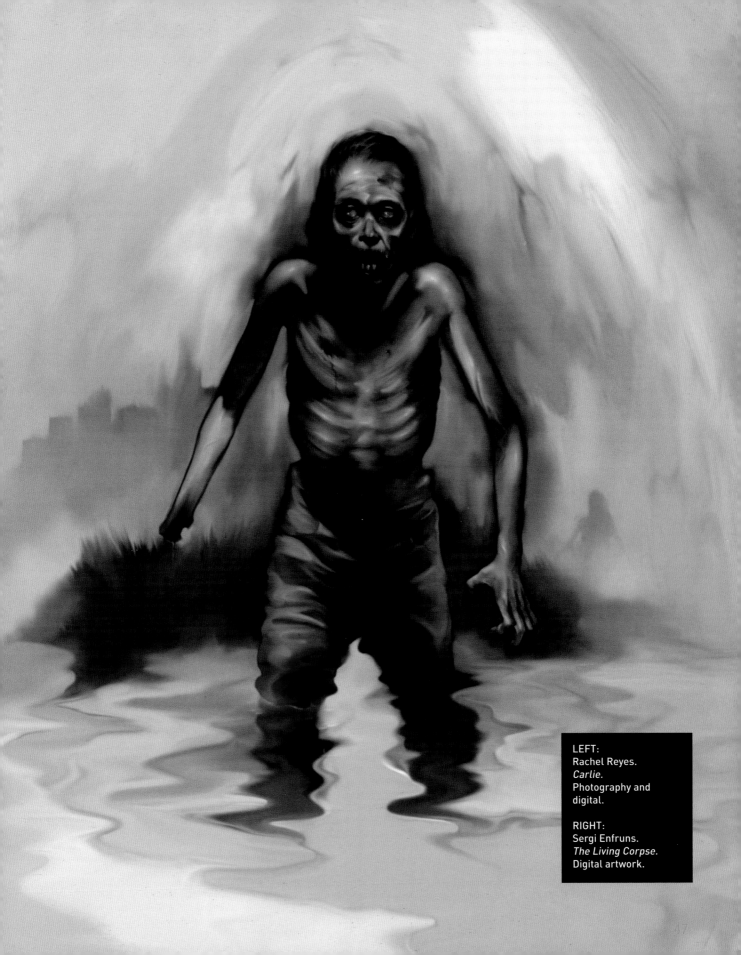

LEFT:
Rachel Reyes.
Carlie.
Photography and
digital.

RIGHT:
Sergi Enfruns.
The Living Corpse.
Digital artwork.

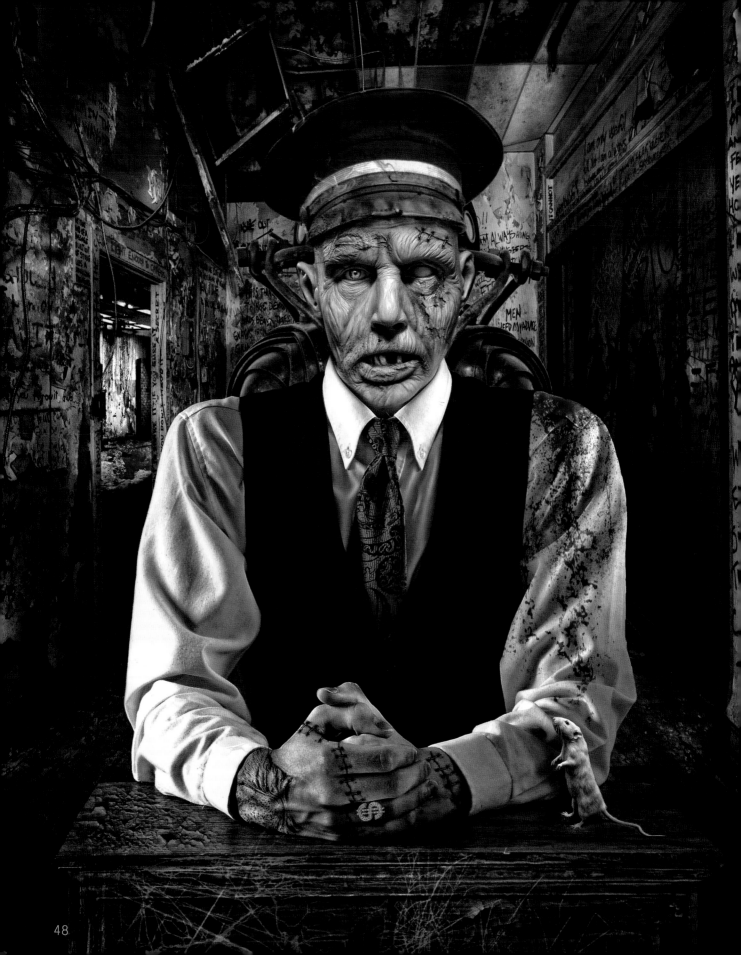

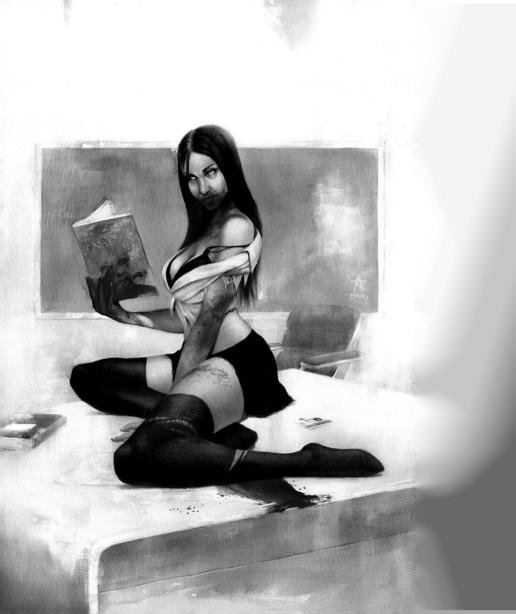

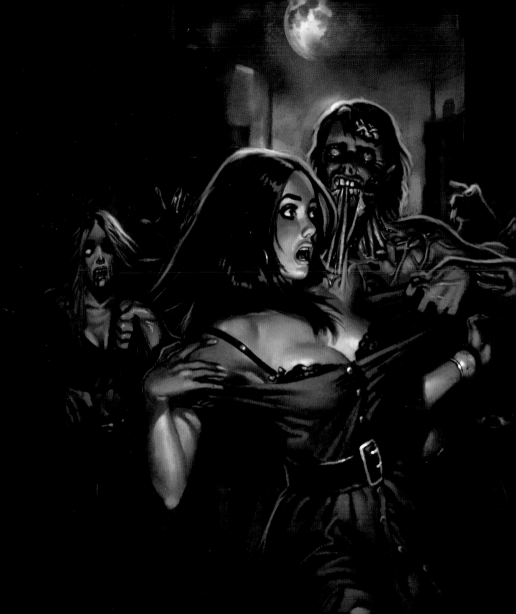

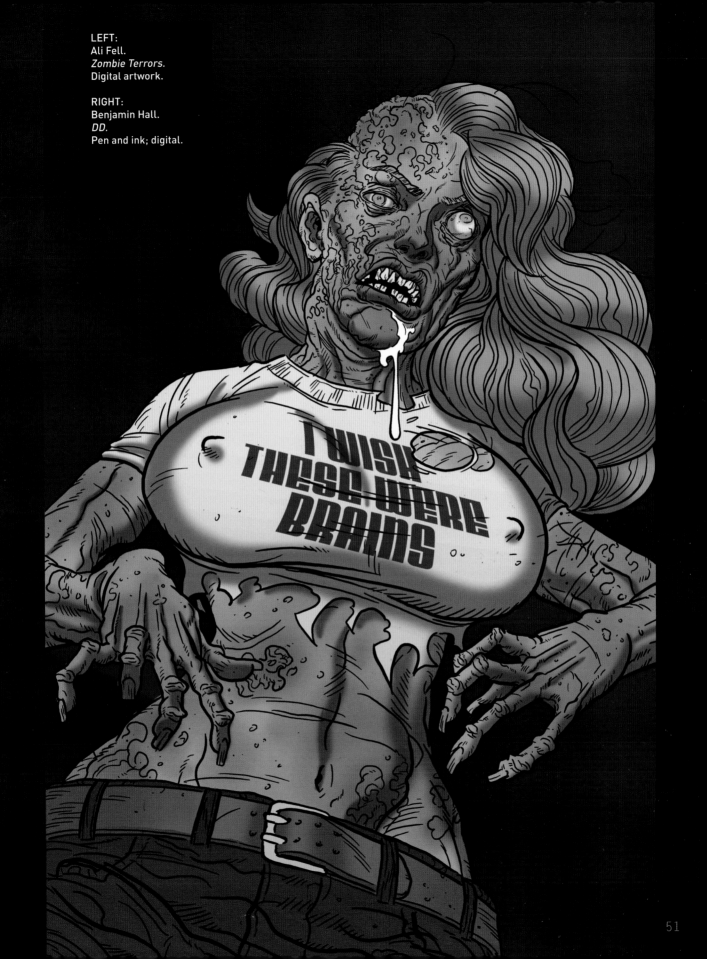

51

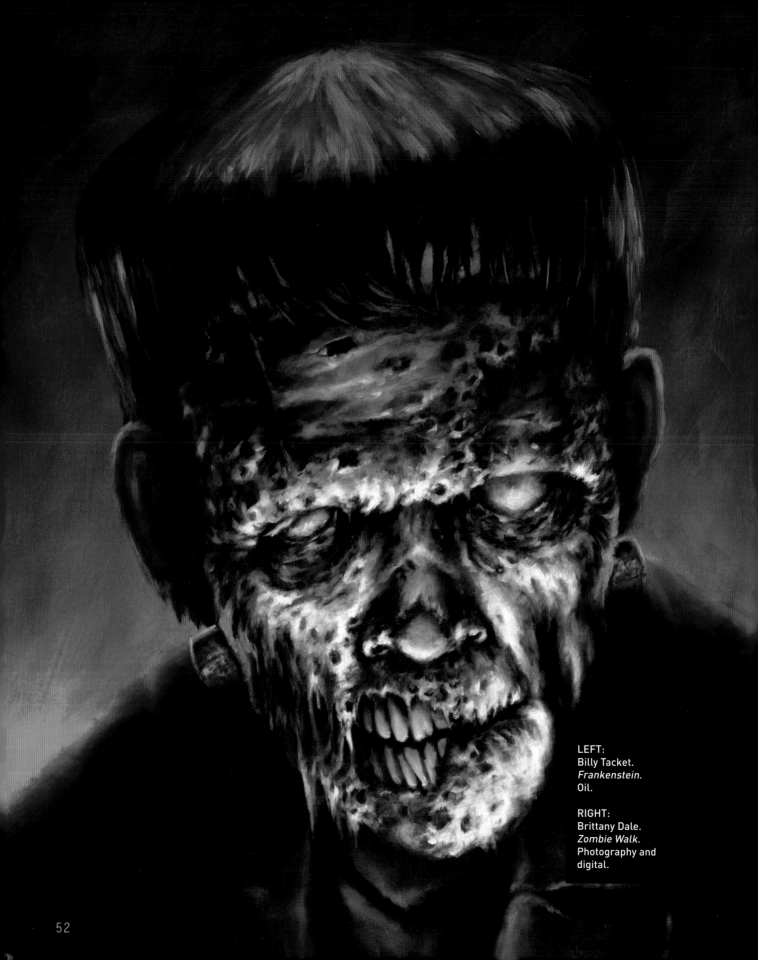

LEFT:
Billy Tacket.
Frankenstein.
Oil.

RIGHT:
Brittany Dale.
Zombie Walk.
Photography and
digital.

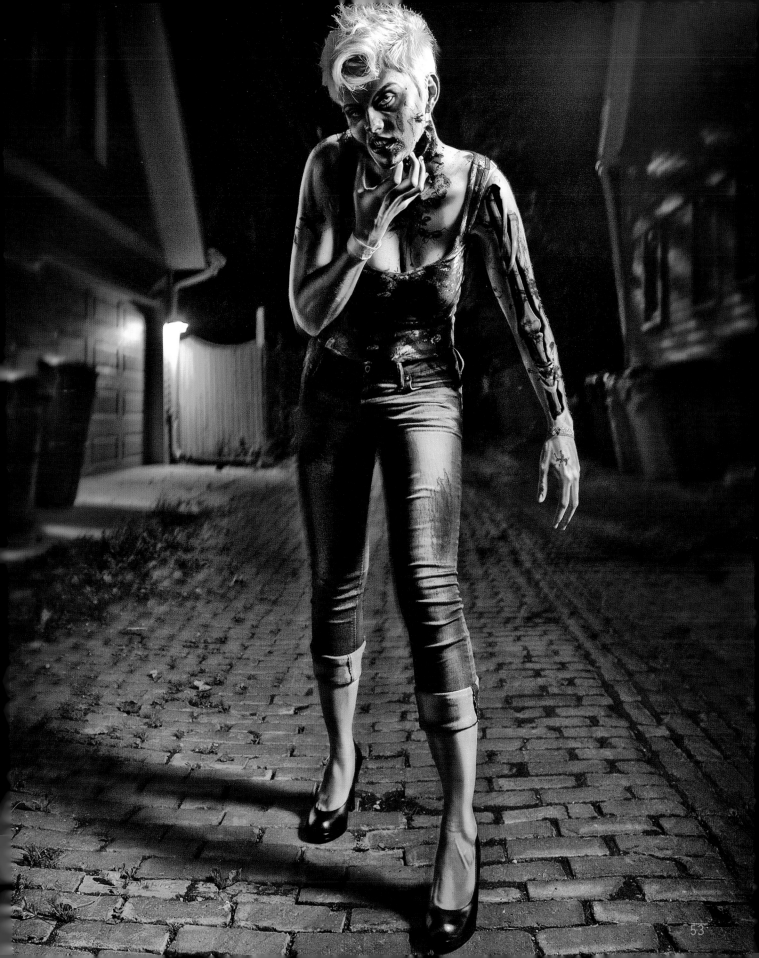

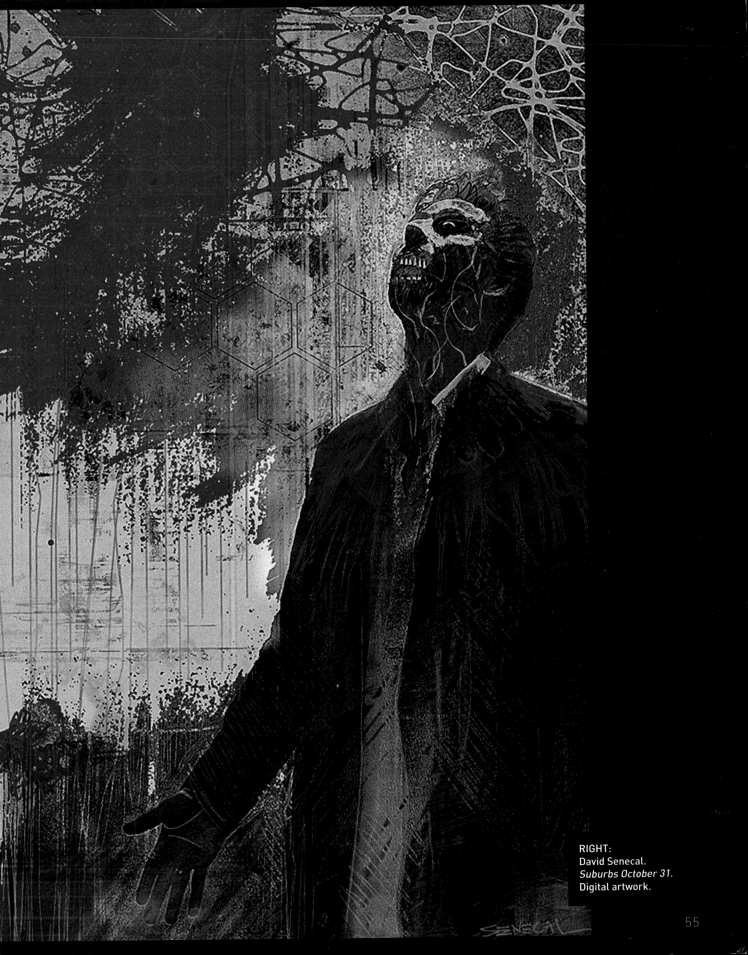

RIGHT:
David Senecal.
Suburbs October 31.
Digital artwork.

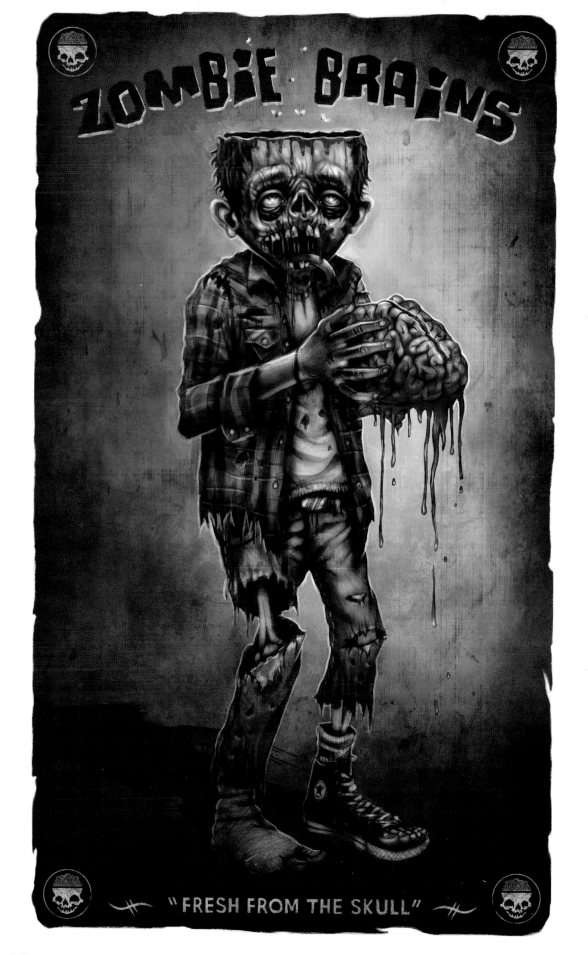

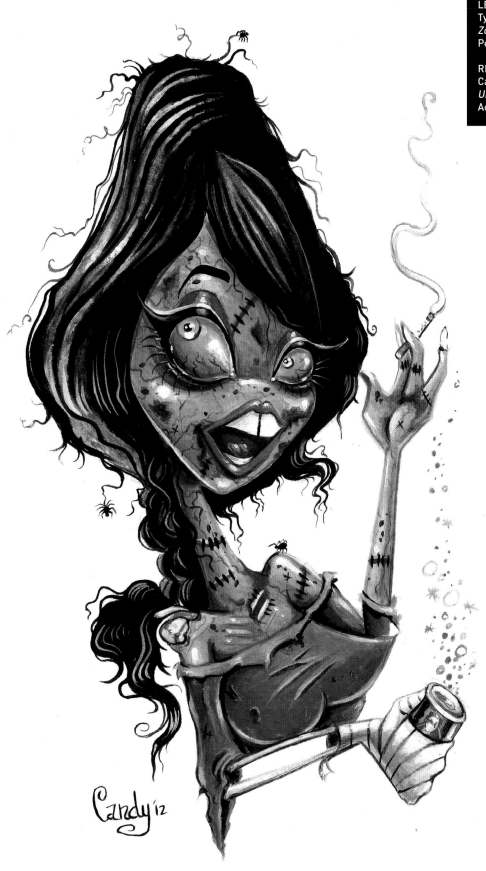

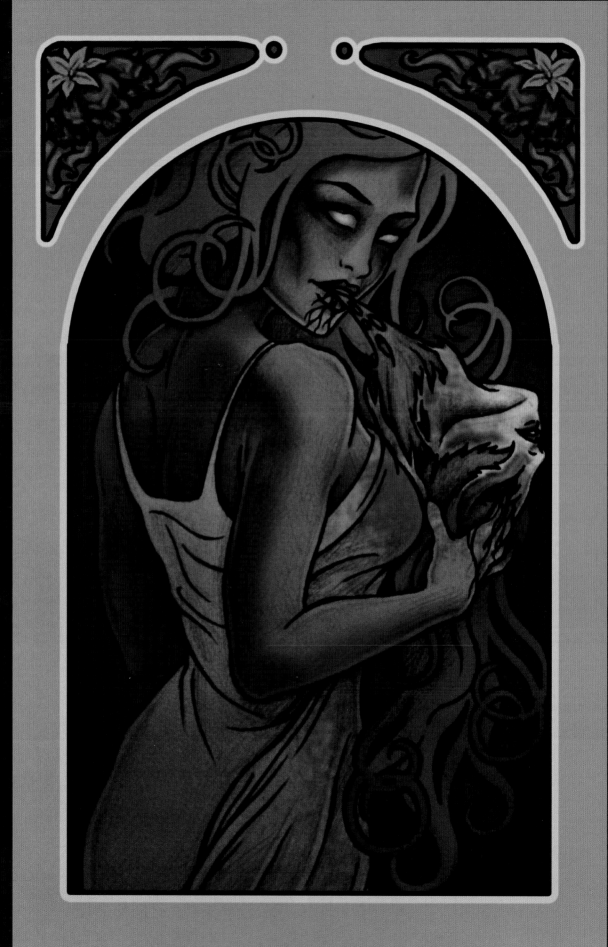

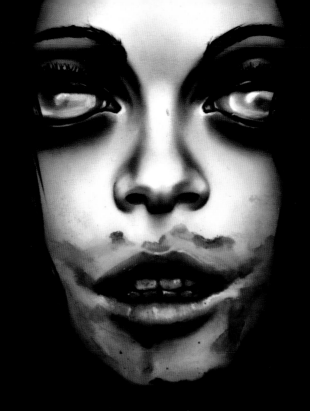

LEFT:
Paula Stirland.
Mucha Massacre.
Pen and ink; digital.

RIGHT:
Patrick Fatica.
*We Couldn't Let
Rosemary Go; She's
Shackled in the Cellar.*
Oil.

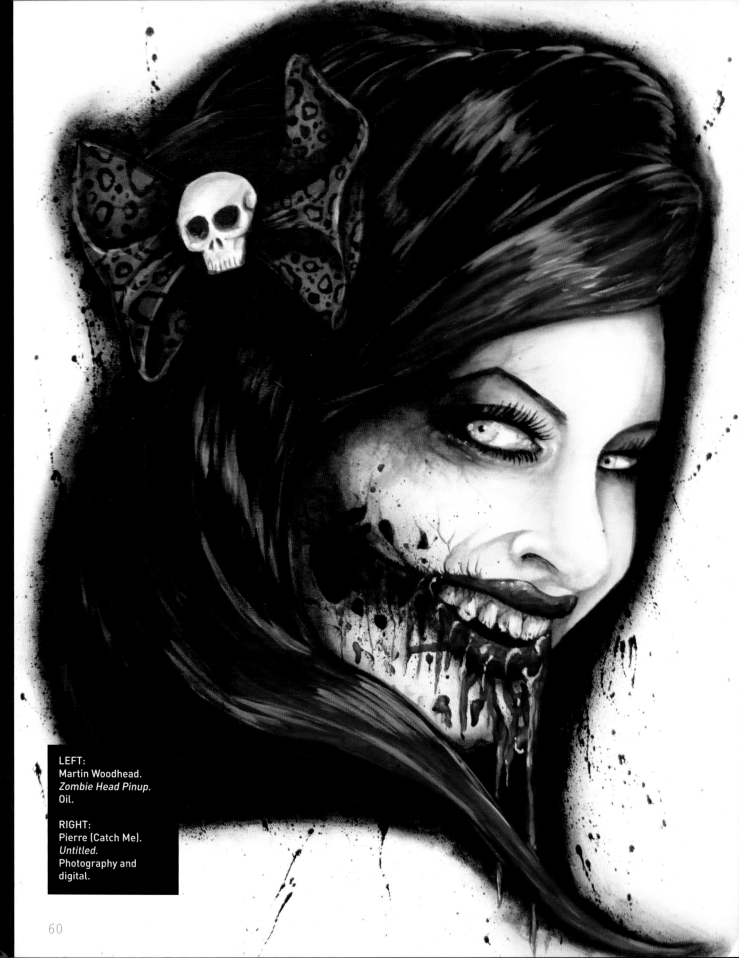

LEFT:
Martin Woodhead.
Zombie Head Pinup.
Oil.

RIGHT:
Pierre (Catch Me).
Untitled.
Photography and
digital.

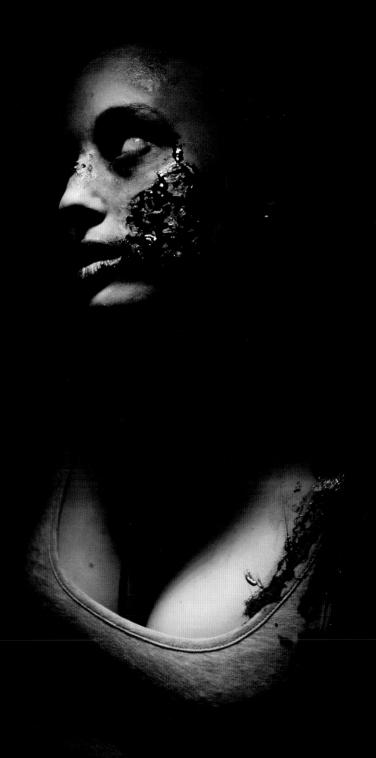

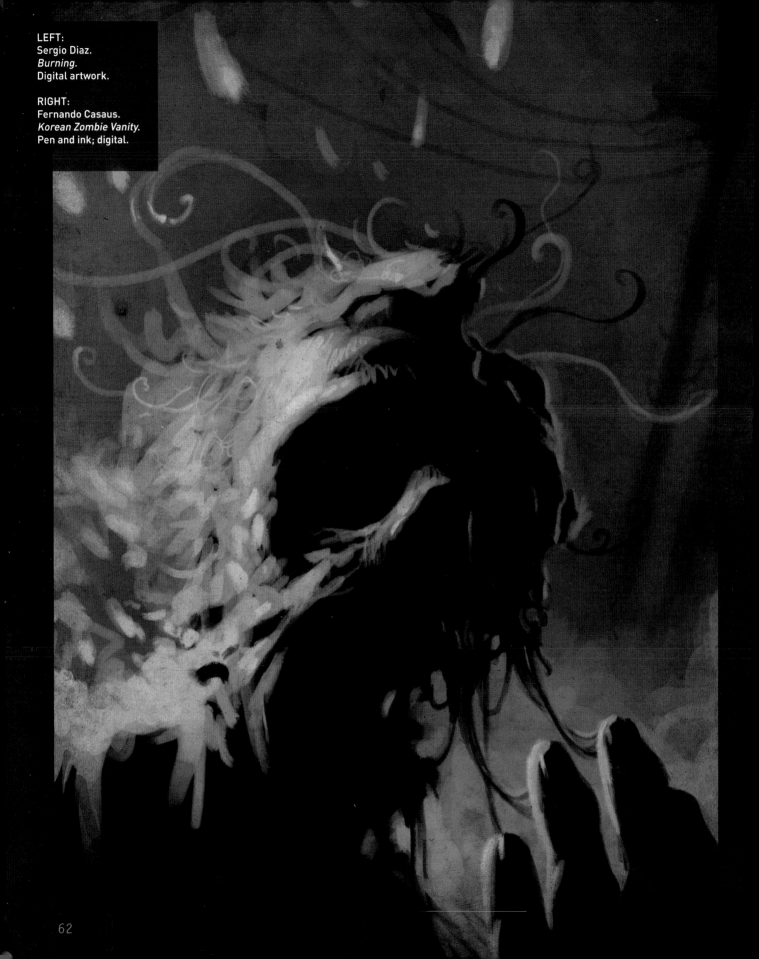

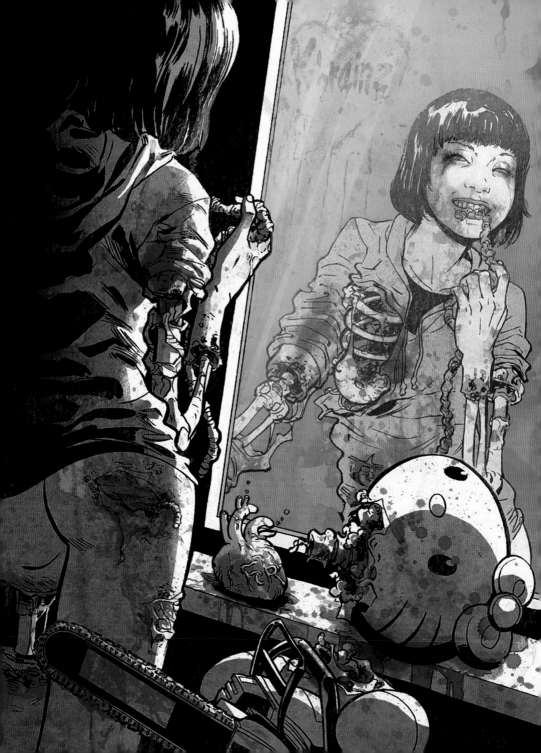

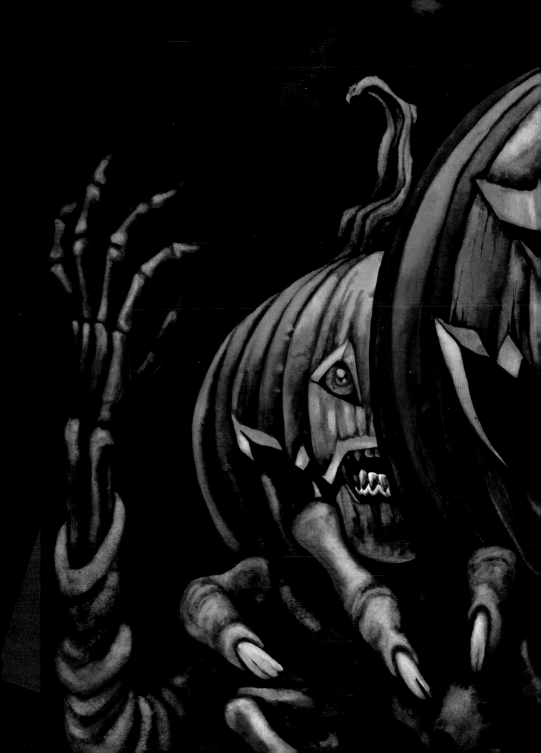

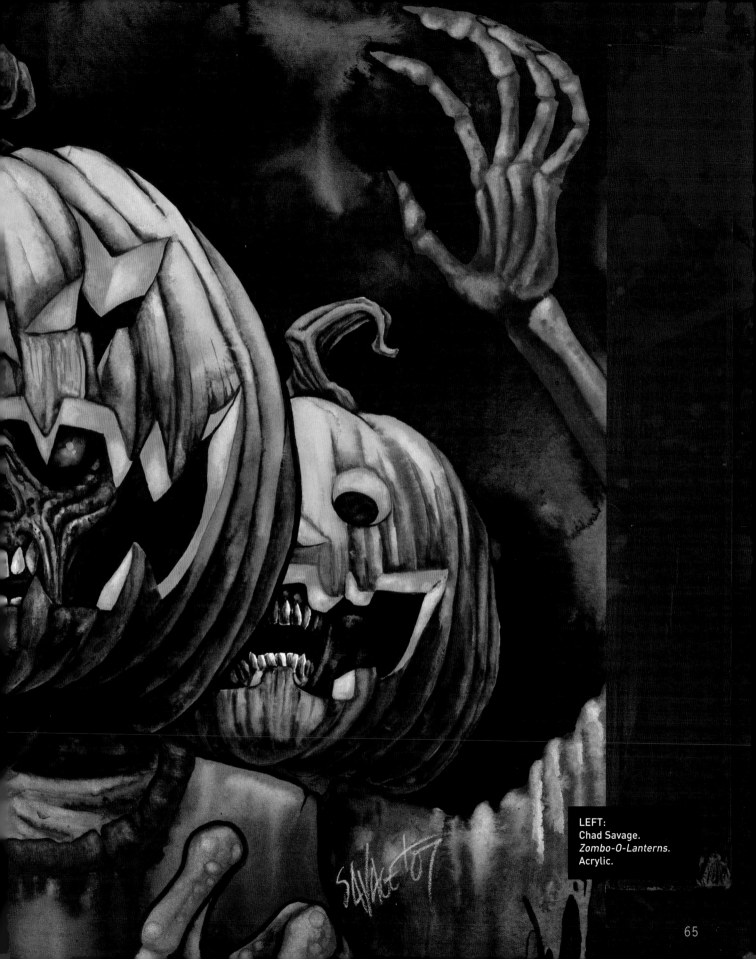

LEFT:
Chad Savage.
Zombo-O-Lanterns.
Acrylic.

ABOVE:
Feng.
Zombie Infestation.
Sculpted toy,
photography and
digital.

TRANSFORMATION

ABOVE:
Josh (YOTD).
August.
Pen and ink; digital.

"I'LL SHOOT
YOU DEAD!
YOU CAN'T SHOOT
US DEAD, RICHARD...
...BECAUSE
WE'RE ALREADY
DEAD!"

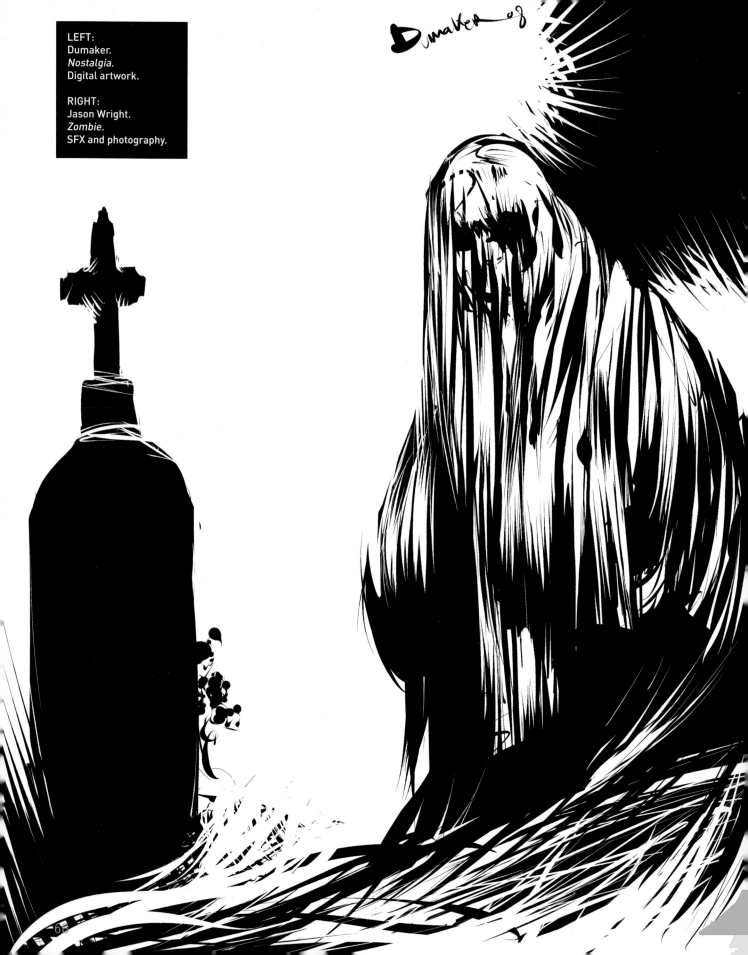

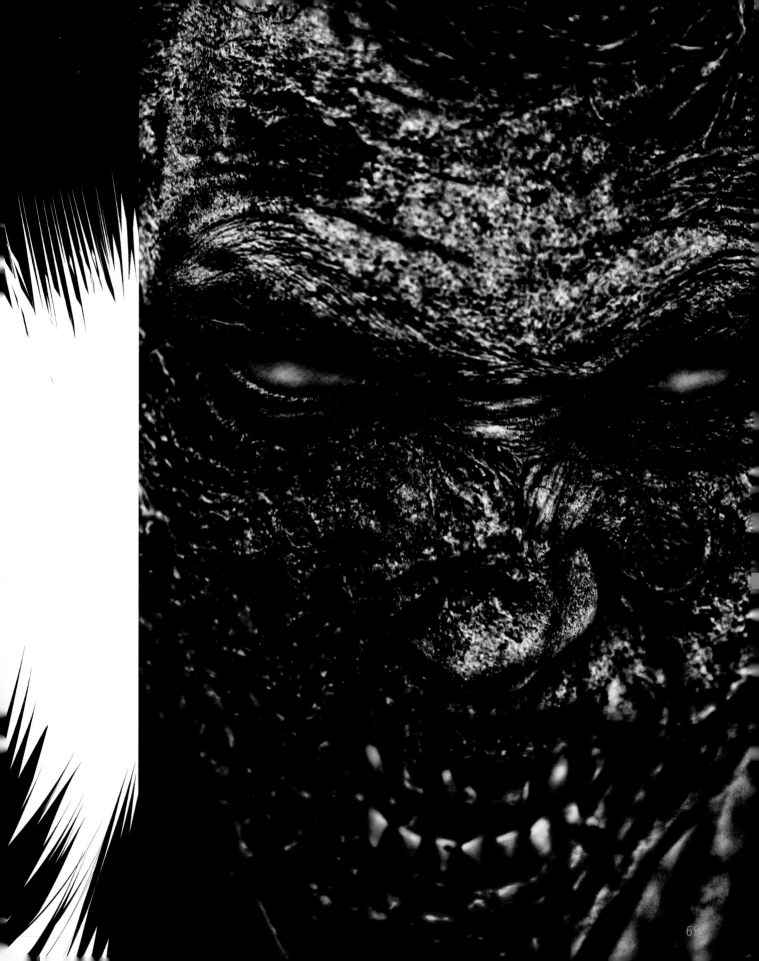

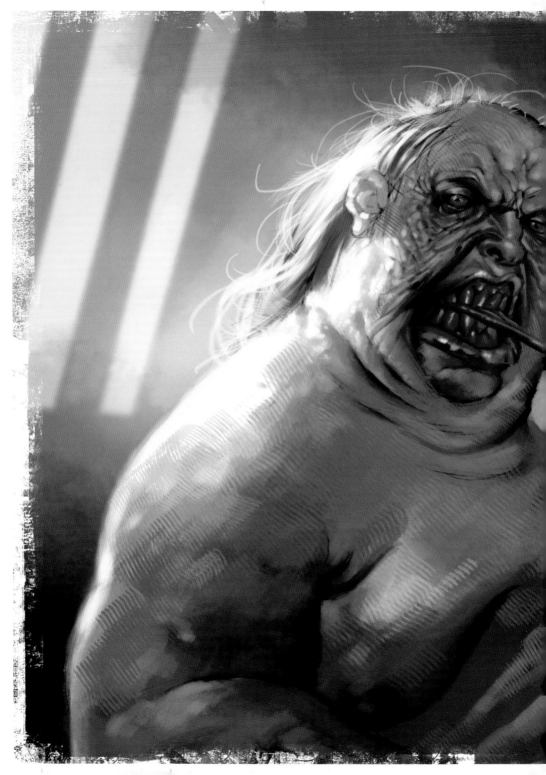

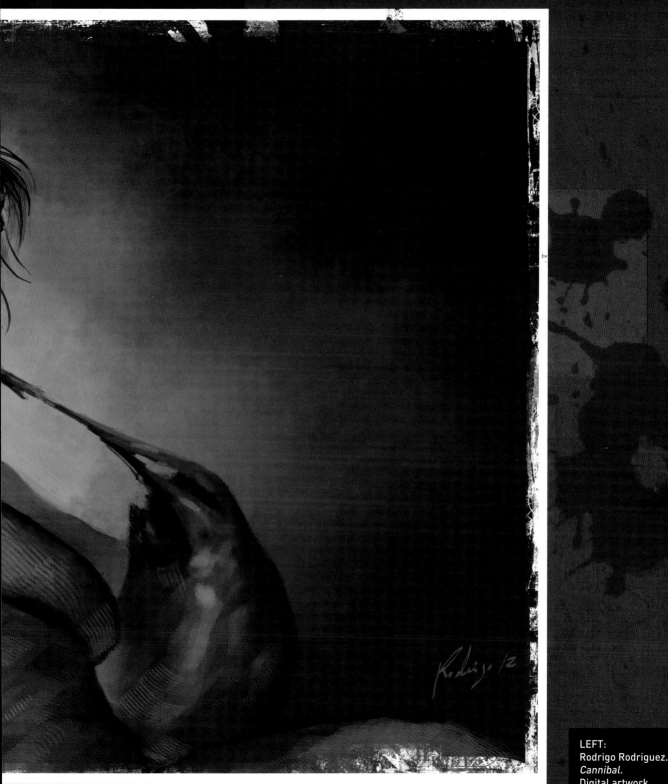

THE CHOICE OF THE LIVING DEAD

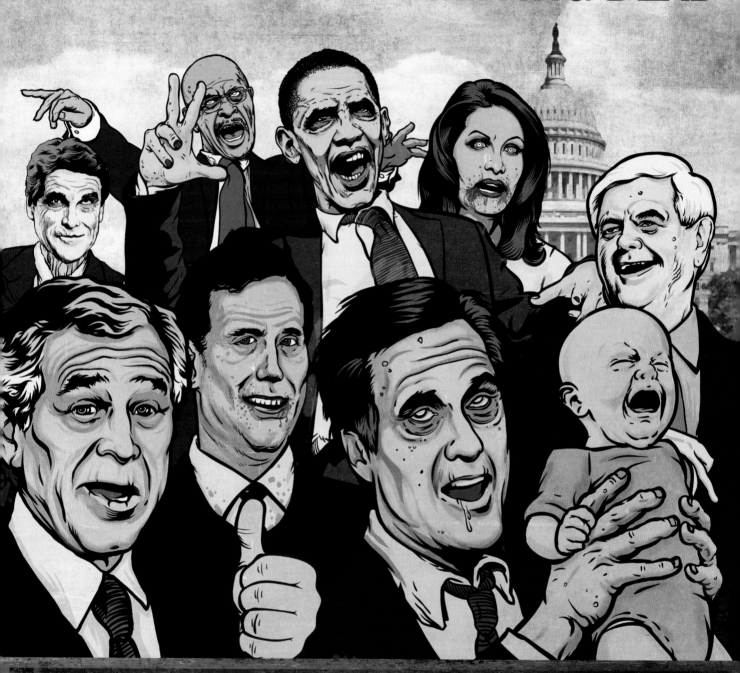

VOTE
ZOMBIE

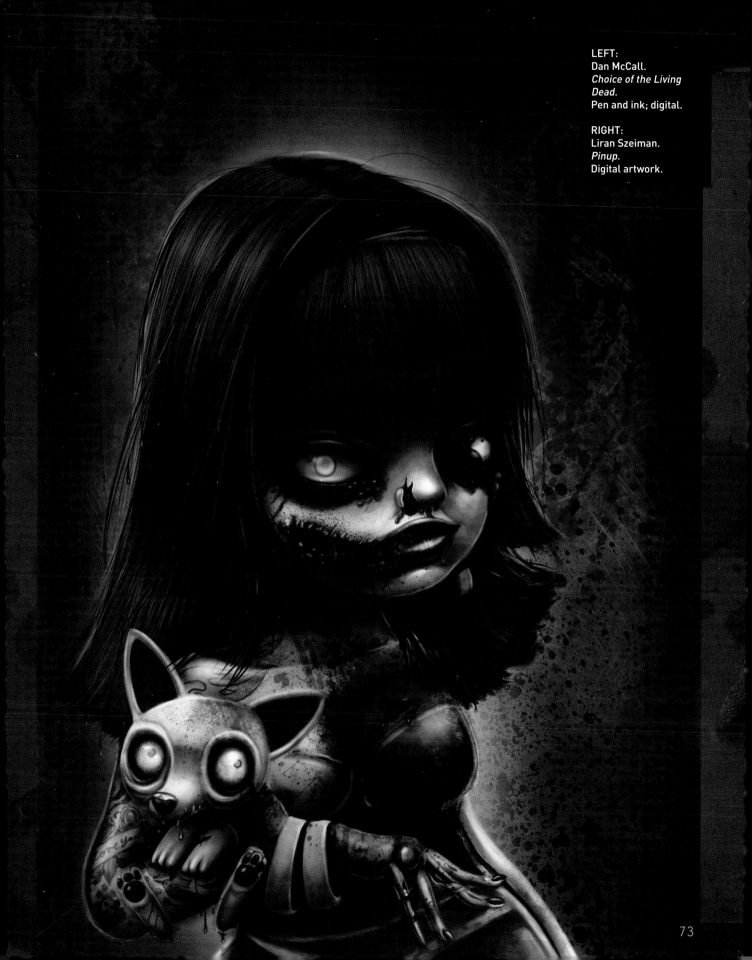

LEFT:
Dan McCall.
Choice of the Living Dead.
Pen and ink; digital.

RIGHT:
Liran Szeiman.
Pinup.
Digital artwork.

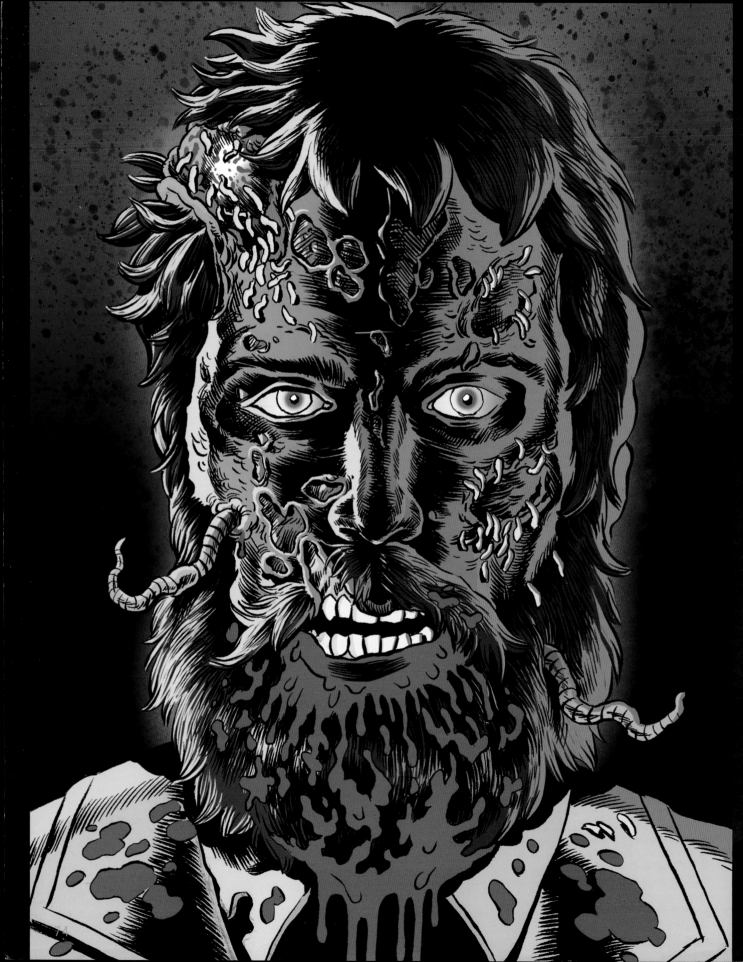

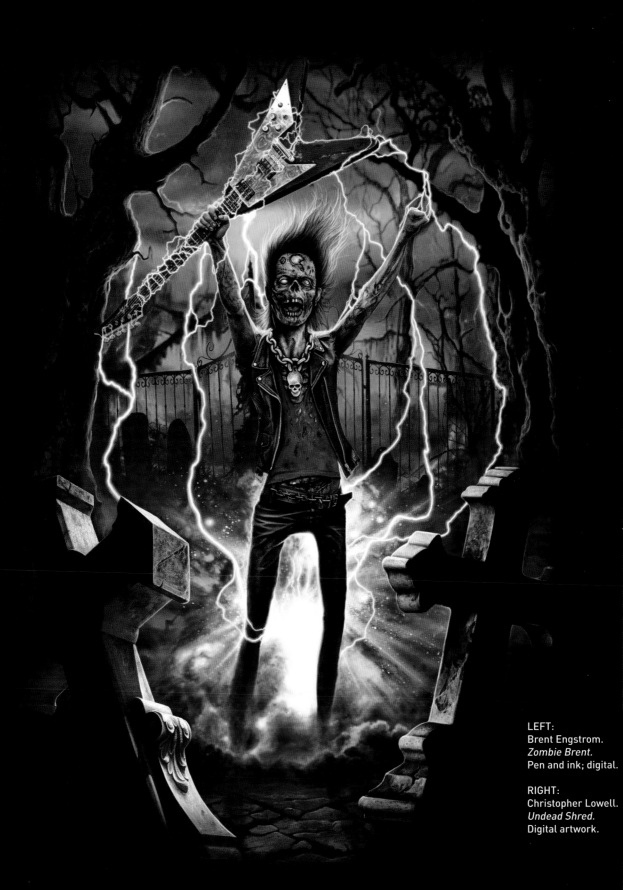

LEFT:
Brent Engstrom.
Zombie Brent.
Pen and ink; digital.

RIGHT:
Christopher Lowell.
Undead Shred.
Digital artwork.

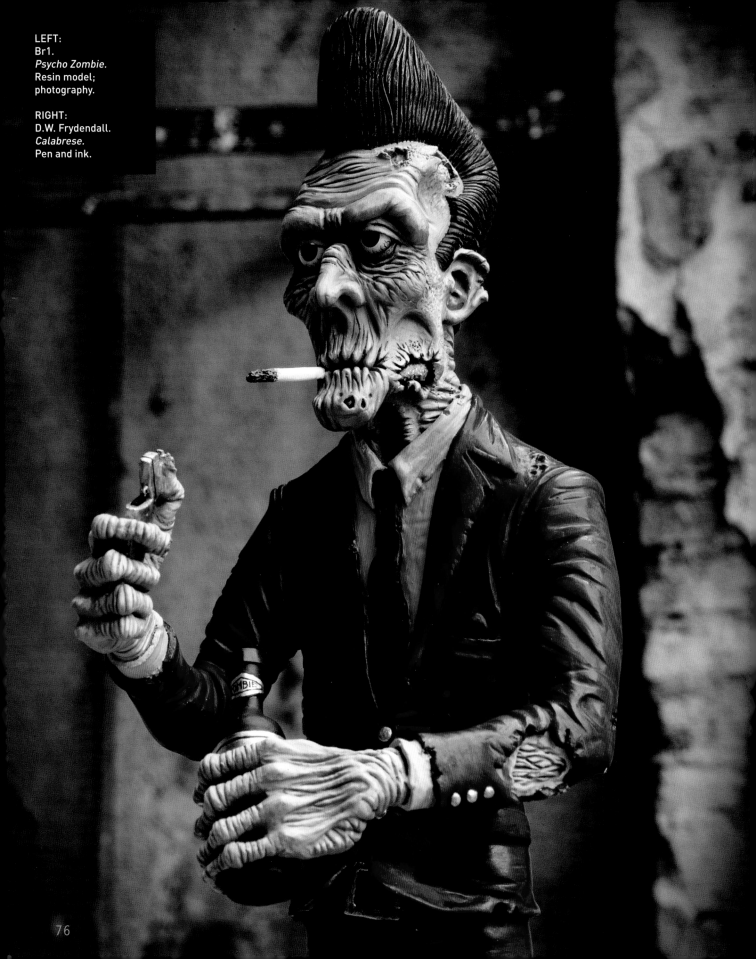

LEFT:
Br1.
Psycho Zombie.
Resin model;
photography.

RIGHT:
D.W. Frydendall.
Calabrese.
Pen and ink.

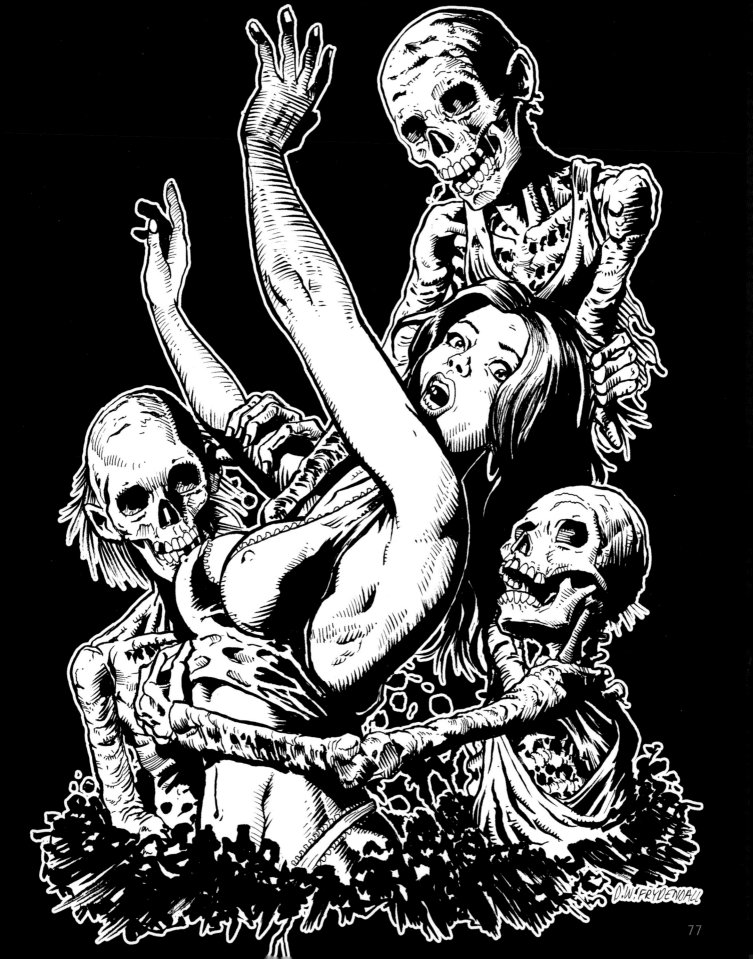

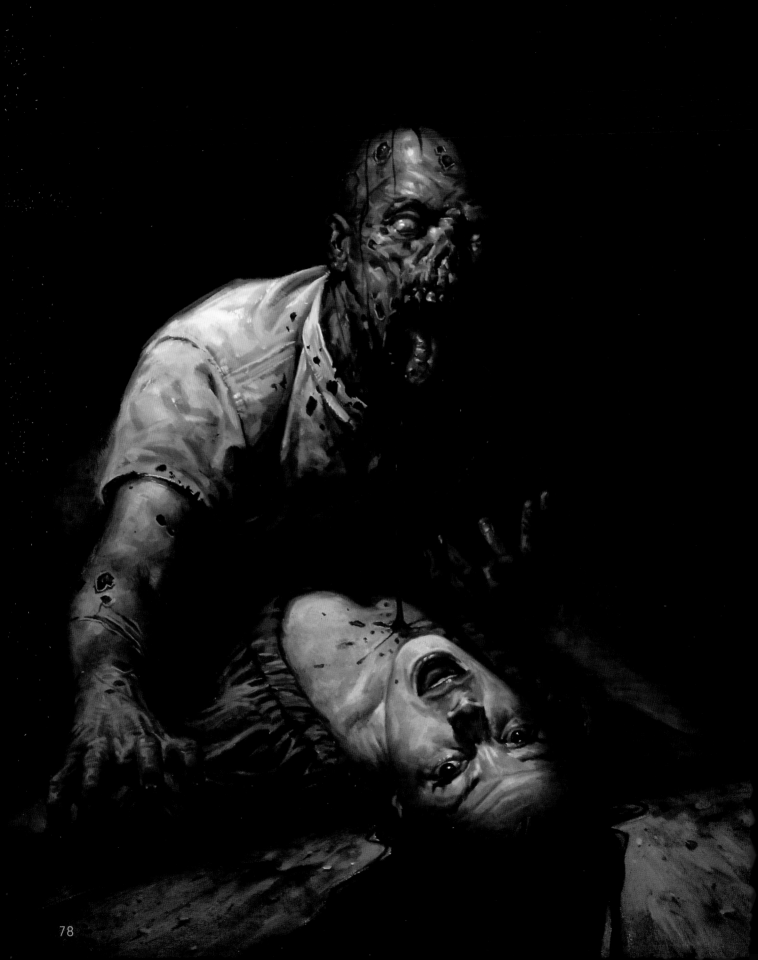

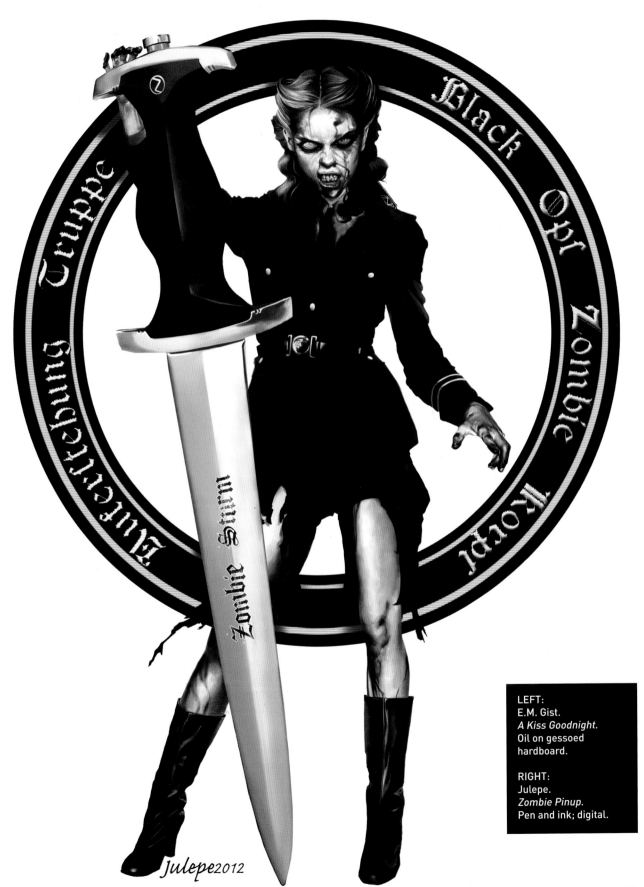

Zombie Sturm

Julepe2012

LEFT:
E.M. Gist.
A Kiss Goodnight.
Oil on gessoed
hardboard.

RIGHT:
Julepe.
Zombie Pinup.
Pen and ink; digital.

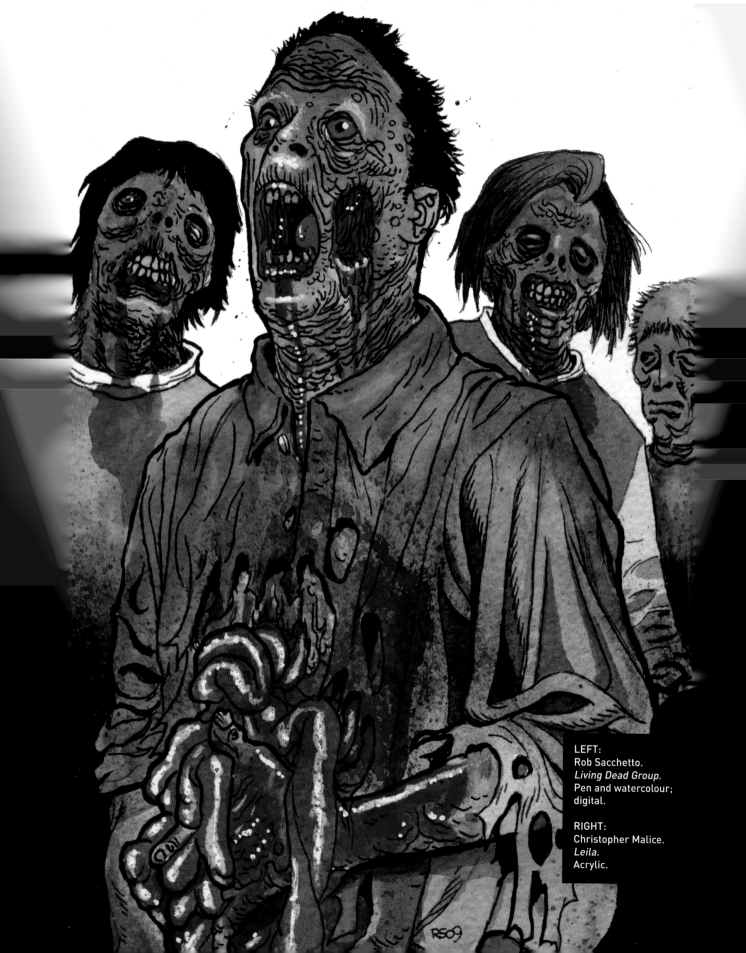

LEFT:
Rob Sacchetto.
Living Dead Group.
Pen and watercolour;
digital.

RIGHT:
Christopher Malice.
Leila.
Acrylic.

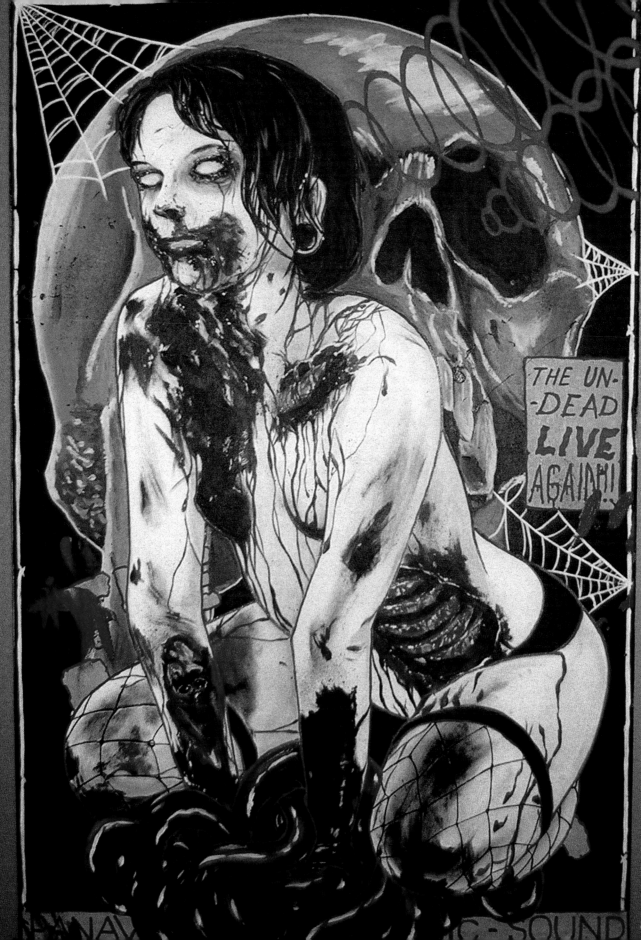

THE UN-
-DEAD
LIVE
AGAIN!

BELOW:
Matthew Bartlett.
Living Dead Girl.
Pen and ink.

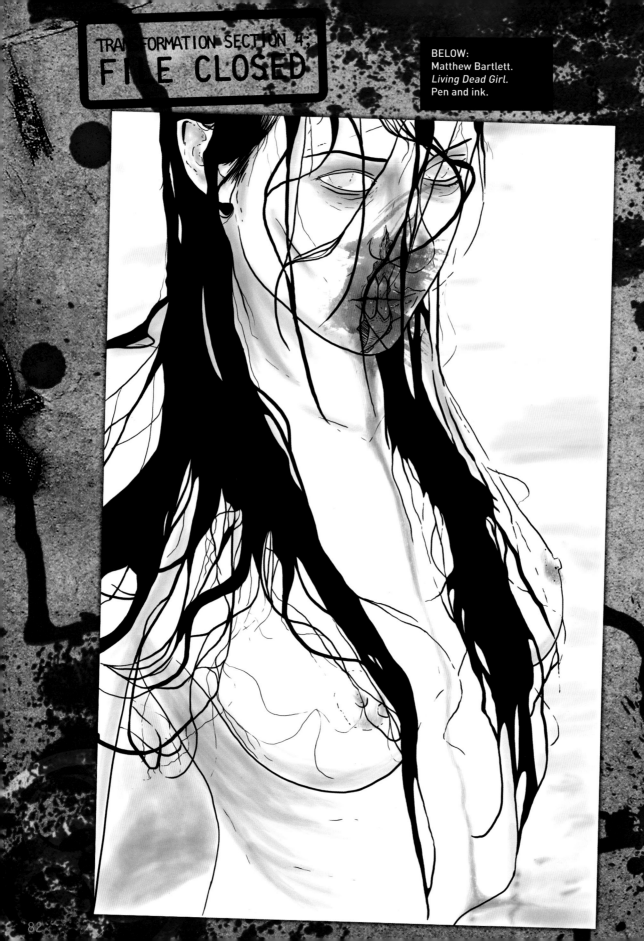

RAGE

ABOVE:
Connor Addams.
Monster Me.
Pen and ink; digital.

"YOU THINK THIS IS A FUCKIN' COSTUME? THIS IS A WAY OF LIFE."

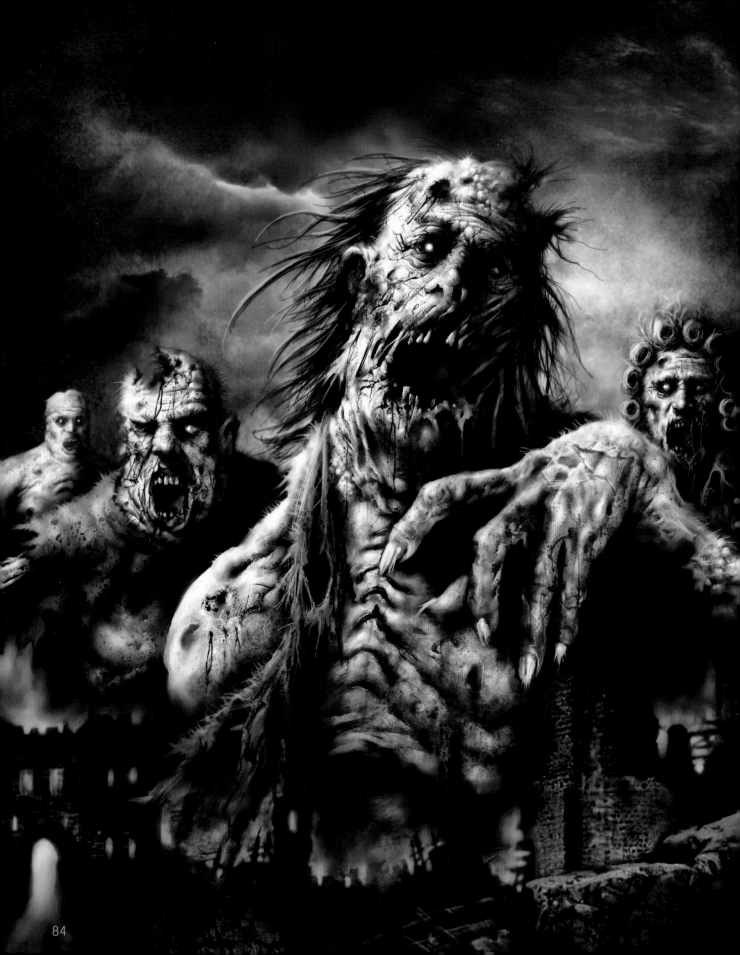

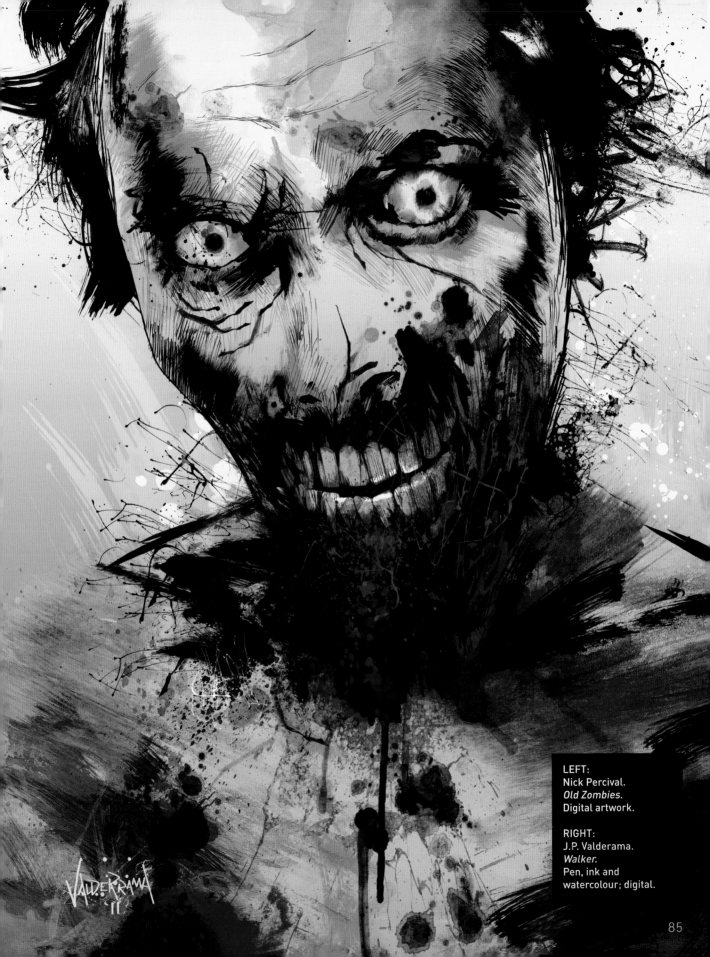

LEFT:
Nick Percival.
Old Zombies.
Digital artwork.

RIGHT:
J.P. Valderama.
Walker.
Pen, ink and
watercolour; digital.

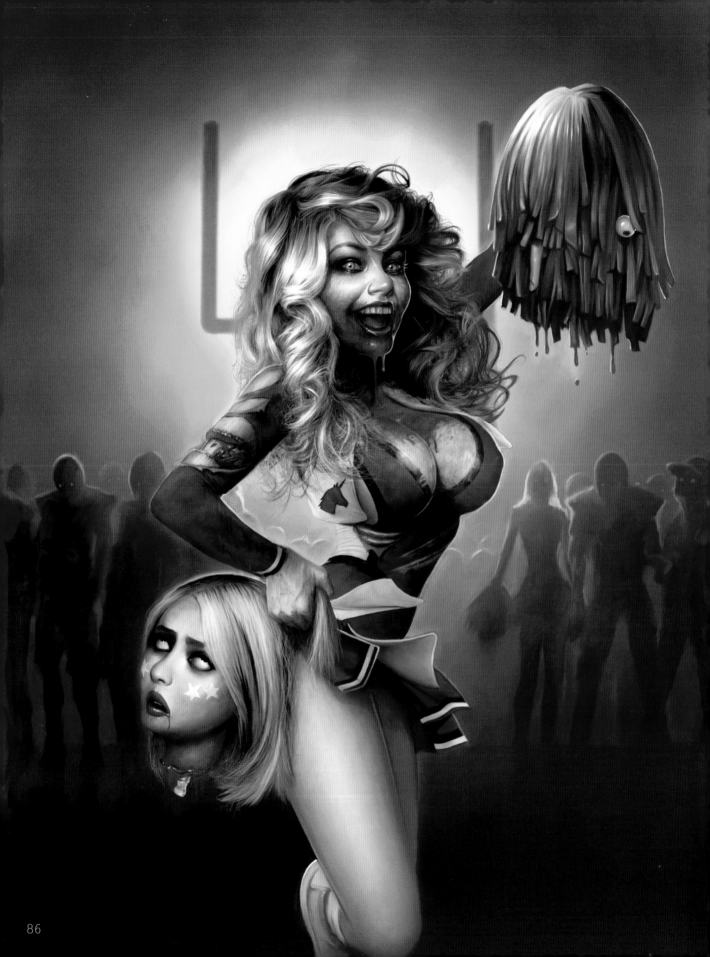

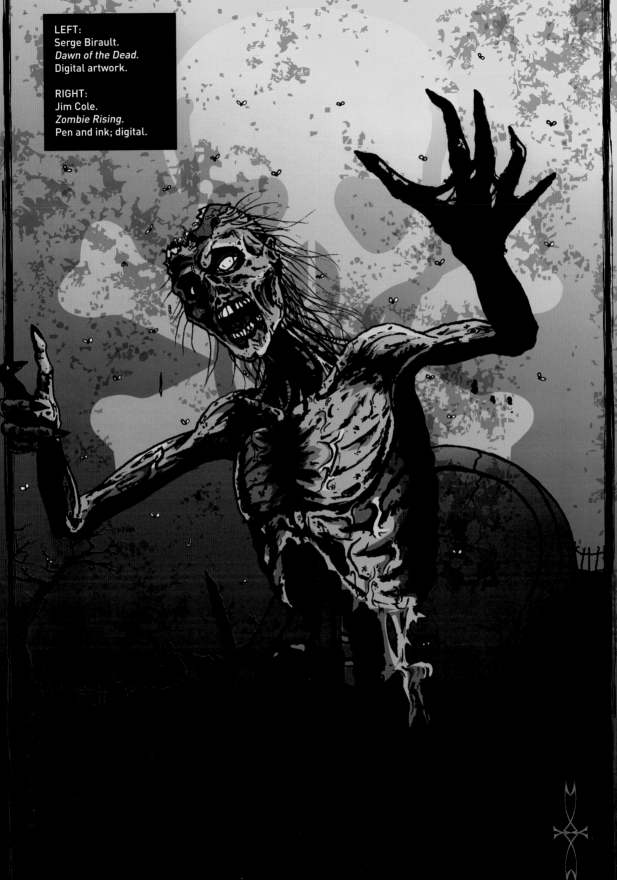

LEFT:
Serge Birault.
Dawn of the Dead.
Digital artwork.

RIGHT:
Jim Cole.
Zombie Rising.
Pen and ink; digital.

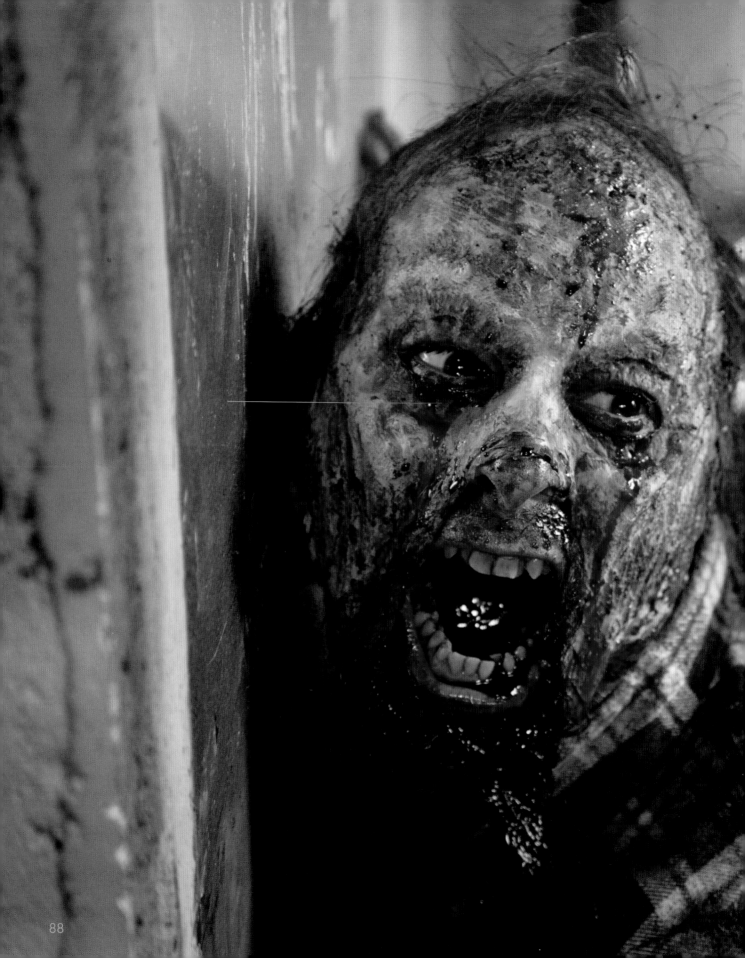

LEFT:
Monica Mur
Zombies.
SFX still ph
shoot.

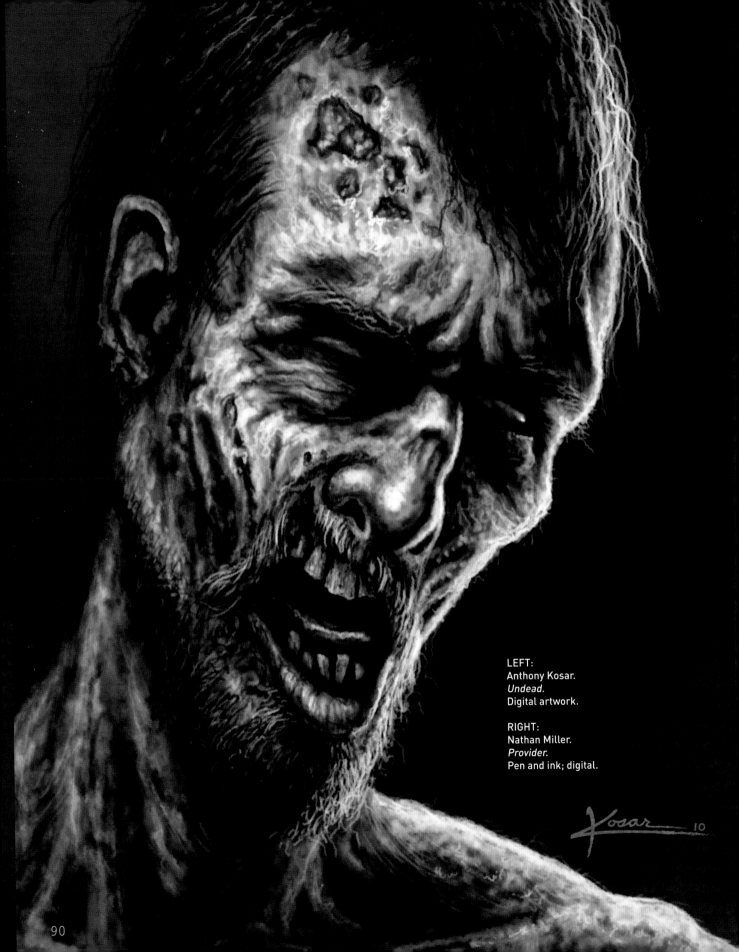

LEFT:
Anthony Kosar.
Undead.
Digital artwork.

RIGHT:
Nathan Miller.
Provider.
Pen and ink; digital.

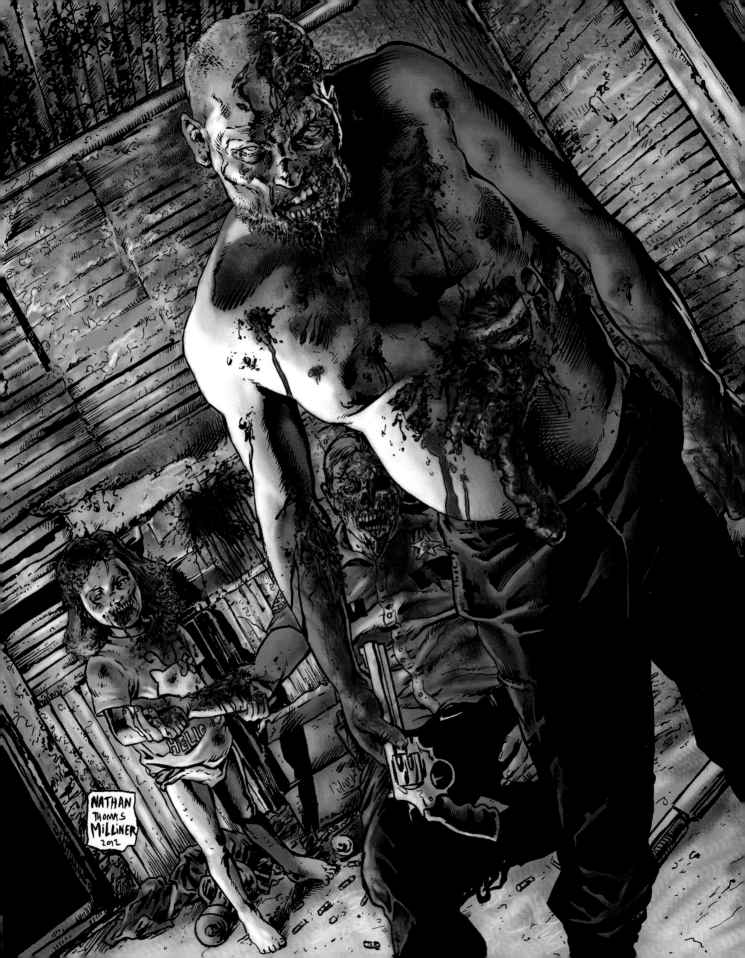

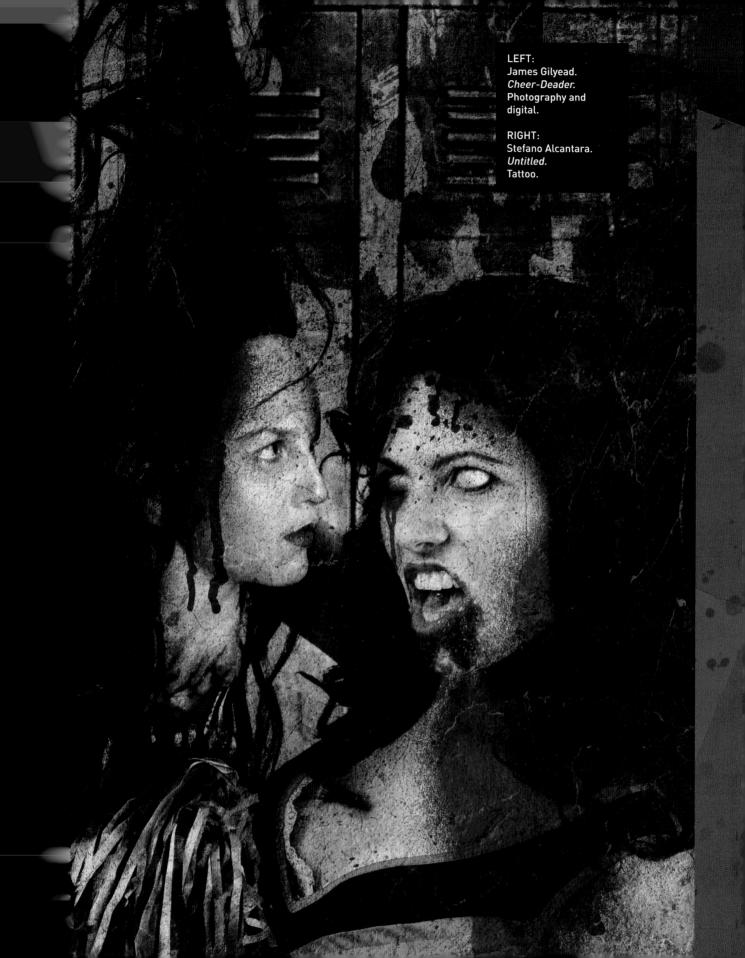

LEFT:
James Gilyead.
Cheer-Deader.
Photography and
digital.

RIGHT:
Stefano Alcantara.
Untitled.
Tattoo.

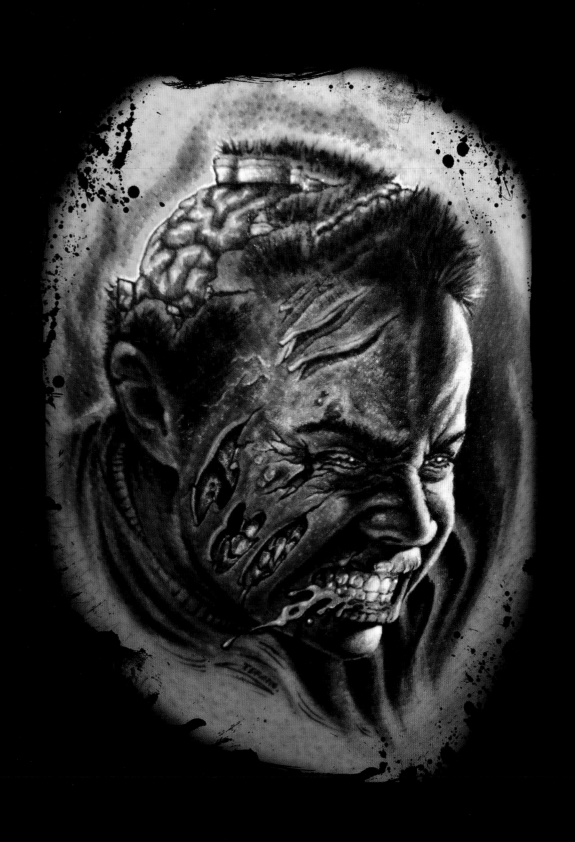

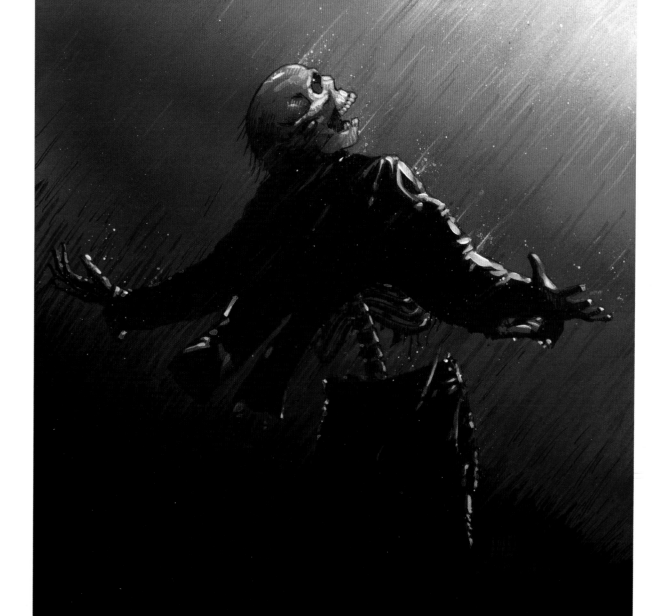

LIFE CAN HOLD YOU PRISONER.
DEATH CAN SET YOU FREE.

SLIM ROBBINS MORTAL FREEMAN

SHAWSHANK
REANIMATED

PLANETMATT ENTERTAINMENT Presents

A HOLLYWOOD IS DEAD Production Starring SLIM ROBBINGS and MORTAL FREEMAN in "SHAWSHANK REANIMATED"

Concieved and Illustrated by MATT BUSCH Immoral Support by LIN ZY Based on the Short Novel by GREIVIN' KING Directed by SHANK DARABONT

In this epic SHAWSHANK zombie tale, the UNDEAD INMATES don't take bets on who's FIRST TO CRY... They take bets on who's FIRST TO DIE.

More KILLER ZOMBIE POSTERS available at WWW.HOLLYWOOD-IS-DEAD.com

MATT BUSCH .com HOLLYWOOD IS Dead

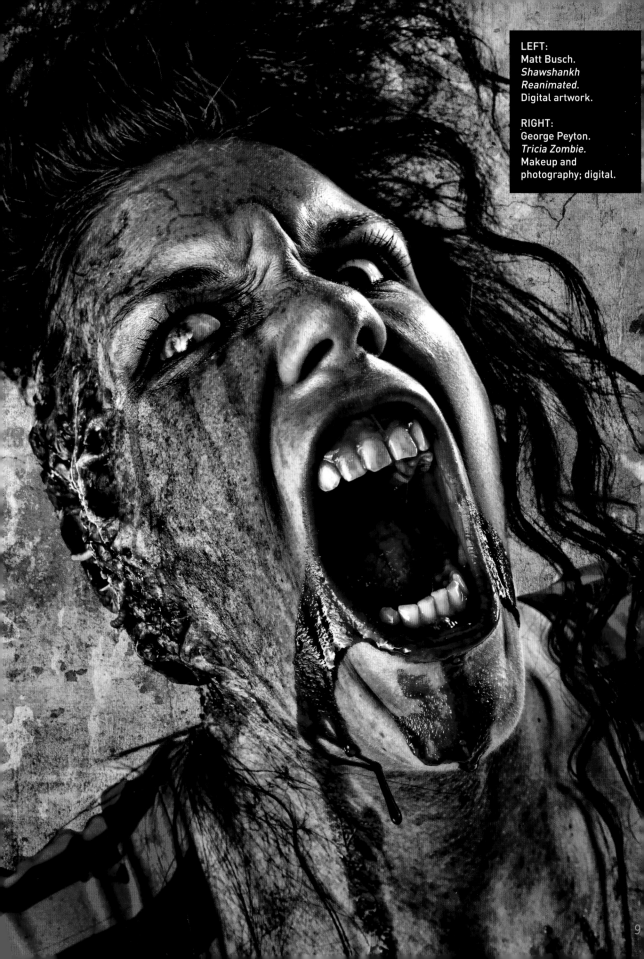

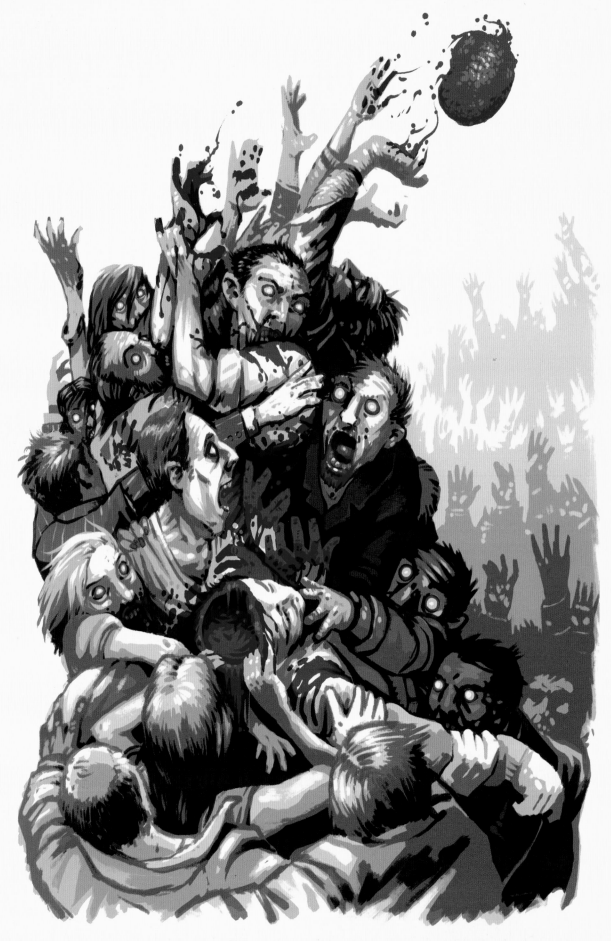

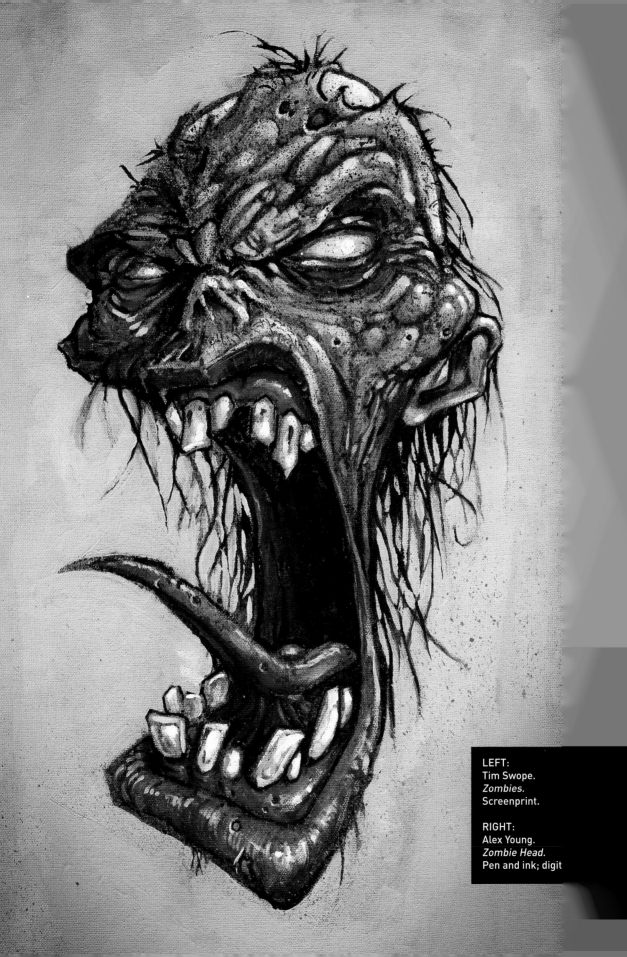

LEFT:
Tim Swope.
Zombies.
Screenprint.

RIGHT:
Alex Young.
Zombie Head.
Pen and ink; digit

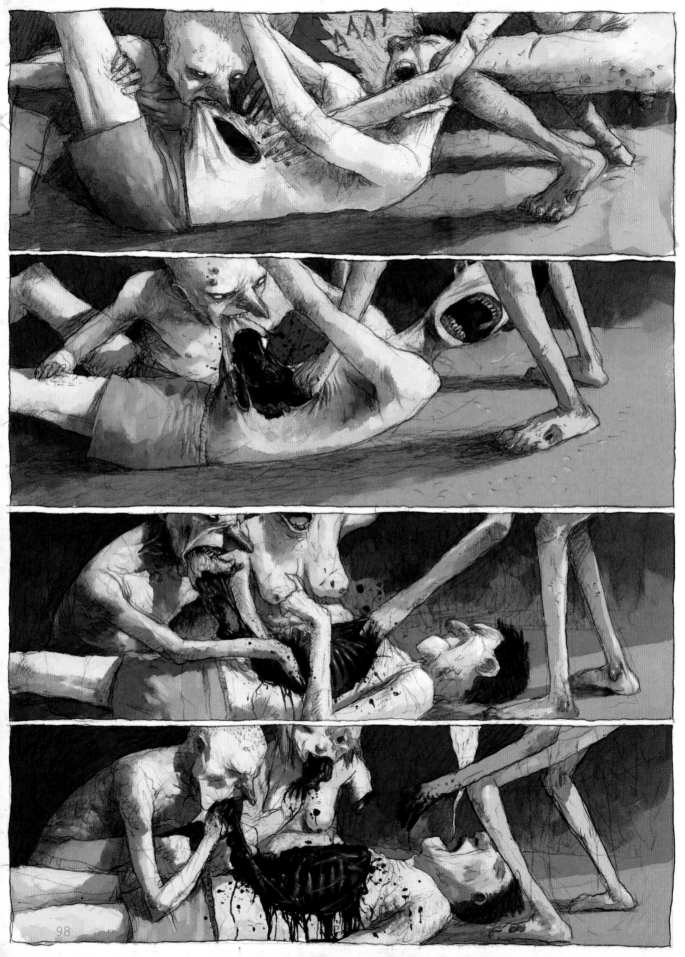

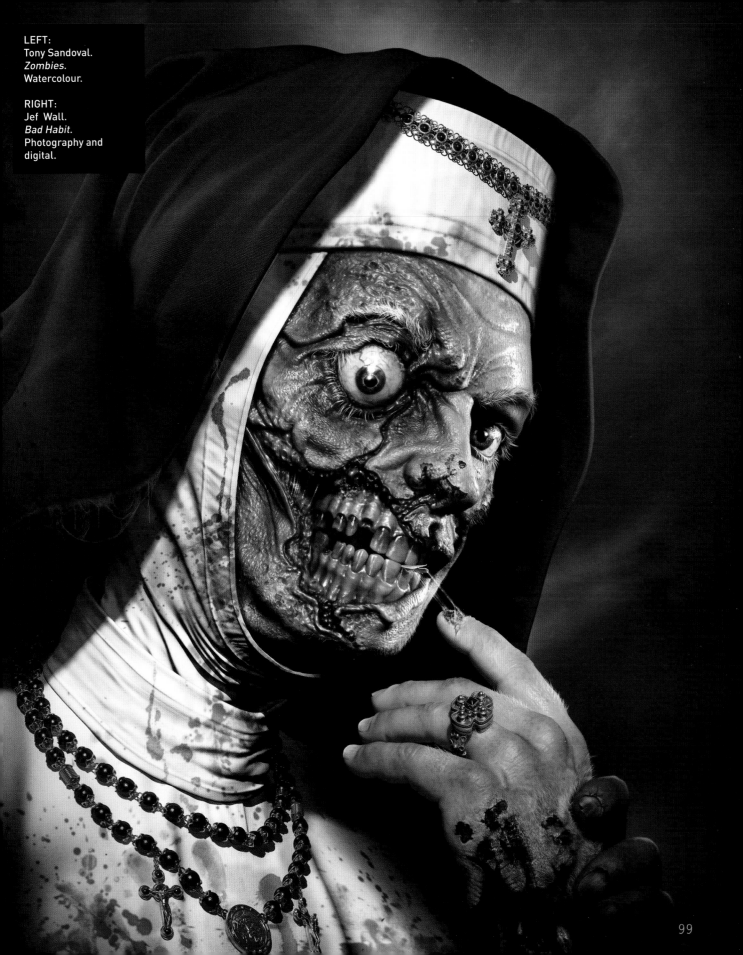

LEFT:
Tony Sandoval.
Zombies.
Watercolour.

RIGHT:
Jef Wall.
Bad Habit.
Photography and
digital.

BELOW:
Allan Graves.
London Terror.
Pen and ink; digital.

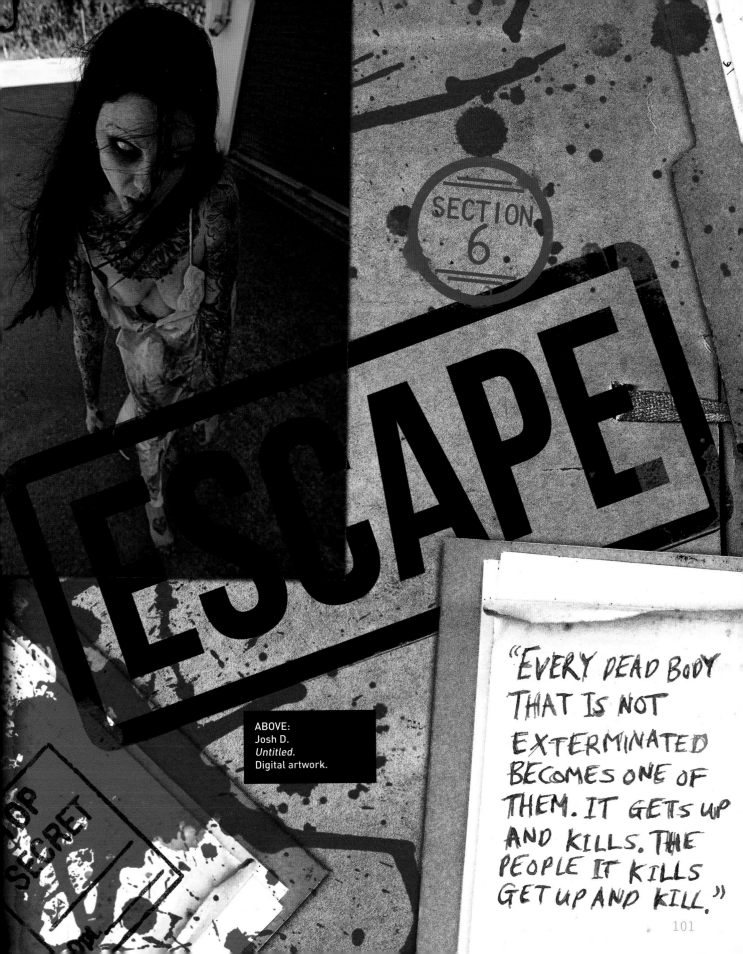

[ESCAPE]

ABOVE:
Josh D.
Untitled.
Digital artwork.

"EVERY DEAD BODY THAT IS NOT EXTERMINATED BECOMES ONE OF THEM. IT GETS UP AND KILLS. THE PEOPLE IT KILLS GET UP AND KILL."

TOP SECRET

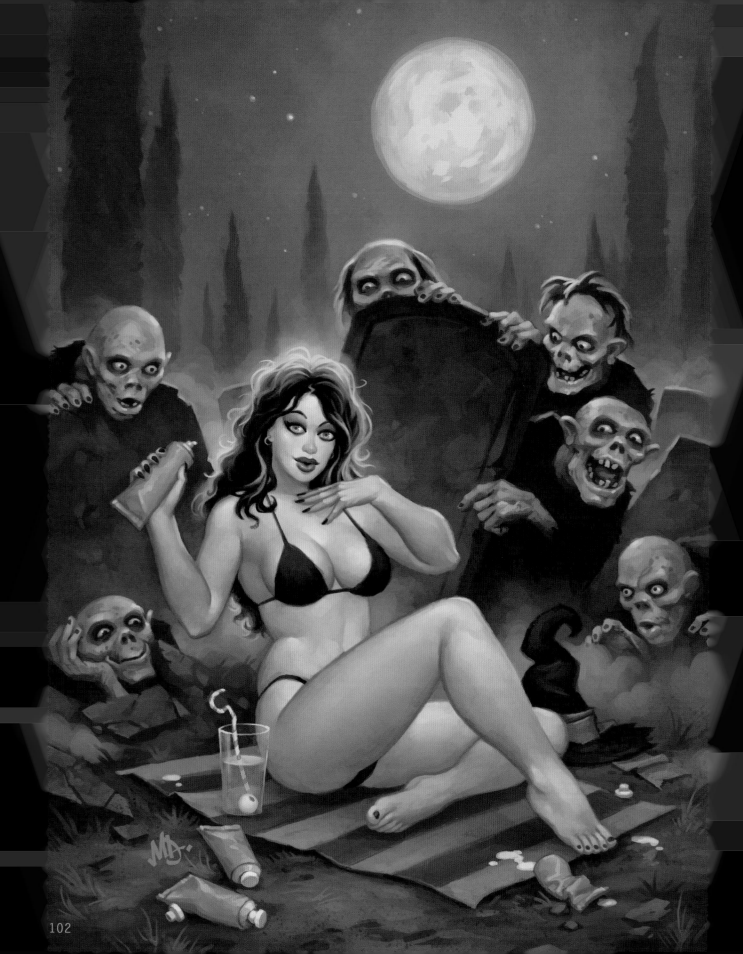

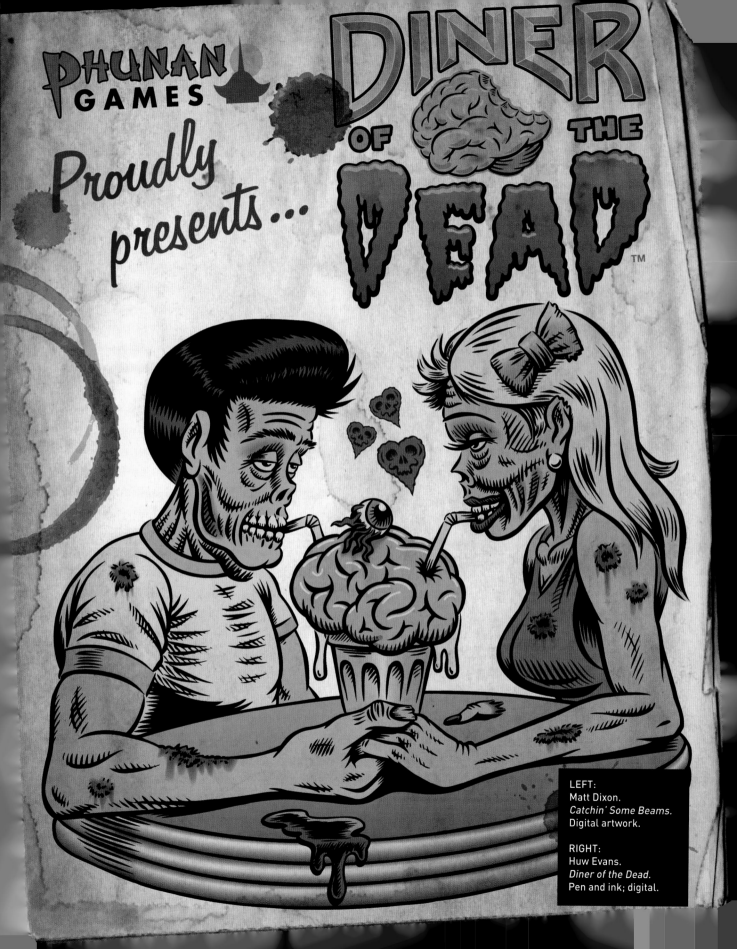

LEFT:
Matt Dixon.
Catchin' Some Beams.
Digital artwork.

RIGHT:
Huw Evans.
Diner of the Dead.
Pen and ink; digital.

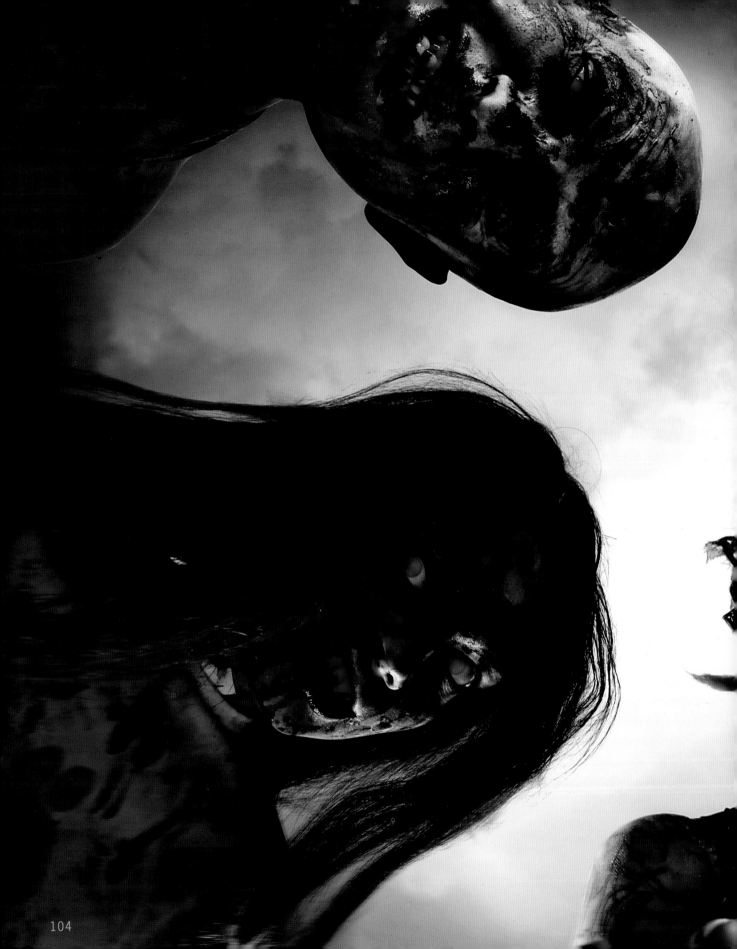

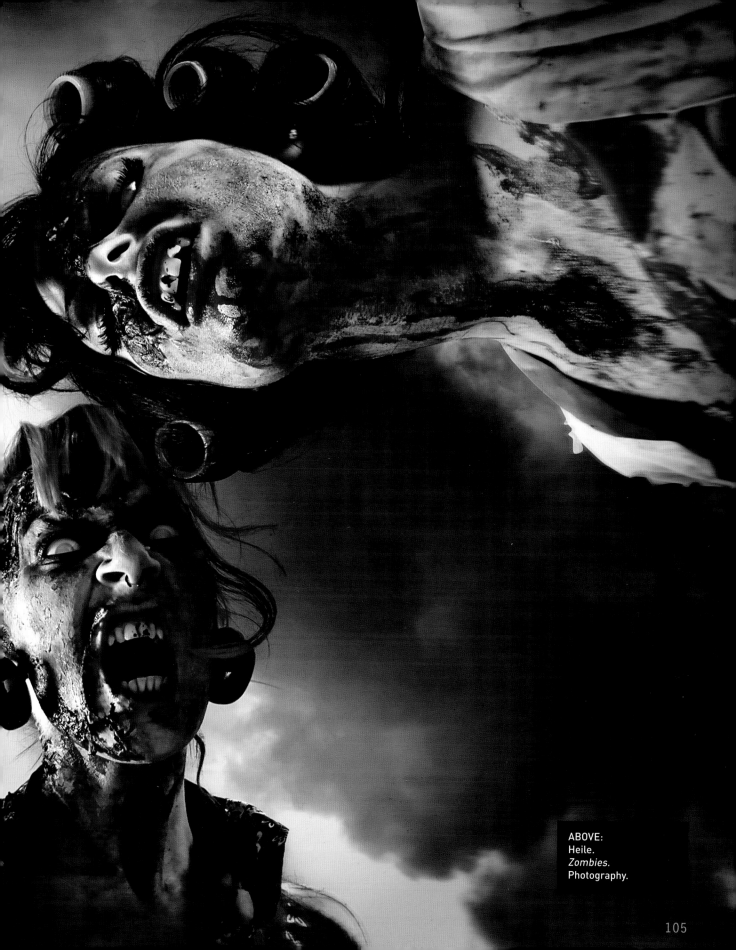

ABOVE:
Heile.
Zombies.
Photography.

105

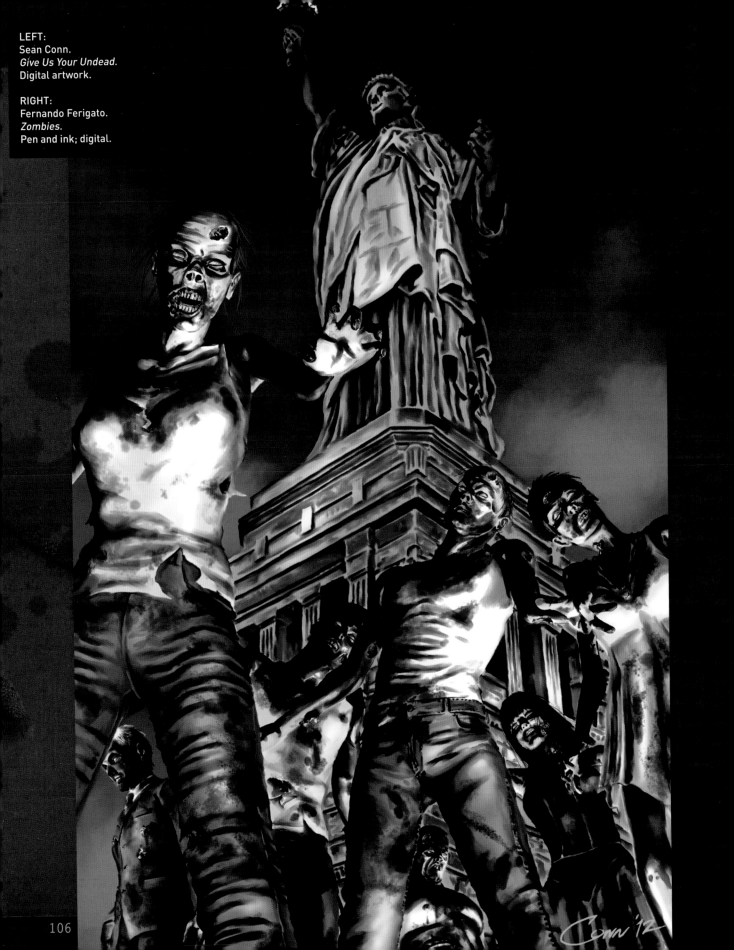

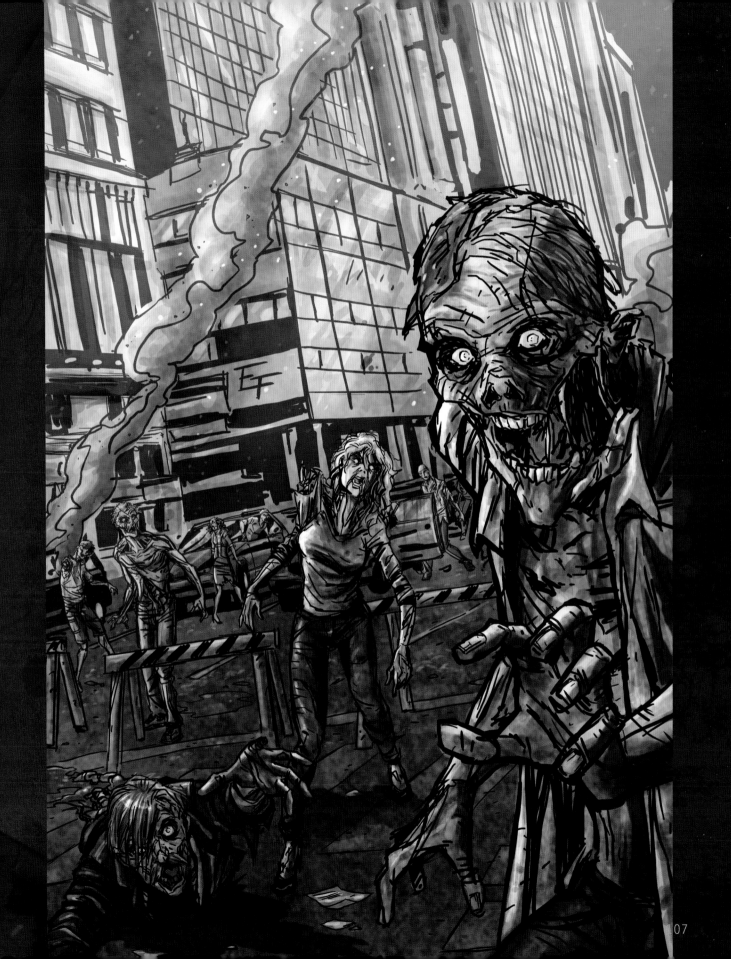

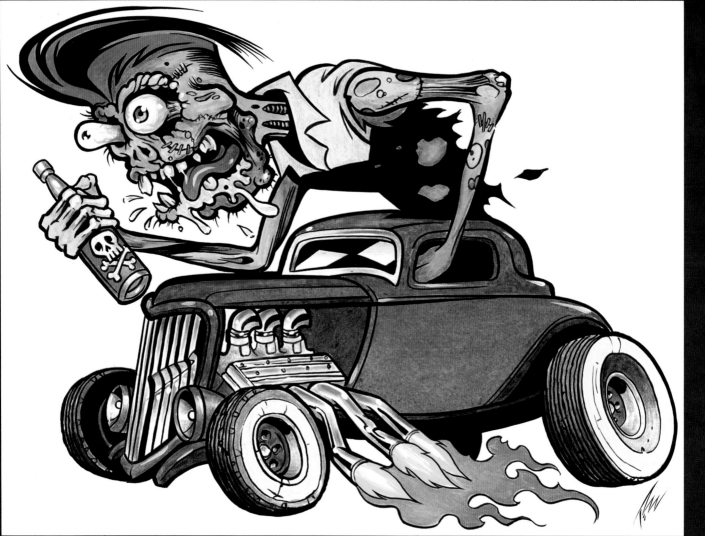

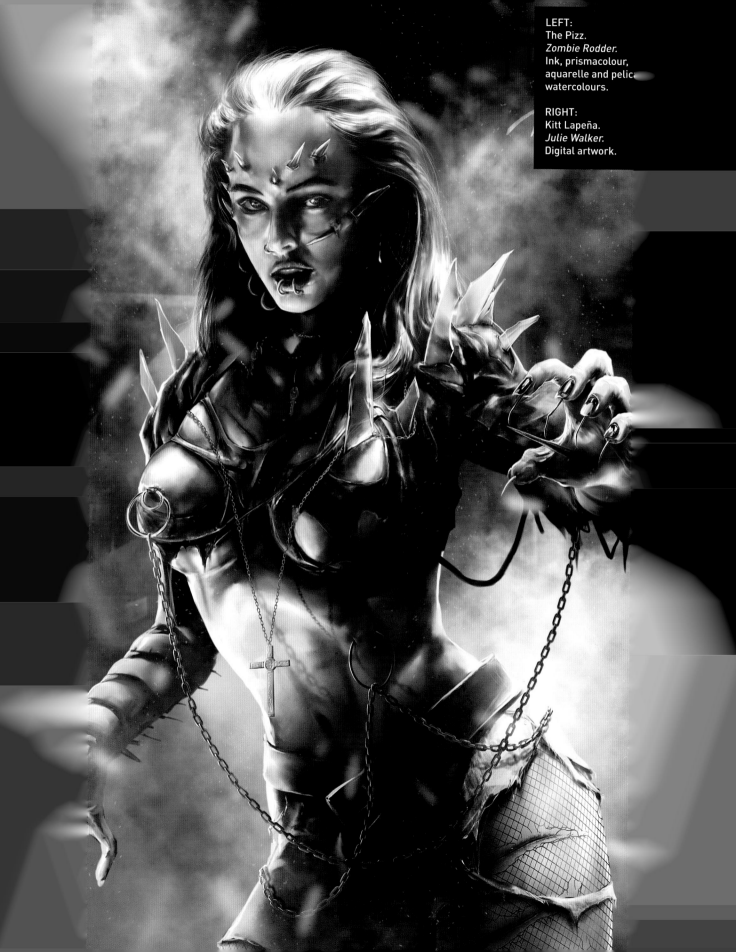

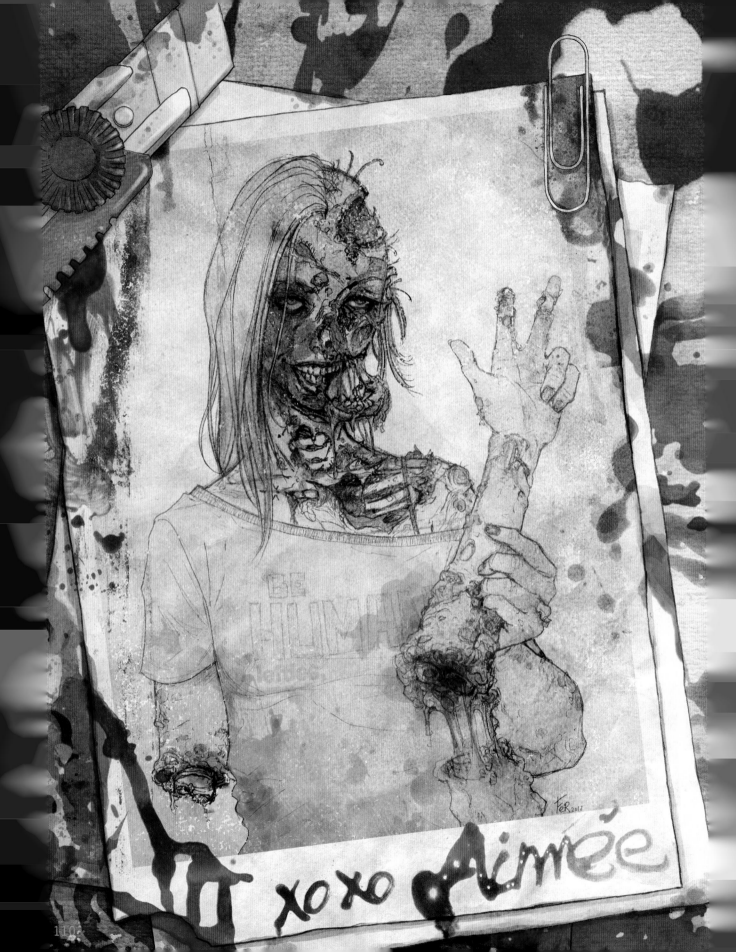

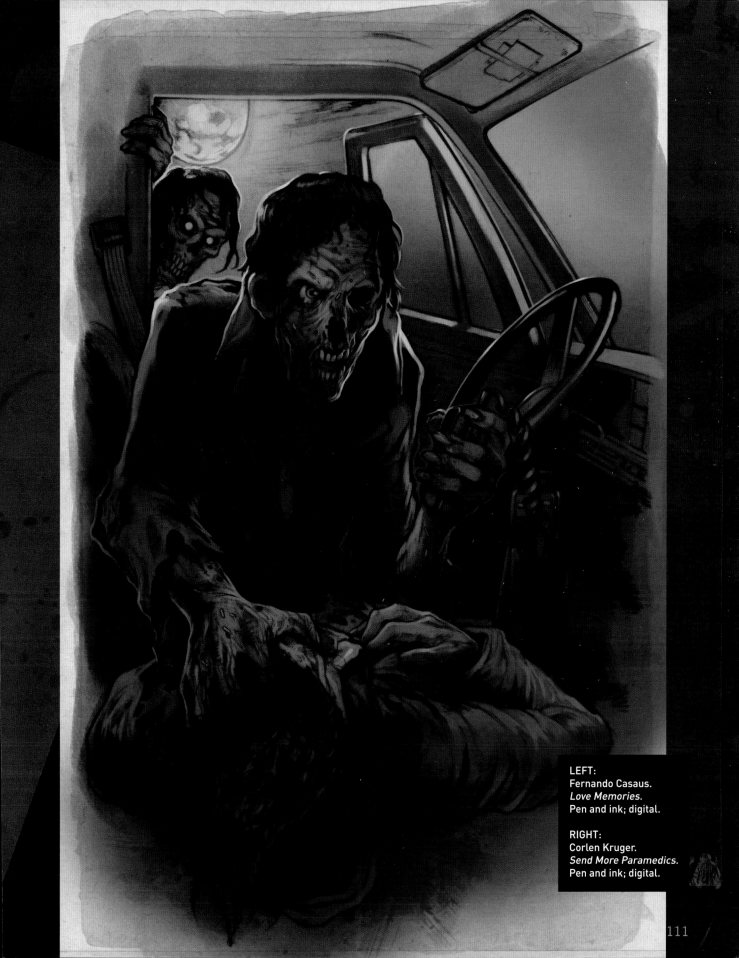

LEFT:
Fernando Casaus.
Love Memories.
Pen and ink; digital.

RIGHT:
Corlen Kruger.
Send More Paramedics.
Pen and ink; digital.

111

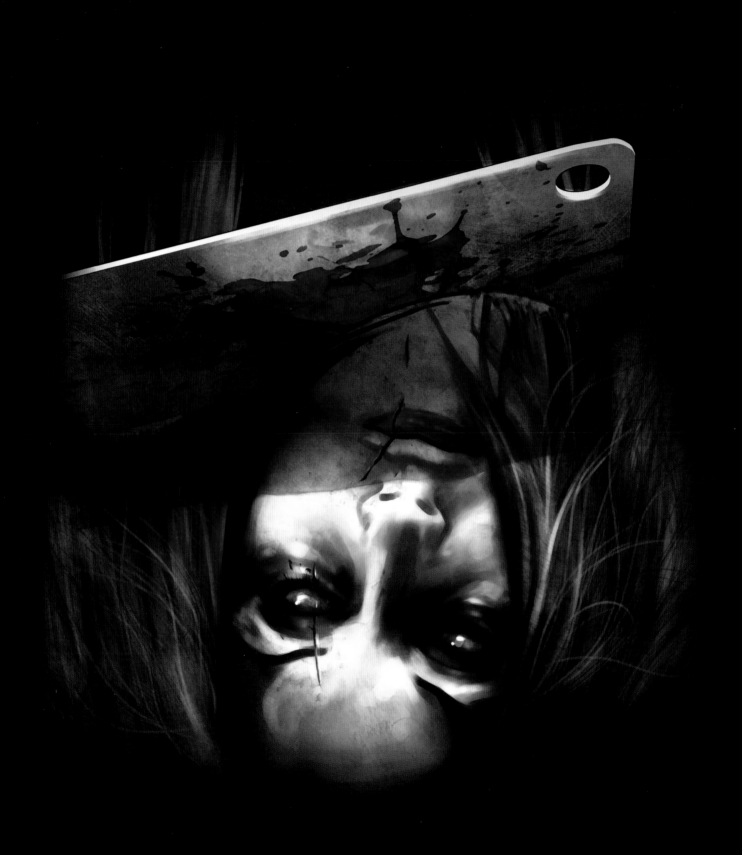

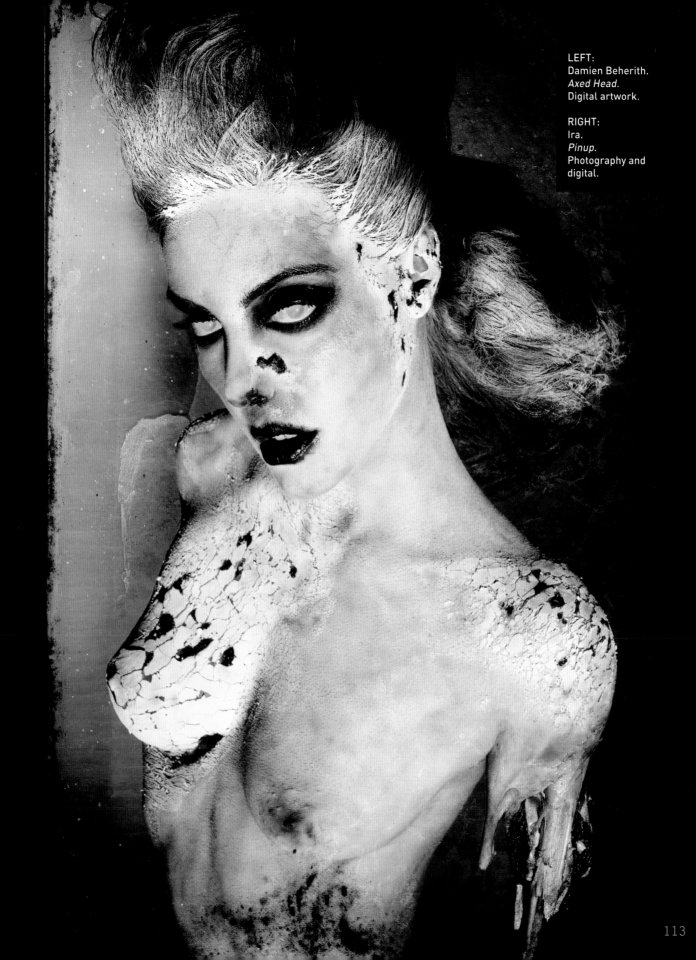

LEFT:
Damien Beherith.
Axed Head.
Digital artwork.

RIGHT:
Ira.
Pinup.
Photography and
digital.

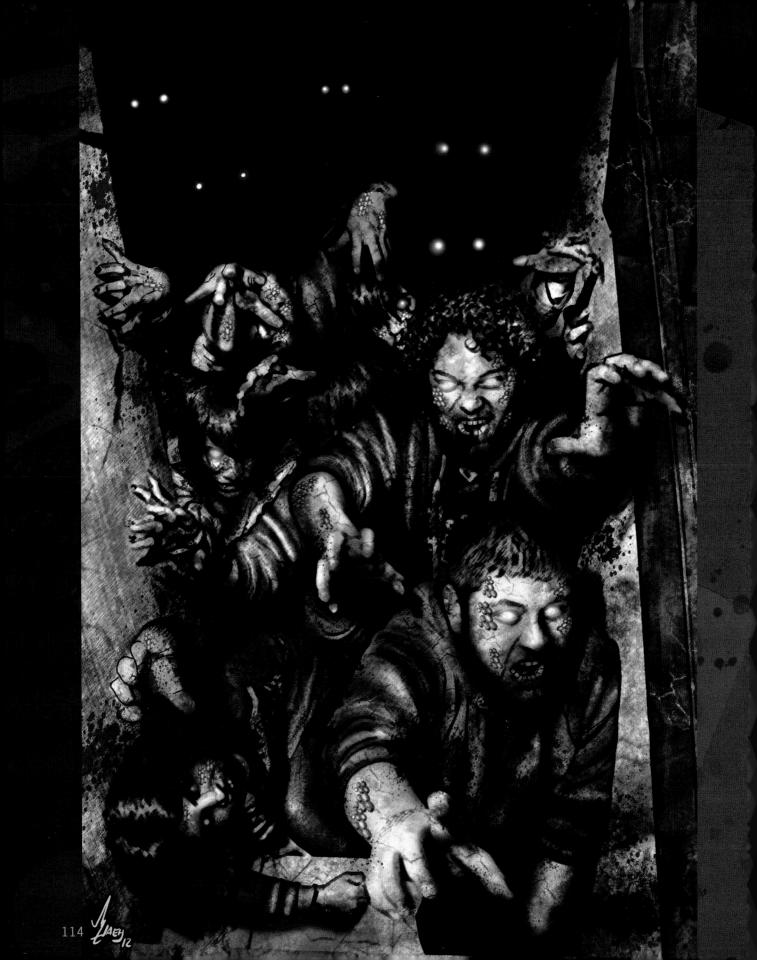

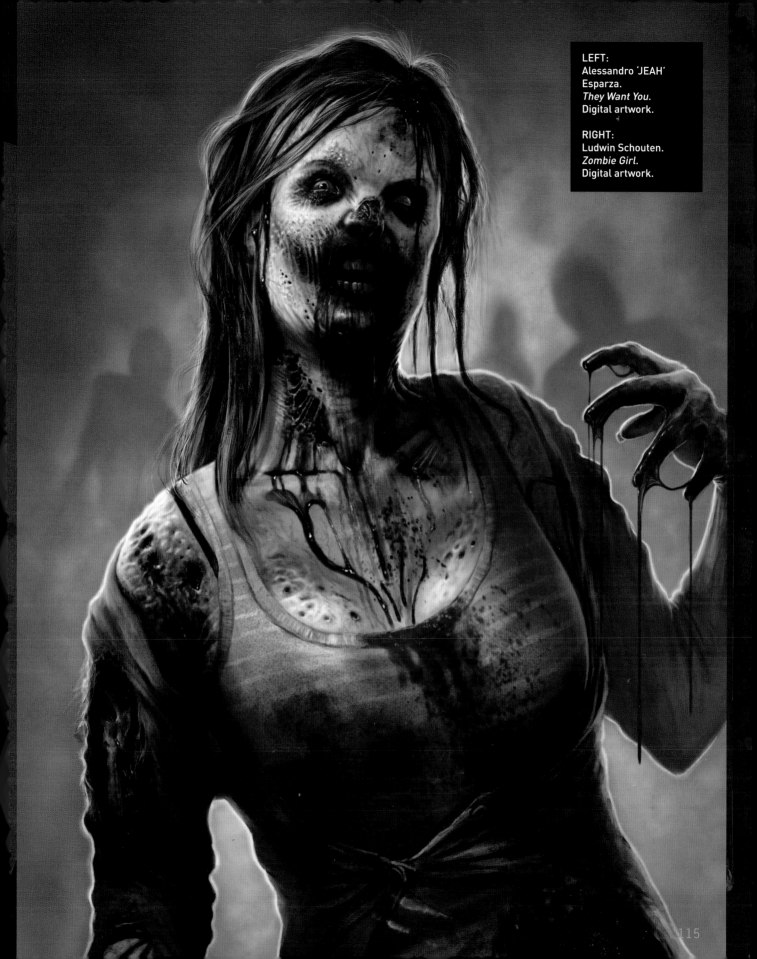

LEFT:
Alessandro 'JEAH'
Esparza.
They Want You.
Digital artwork.

RIGHT:
Ludwin Schouten.
Zombie Girl.
Digital artwork.

115

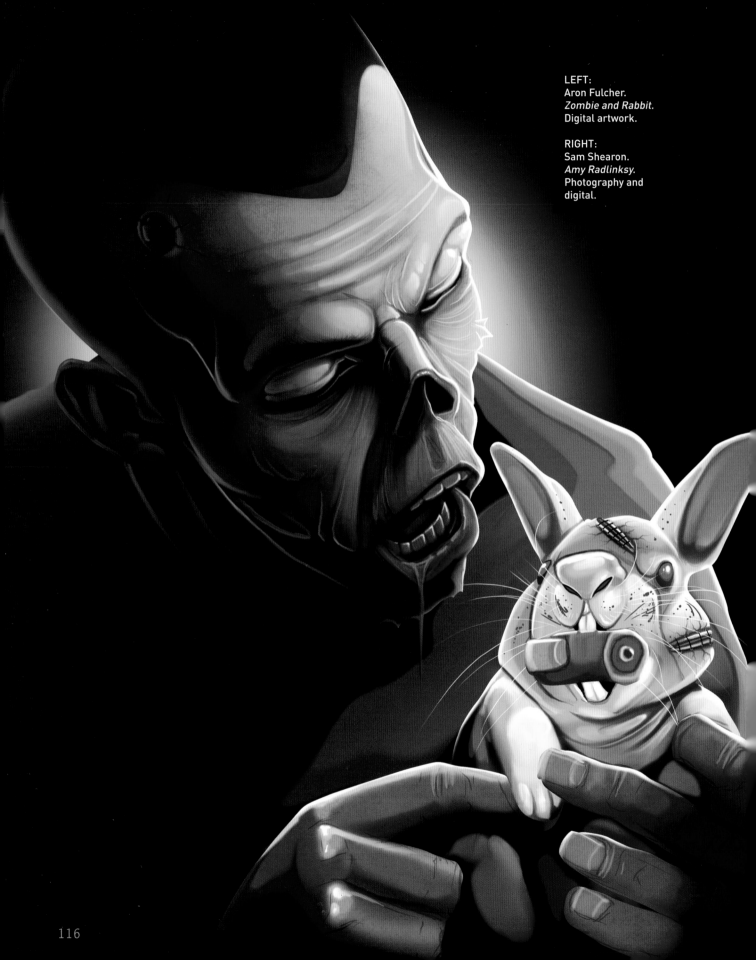

LEFT:
Aron Fulcher.
Zombie and Rabbit.
Digital artwork.

RIGHT:
Sam Shearon.
Amy Radlinksy.
Photography and
digital.

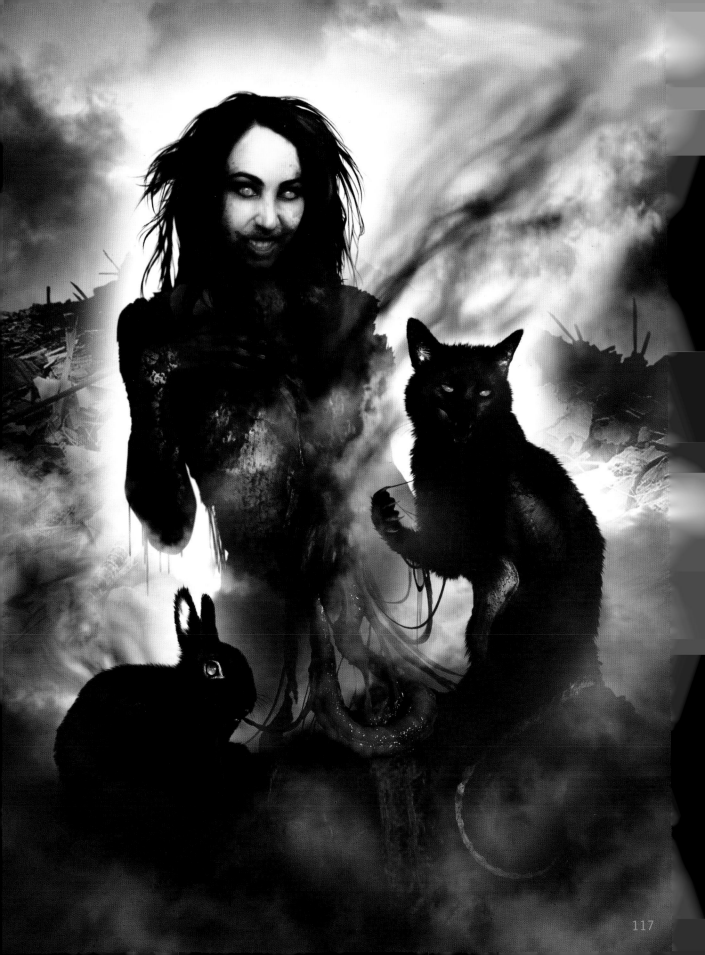

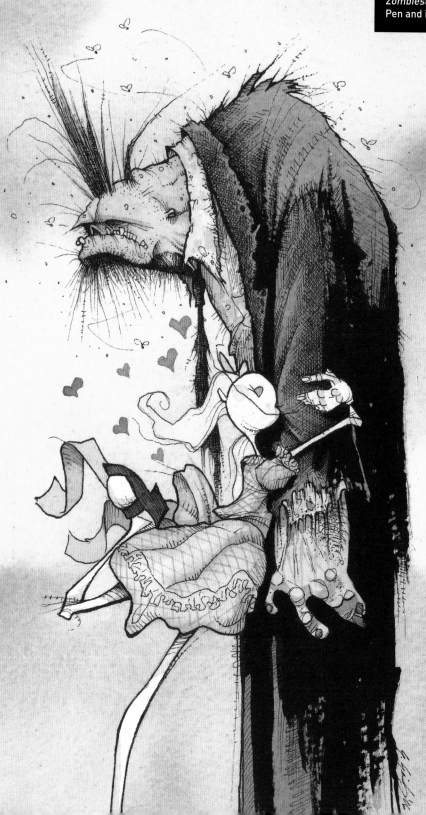

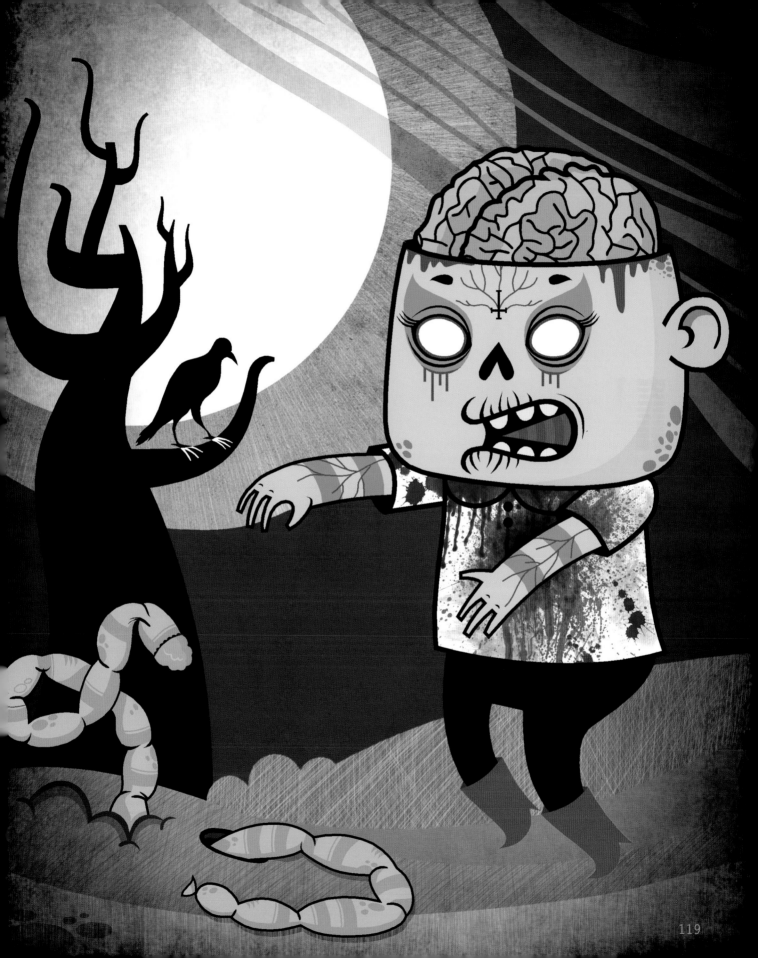

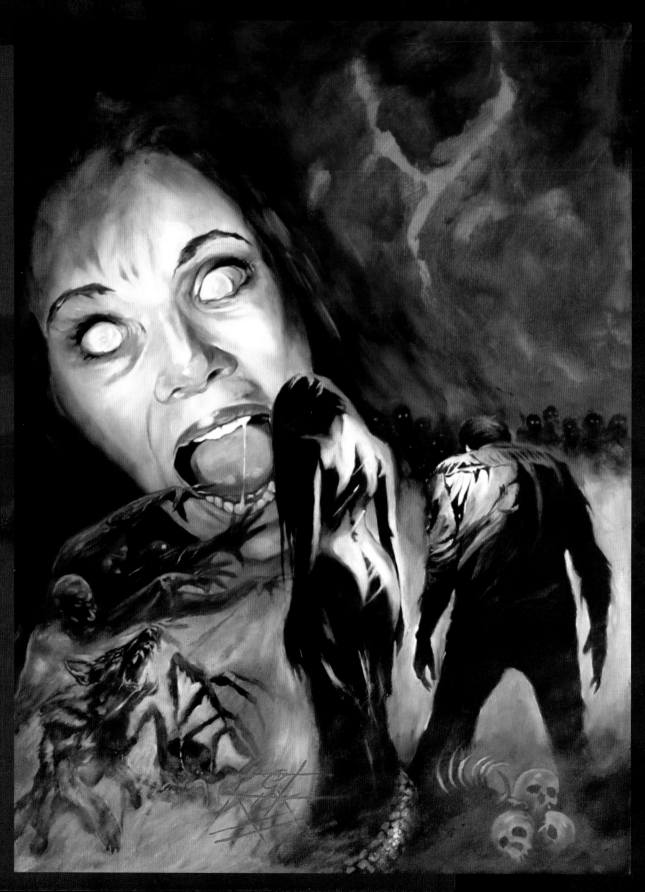

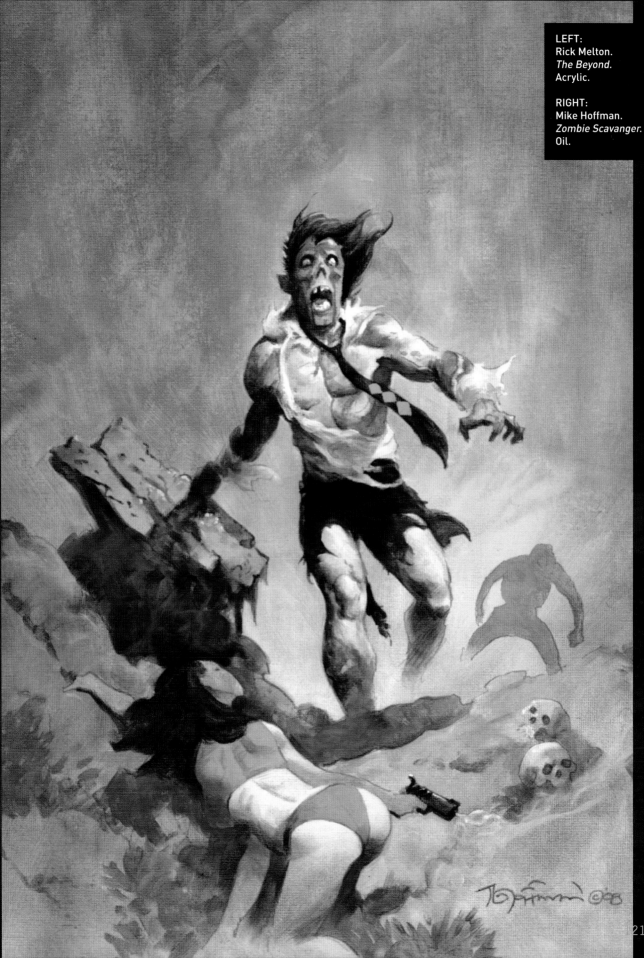

ABOVE:
Aleksandr Poltavskiy.
Zombies.
Pen and ink; digital.

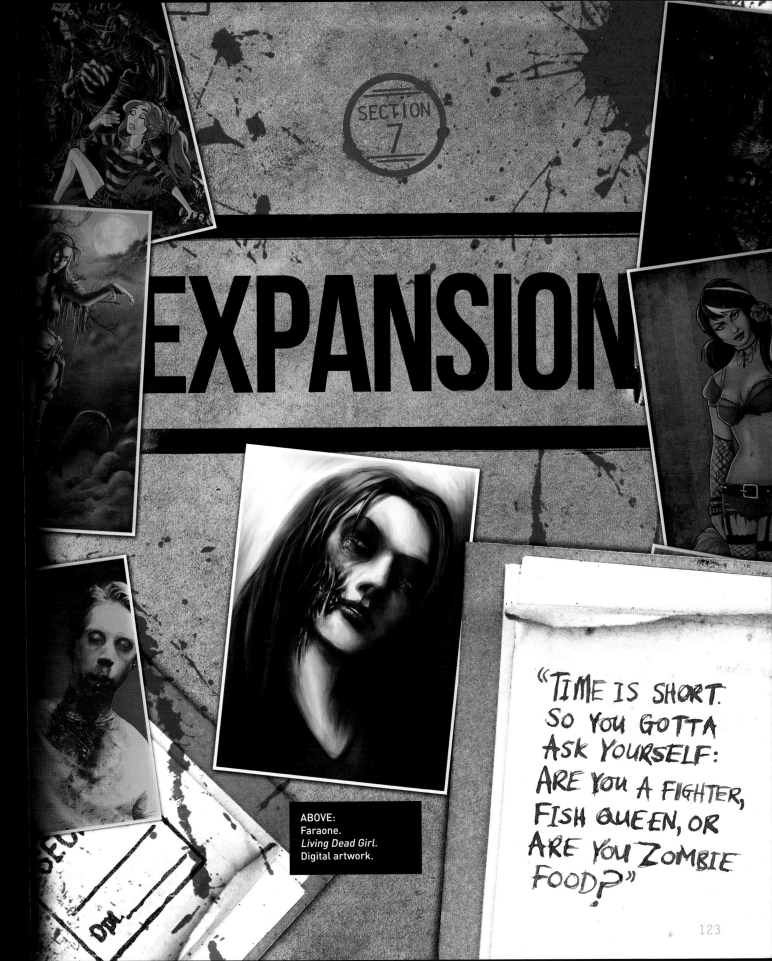

EXPANSION

ABOVE:
Faraone.
Living Dead Girl.
Digital artwork.

"TIME IS SHORT.
SO YOU GOTTA
ASK YOURSELF:
ARE YOU A FIGHTER,
FISH QUEEN, OR
ARE YOU ZOMBIE
FOOD?"

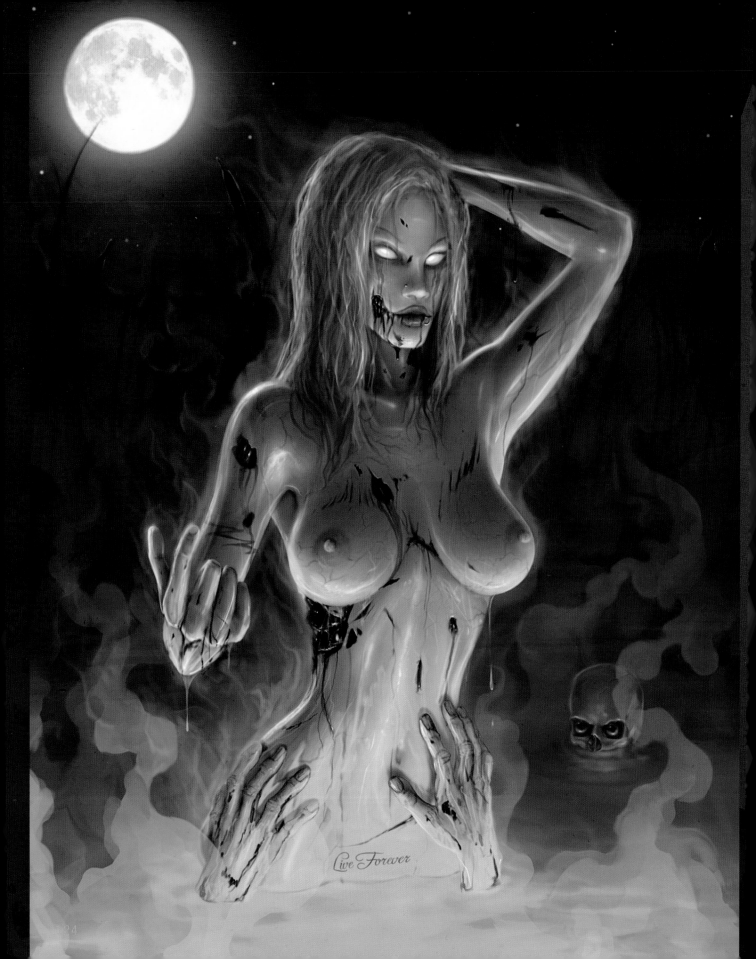

Live Forever

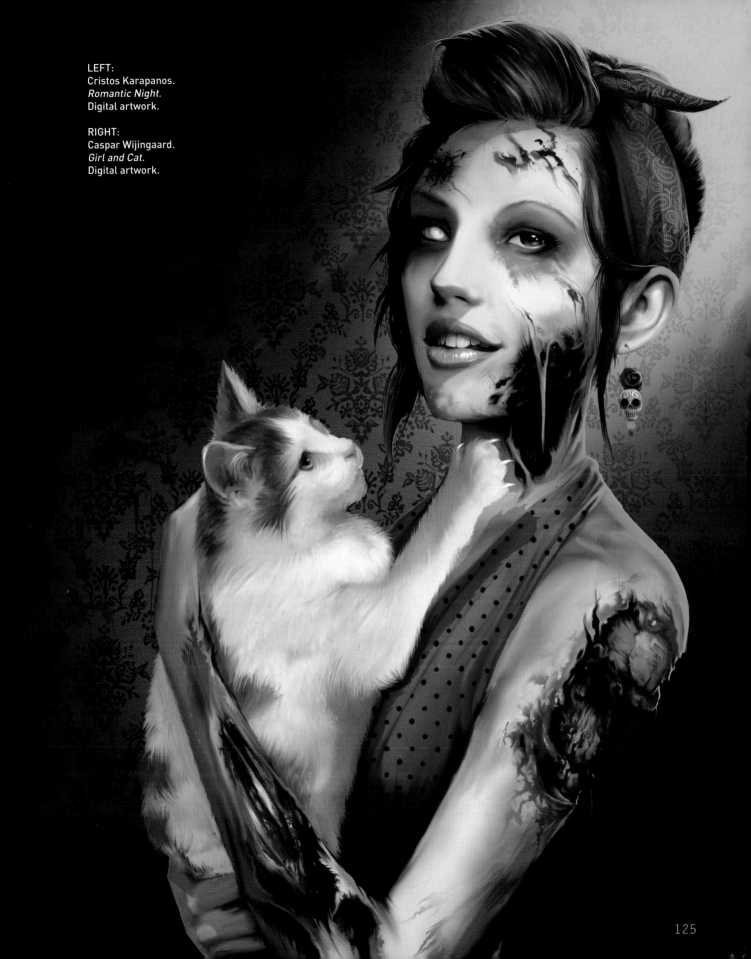

LEFT:
Cristos Karapanos.
Romantic Night.
Digital artwork.

RIGHT:
Caspar Wijingaard.
Girl and Cat.
Digital artwork.

125

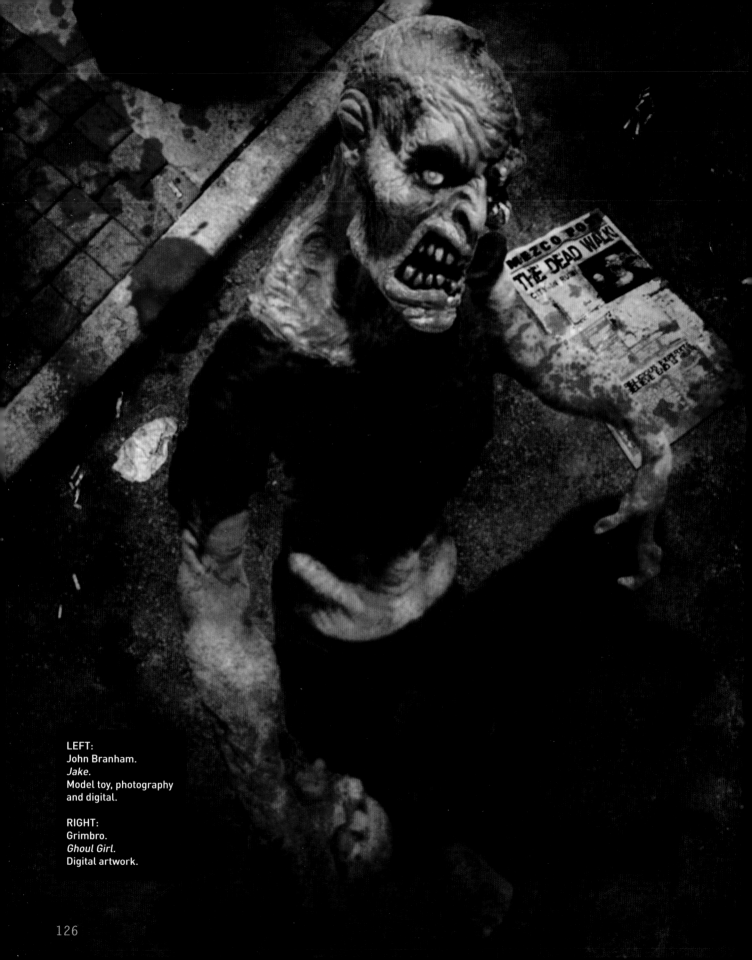

LEFT:
John Branham.
Jake.
Model toy, photography
and digital.

RIGHT:
Grimbro.
Ghoul Girl.
Digital artwork.

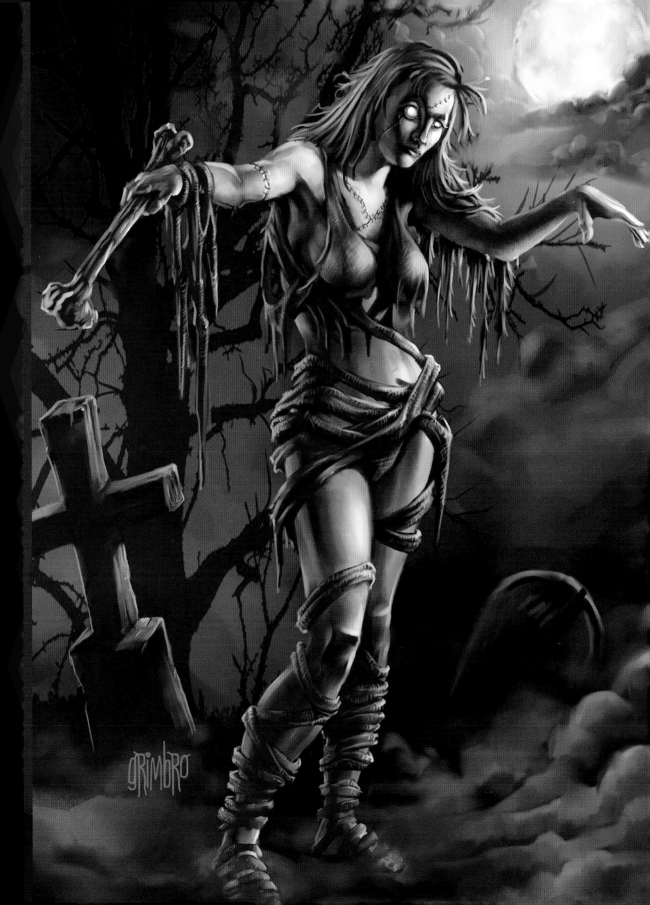

"Lion Tamer"

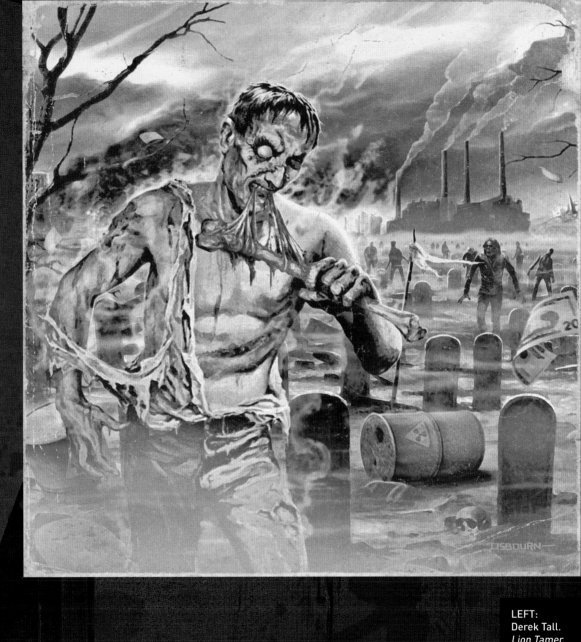

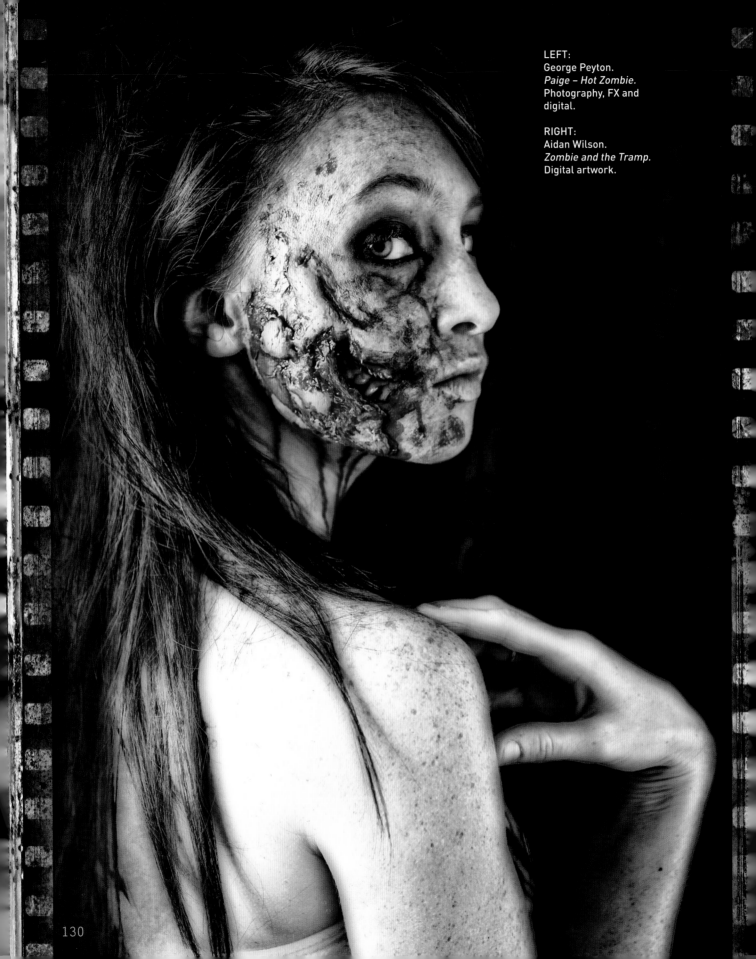

LEFT:
George Peyton.
Paige – Hot Zombie.
Photography, FX and
digital.

RIGHT:
Aidan Wilson.
Zombie and the Tramp.
Digital artwork.

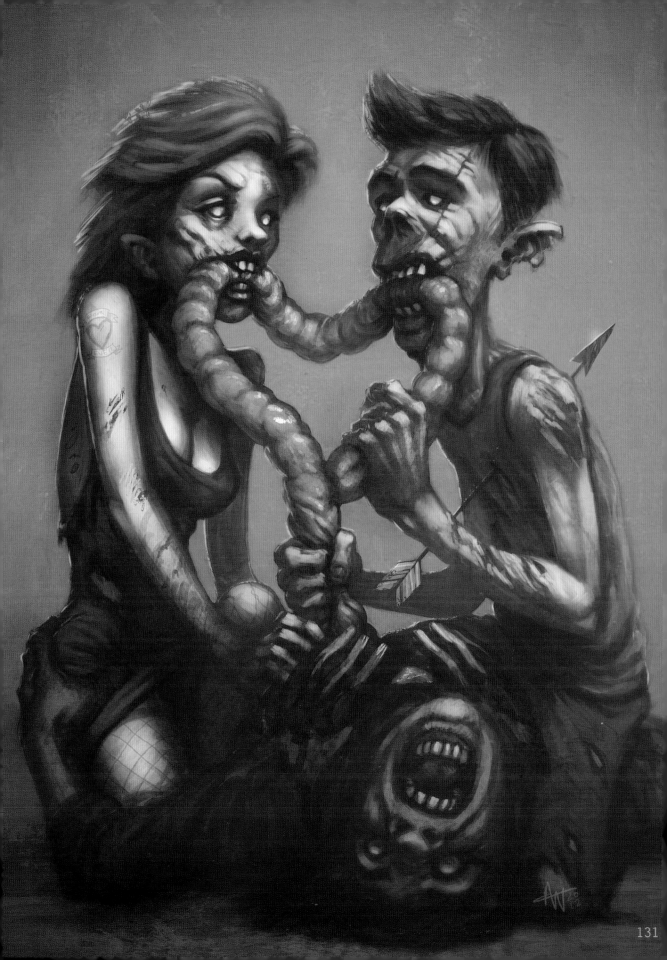

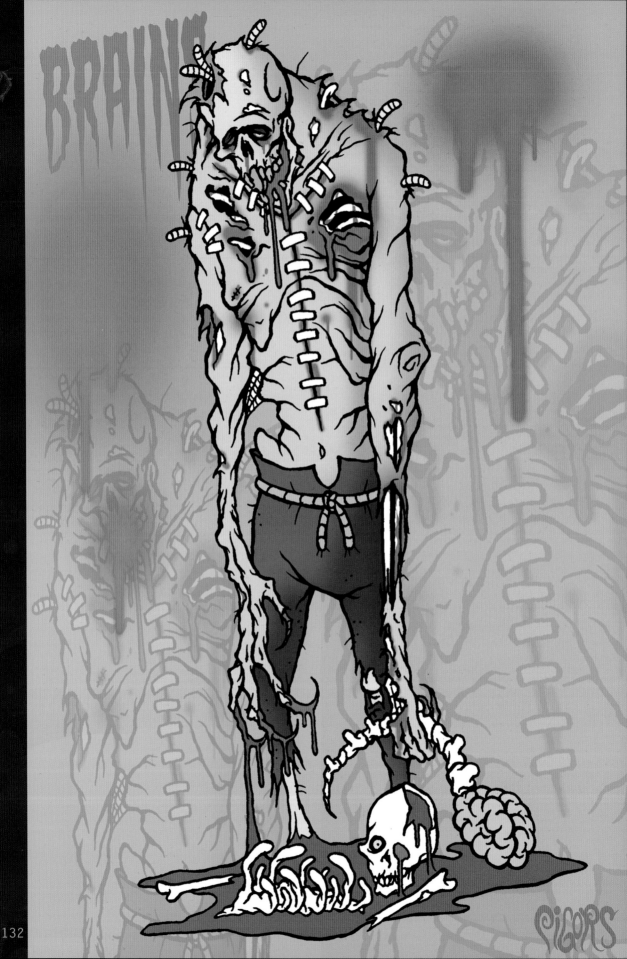

BRAINS

PIGORS

132

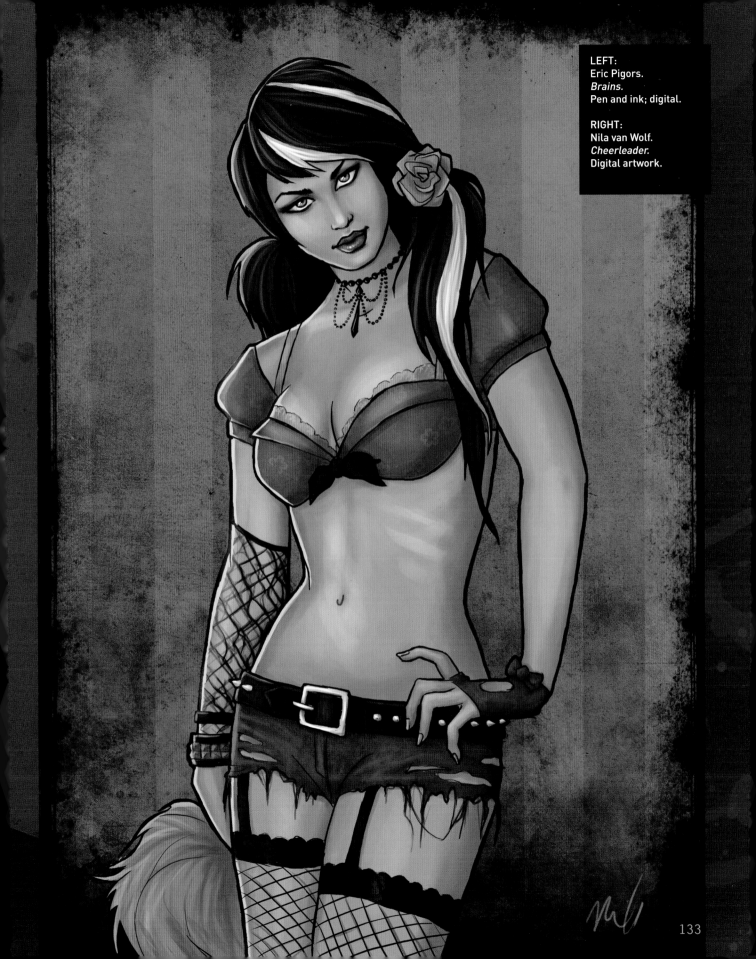

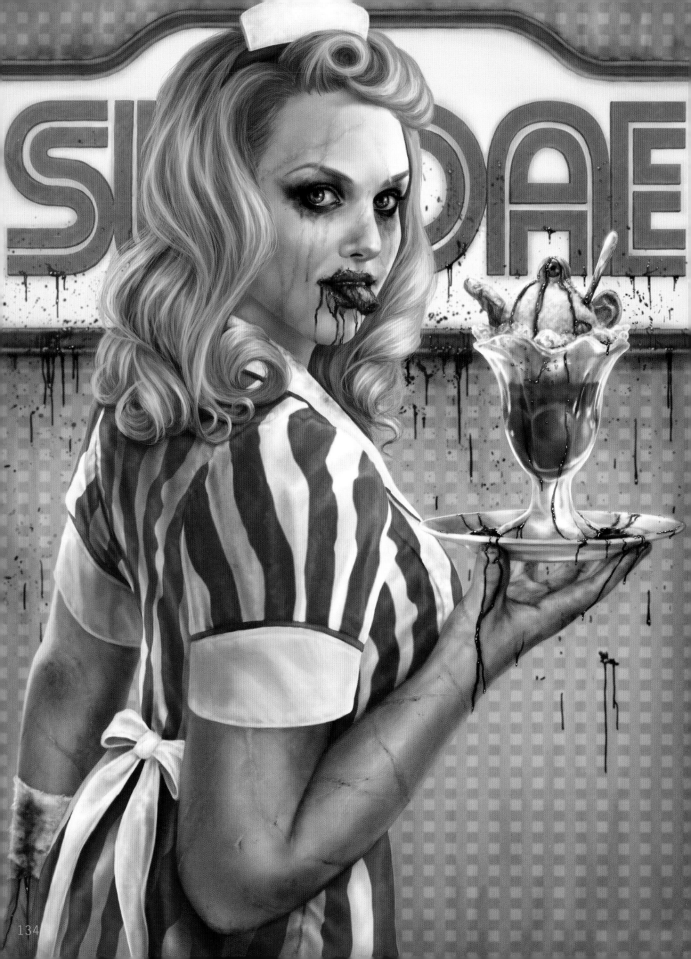

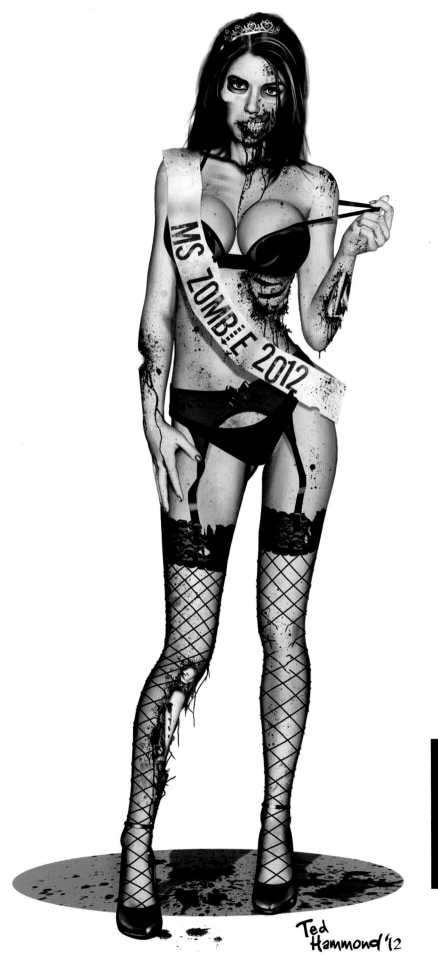

MS ZOMBIE 2012

Ted Hammond '12

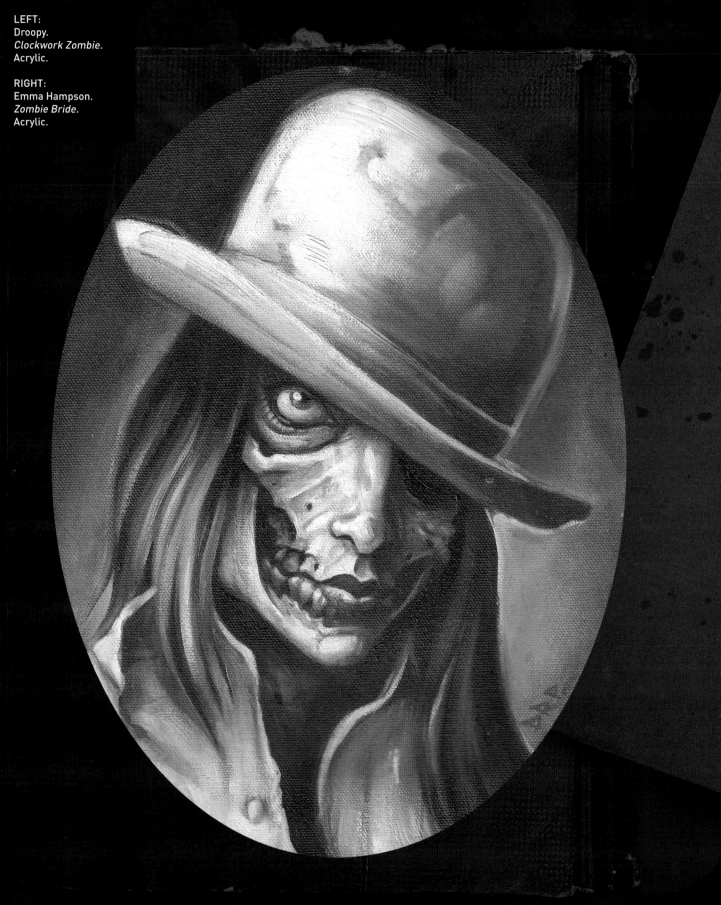

LEFT:
Droopy.
Clockwork Zombie.
Acrylic.

RIGHT:
Emma Hampson.
Zombie Bride.
Acrylic.

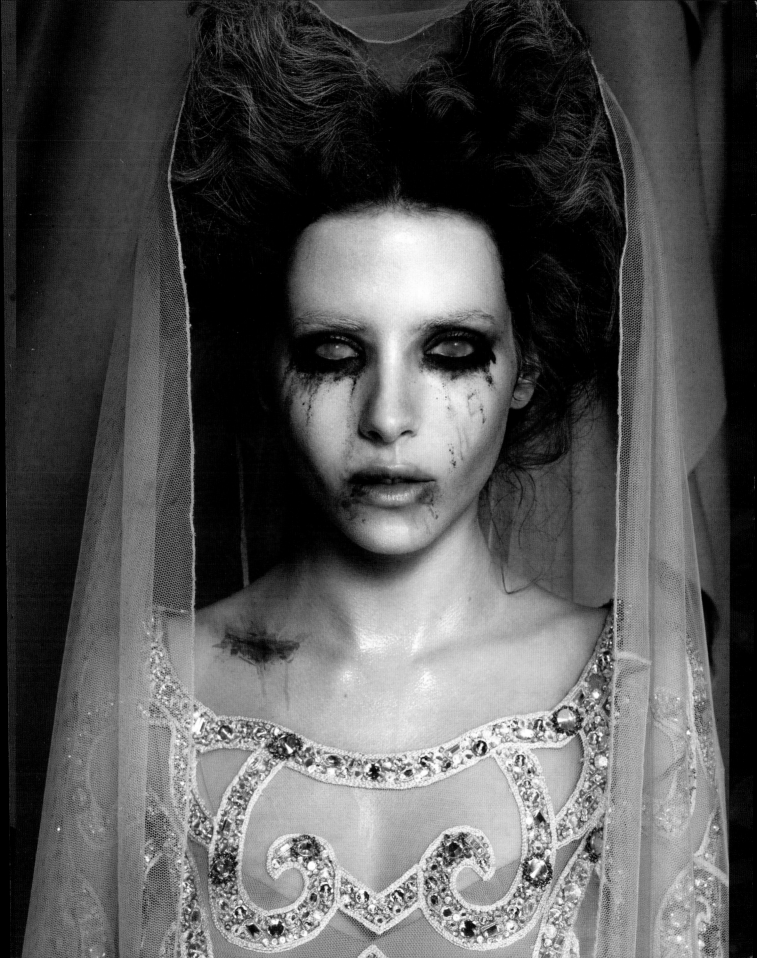

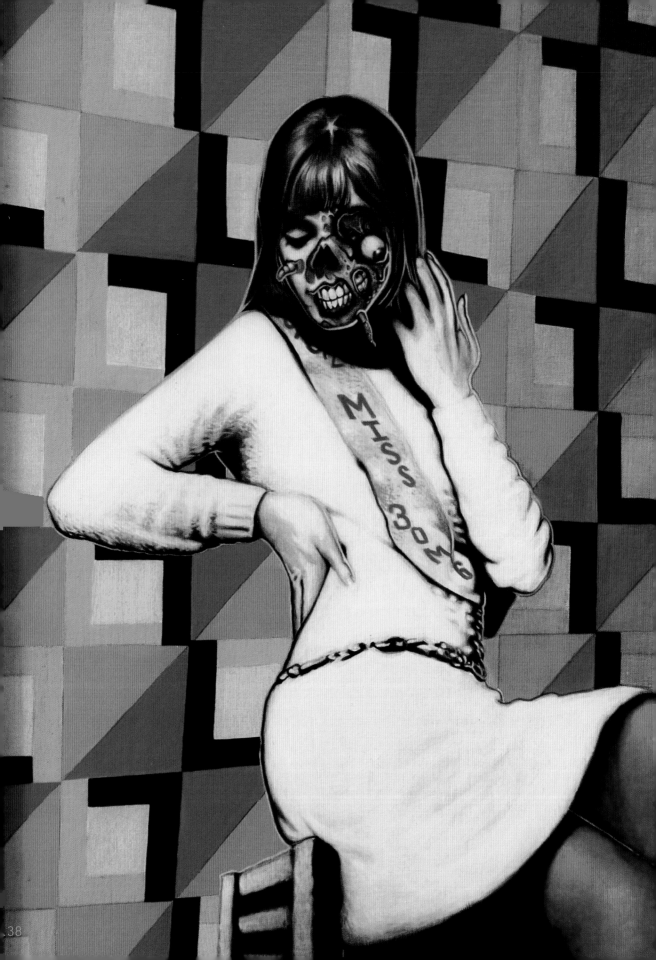

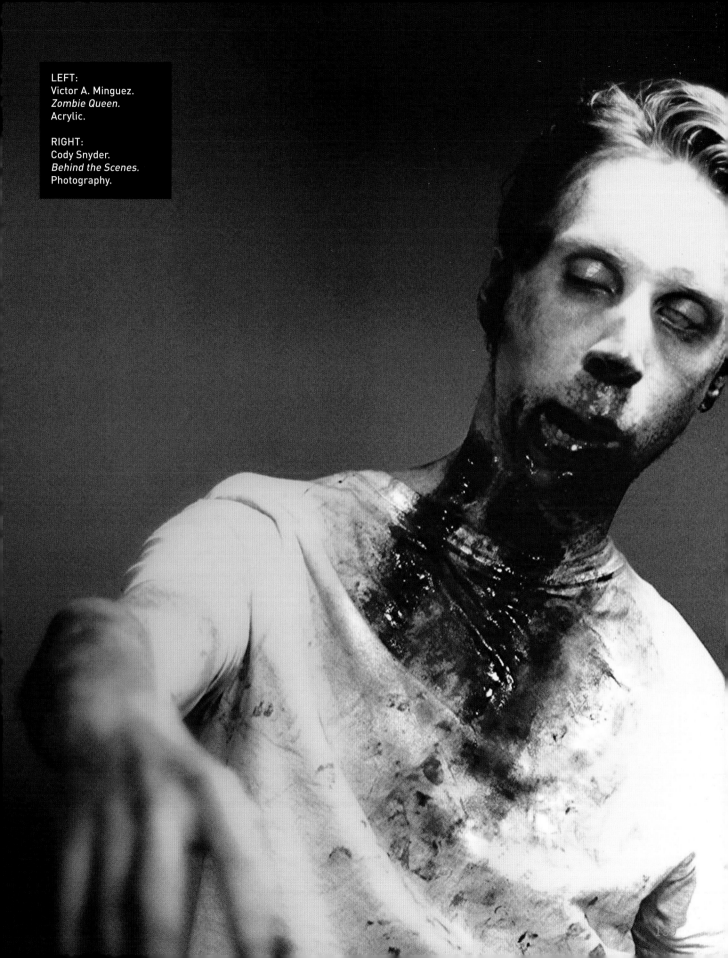

LEFT:
Victor A. Minguez.
Zombie Queen.
Acrylic.

RIGHT:
Cody Snyder.
Behind the Scenes.
Photography.

ABOVE:
Jake Anderson.
One of Many.
Latex mask.

CONTAINMENT

ABOVE:
Martin de Diego.
Dev.
Digital artwork,

"DAN, I'M DEAD!
PLEASE BURY ME!"

142

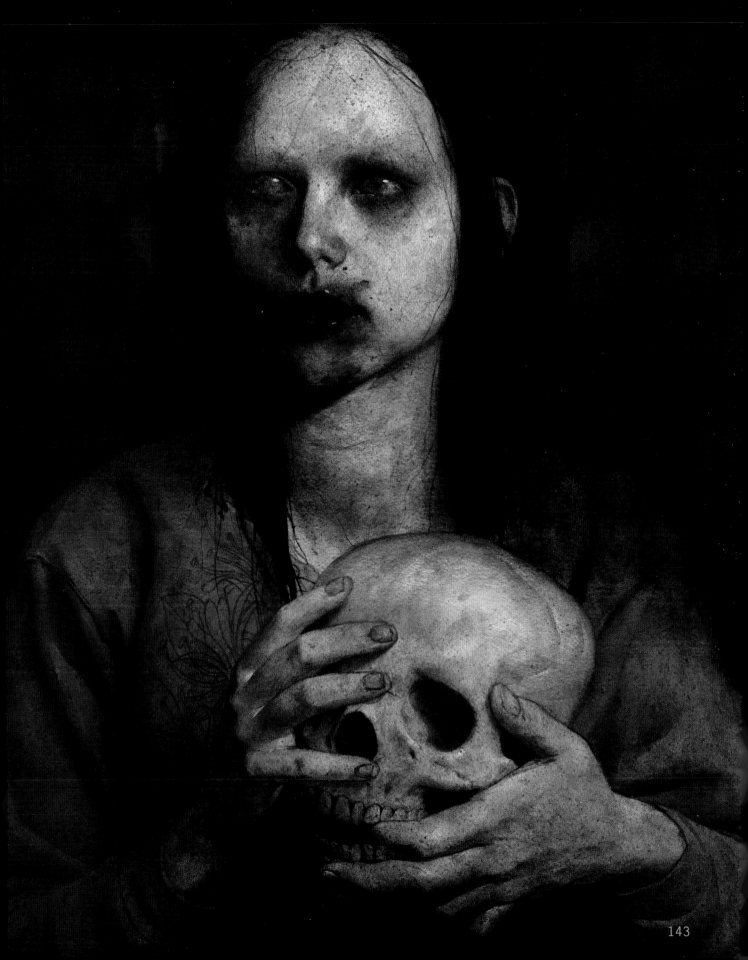

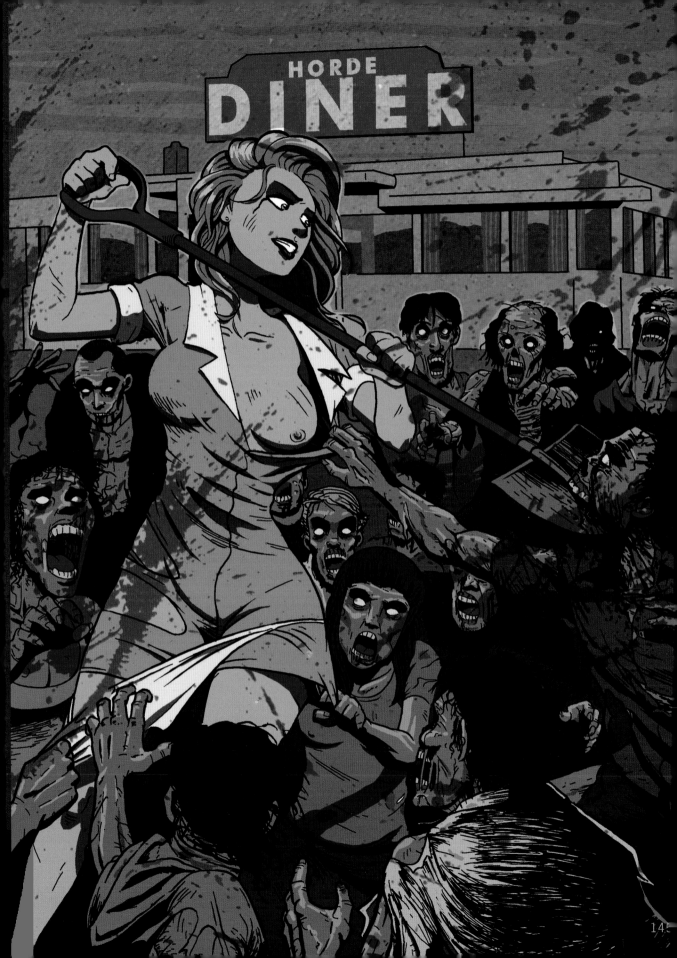

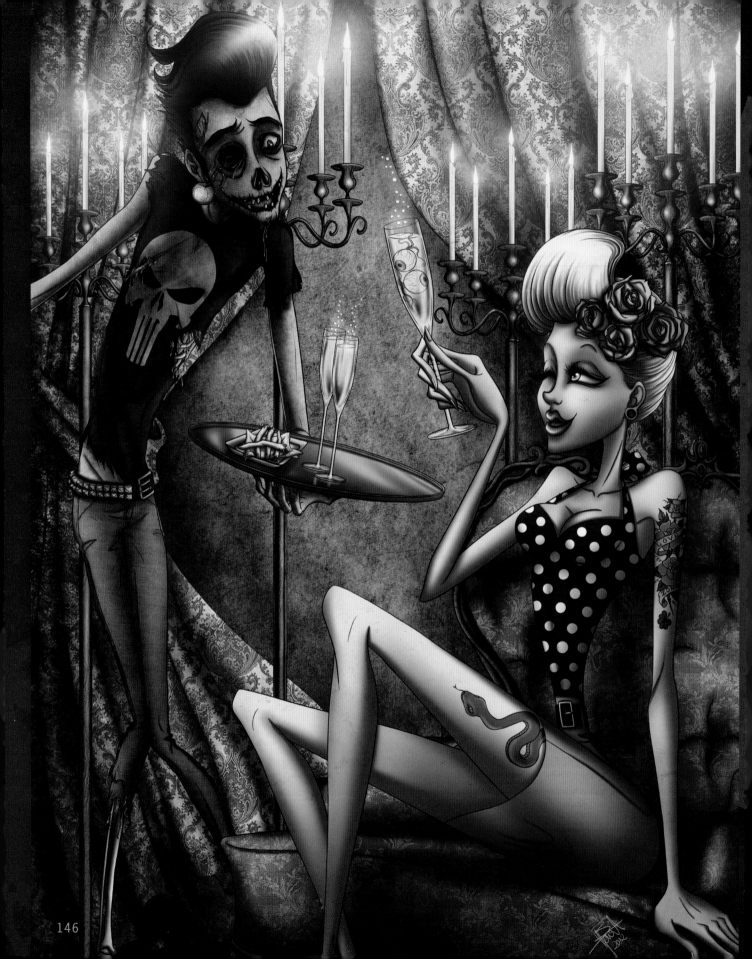

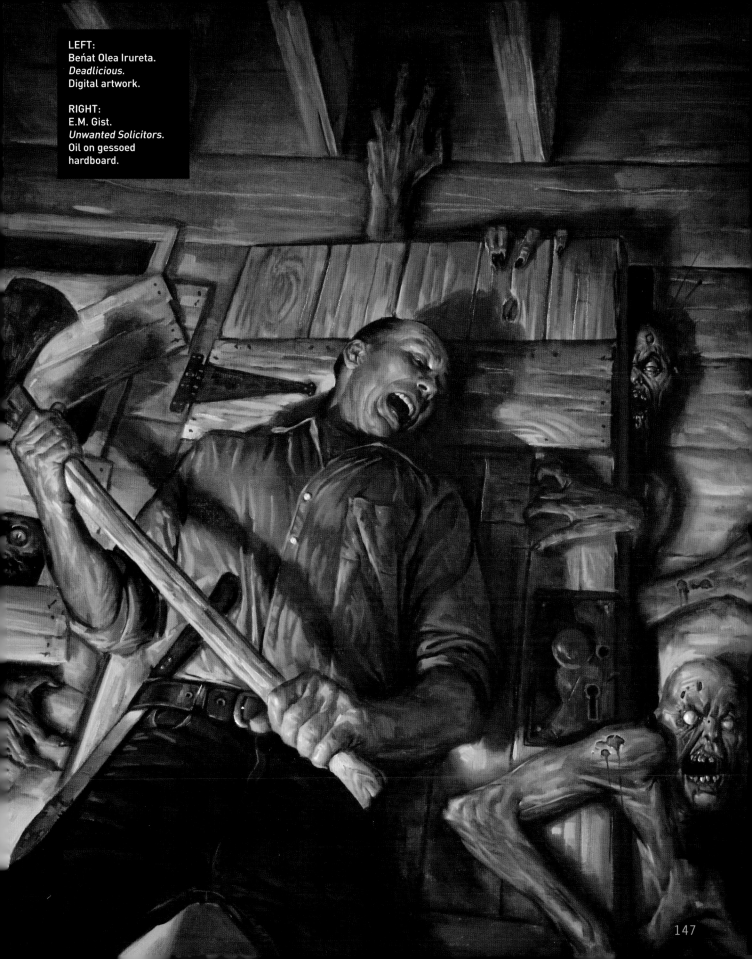

LEFT:
Beñat Olea Irureta.
Deadlicious.
Digital artwork.

RIGHT:
E.M. Gist.
Unwanted Solicitors.
Oil on gessoed
hardboard.

147

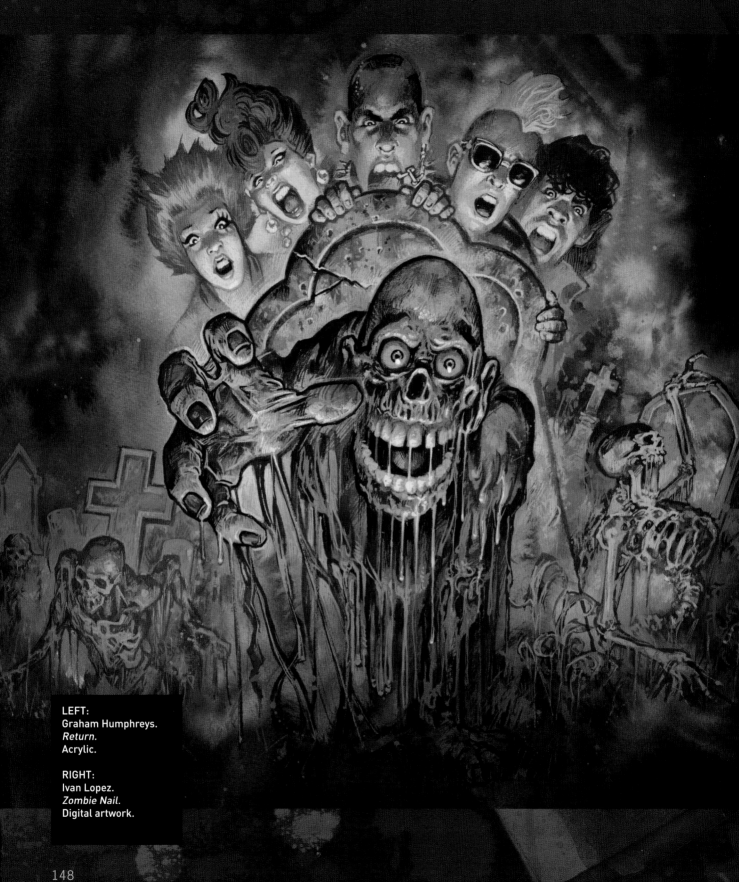

LEFT:
Graham Humphreys.
Return.
Acrylic.

RIGHT:
Ivan Lopez.
Zombie Nail.
Digital artwork.

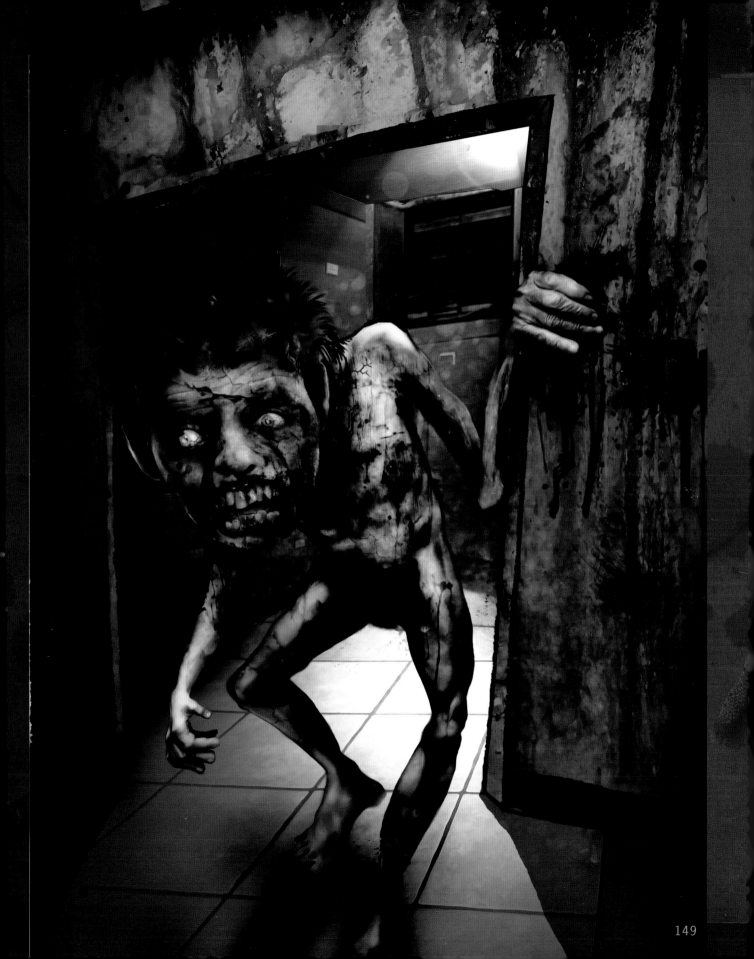

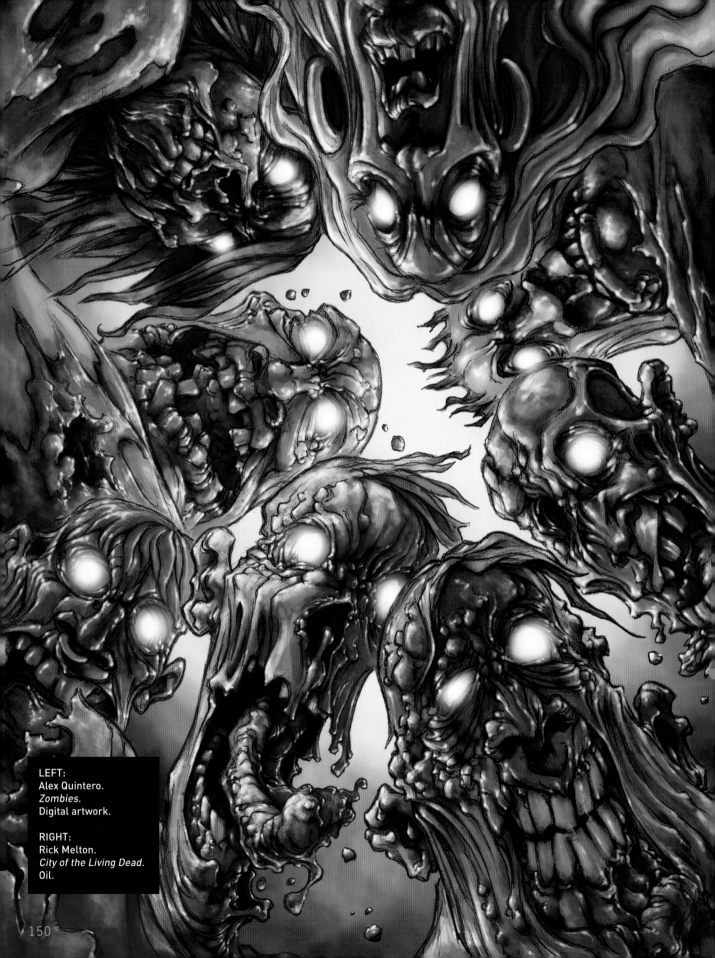

LEFT:
Alex Quintero.
Zombies.
Digital artwork.

RIGHT:
Rick Melton.
City of the Living Dead.
Oil.

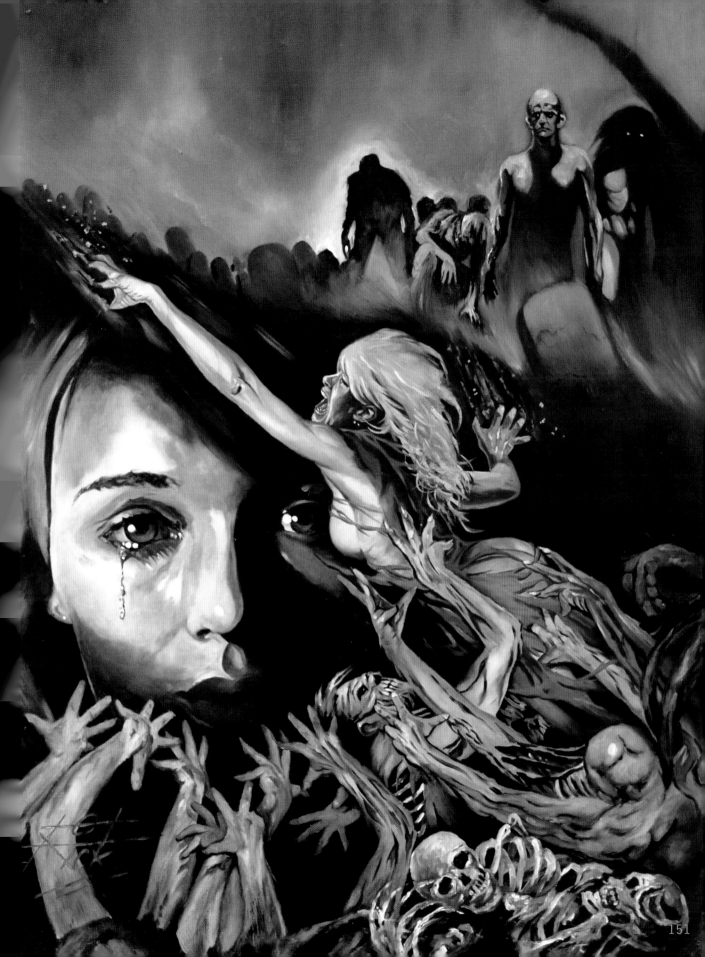

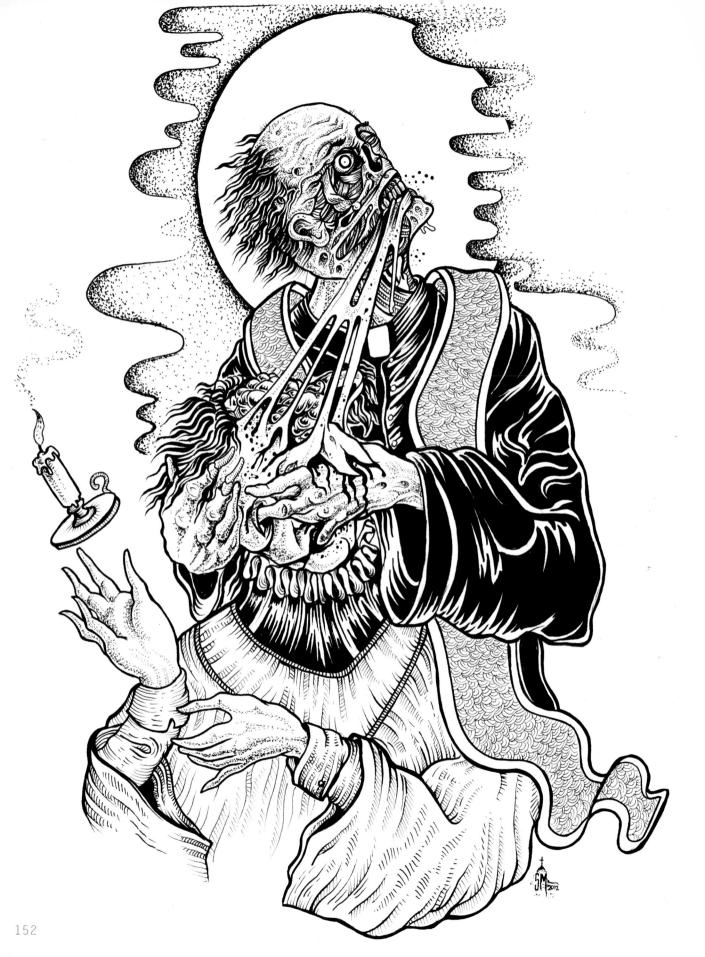

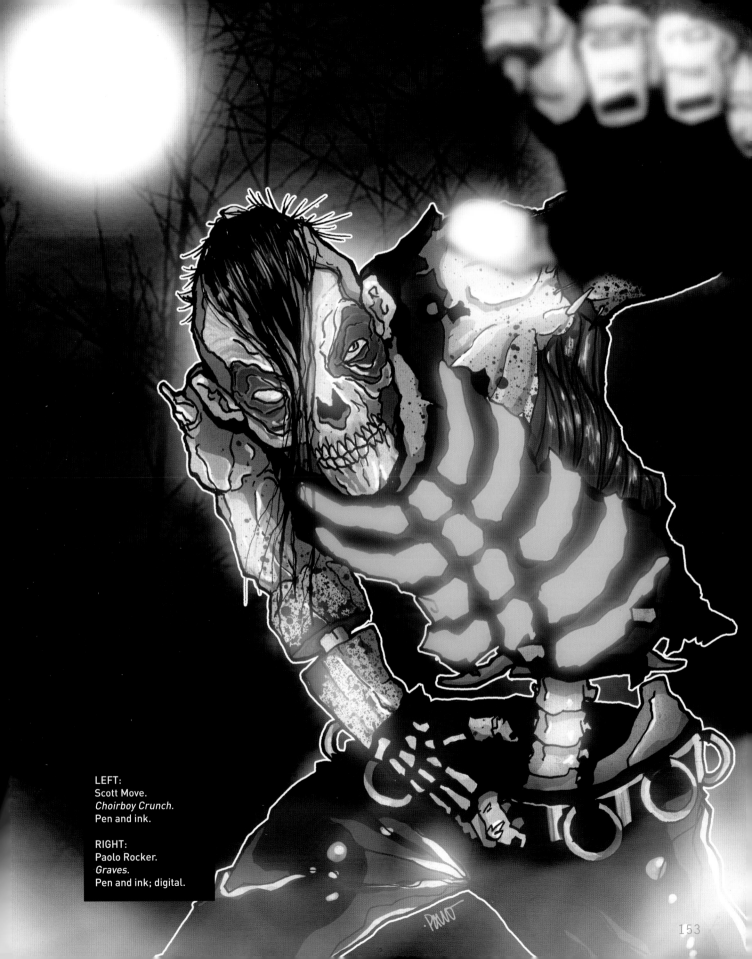

LEFT:
Scott Move.
Choirboy Crunch.
Pen and ink.

RIGHT:
Paolo Rocker.
Graves.
Pen and ink; digital.

153

ABOVE:
Montwain Gonzales.
Best Man.
Digital artwork.

ANATOMY

BELOW:
Yago.
Zombie.
Digital artwork.

TOP SECRET

" I'M GONNA EAT YOUR BRAINS AND GAIN YOUR KNOWLEDGE."

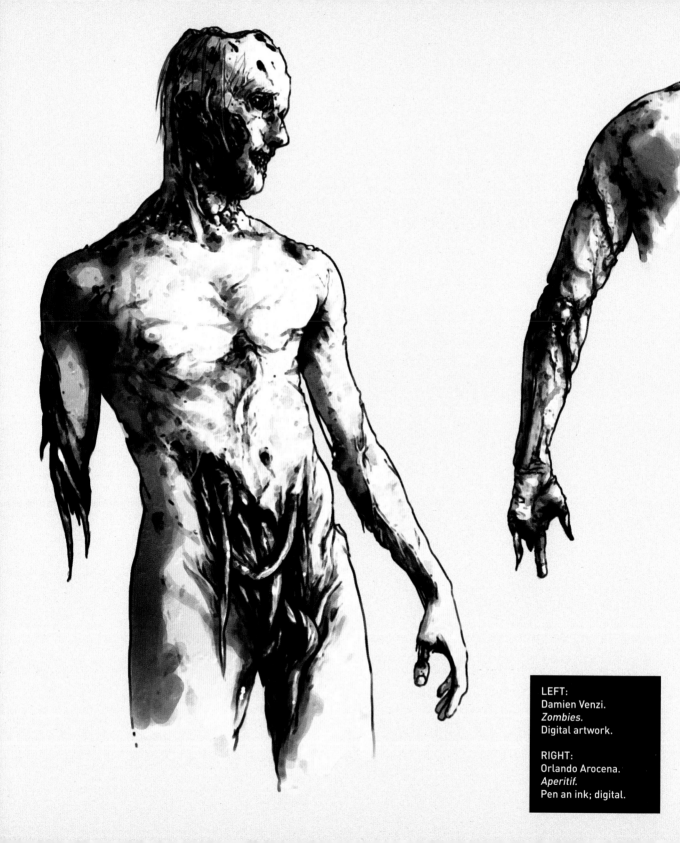

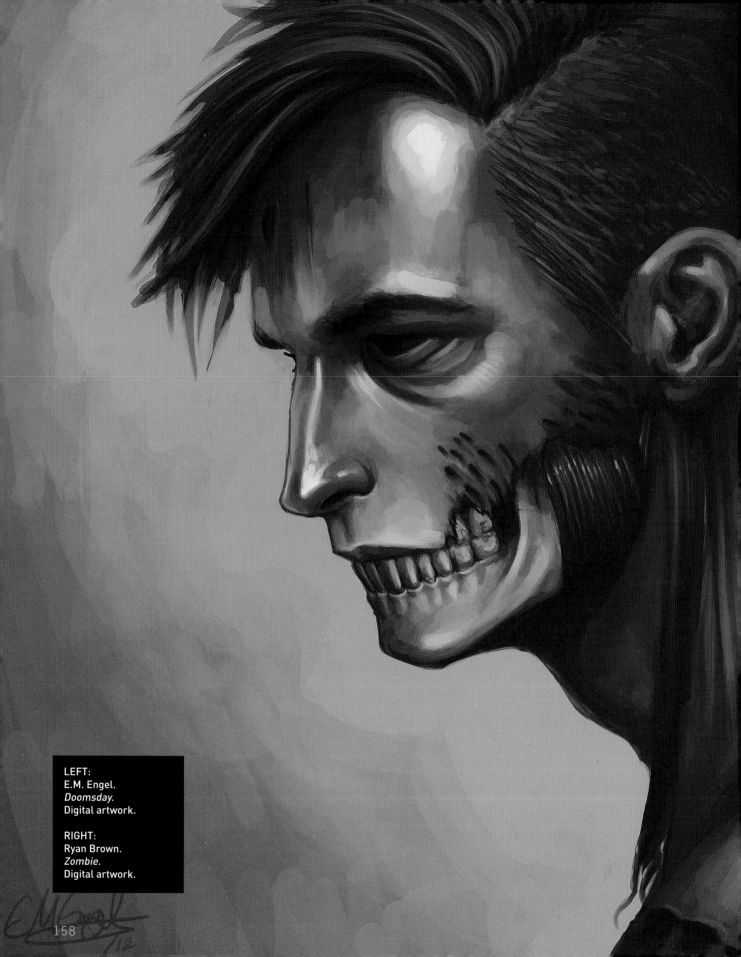

LEFT:
E.M. Engel.
Doomsday.
Digital artwork.

RIGHT:
Ryan Brown.
Zombie.
Digital artwork.

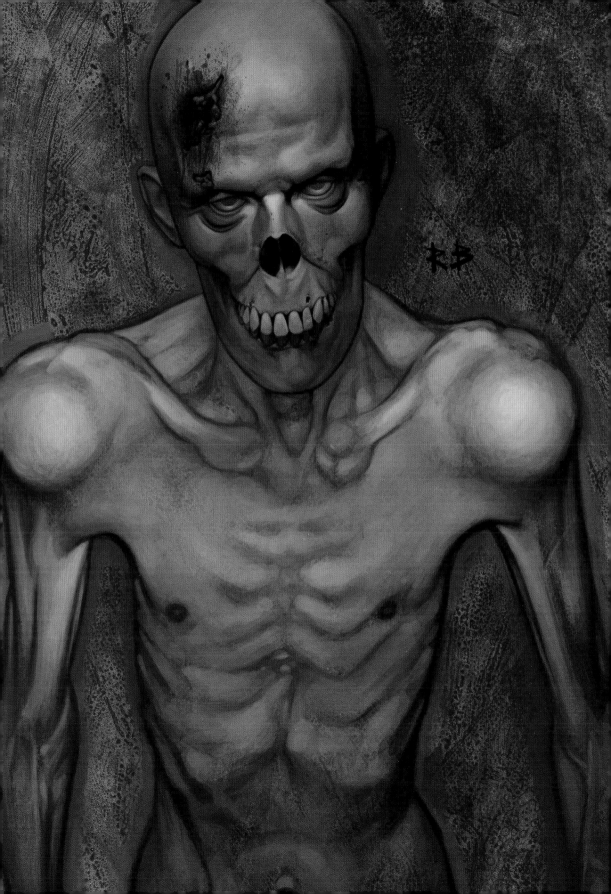

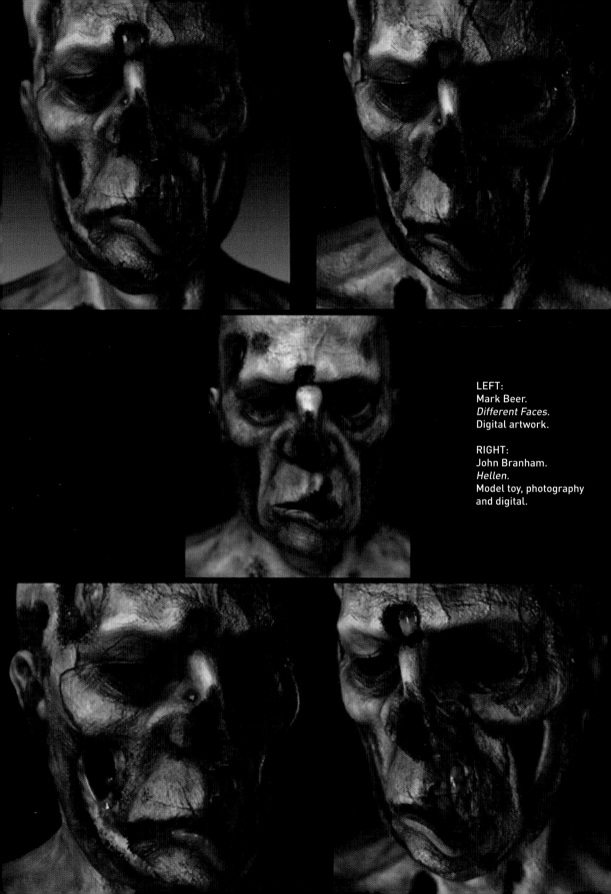

LEFT:
Mark Beer.
Different Faces.
Digital artwork.

RIGHT:
John Branham.
Hellen.
Model toy, photography
and digital.

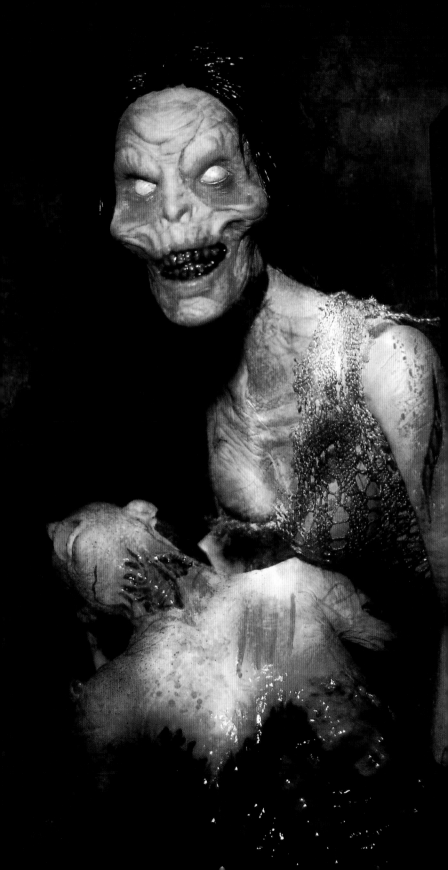

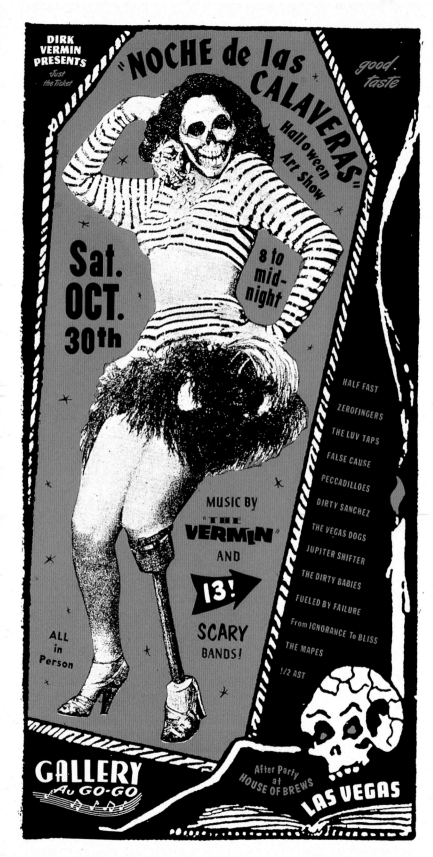

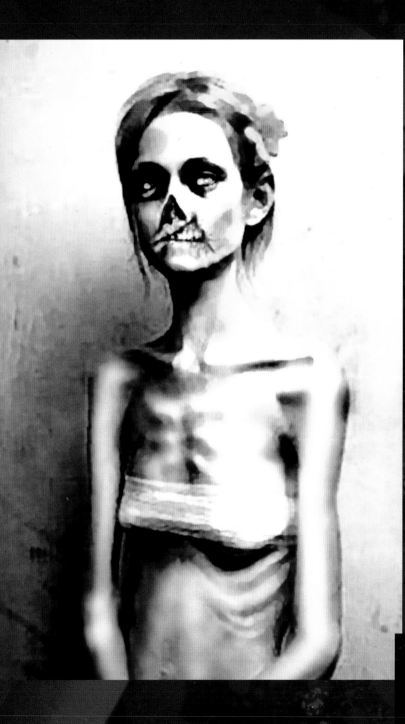

LEFT:
Art Chantry.
Noche Calaveras.
Photo collage.

RIGHT:
Woody Welch.
Zombie Girl.
Watercolour.

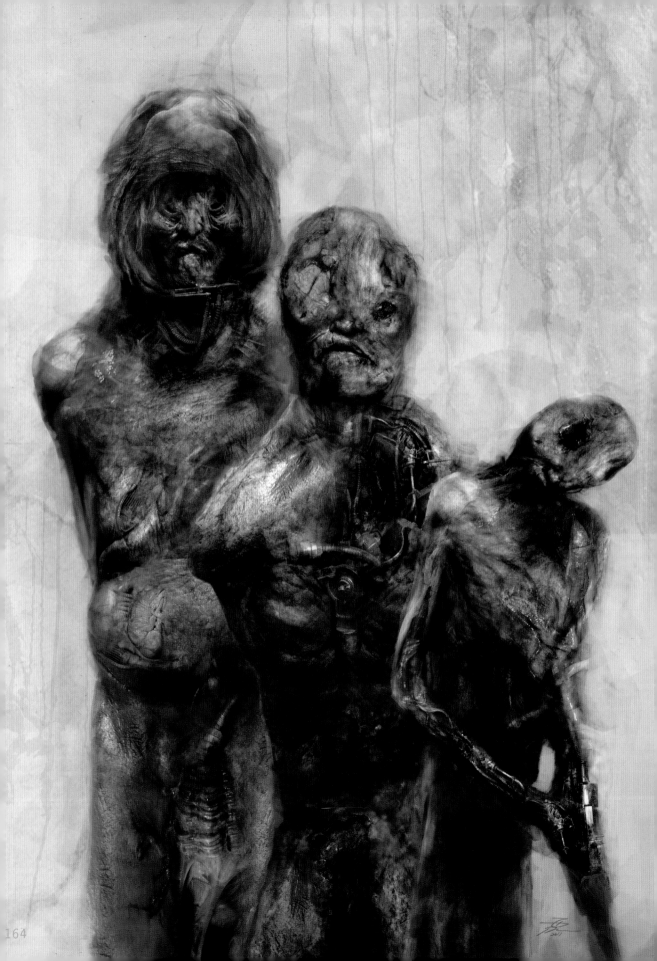

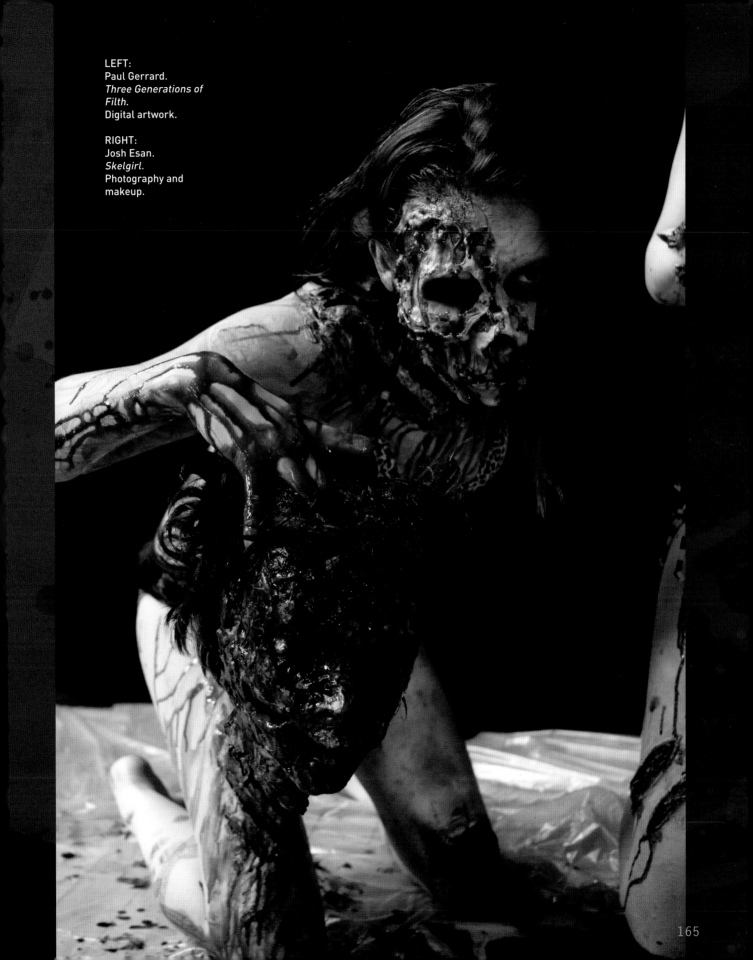

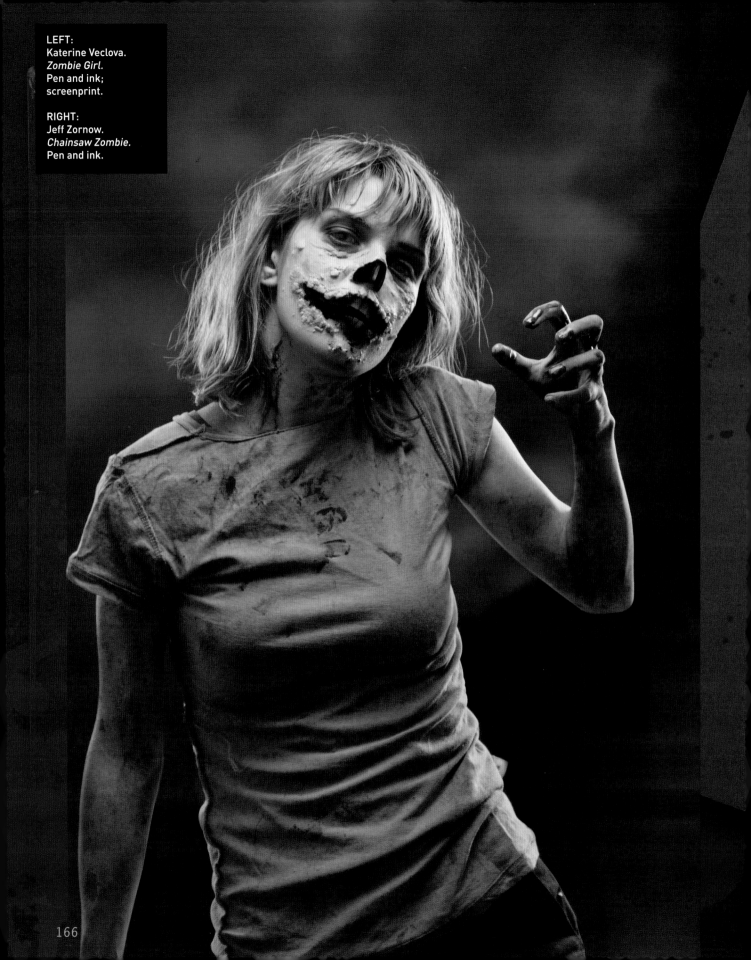

LEFT:
Katerine Veclova.
Zombie Girl.
Pen and ink;
screenprint.

RIGHT:
Jeff Zornow.
Chainsaw Zombie.
Pen and ink.

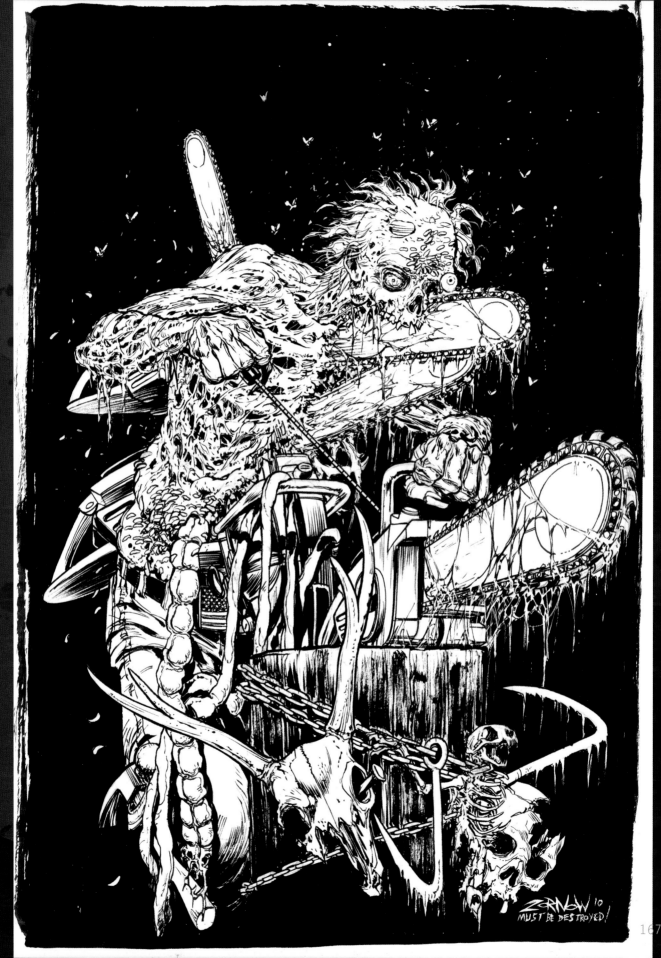

ZORNOW '10
MUST BE DESTROYED!

169

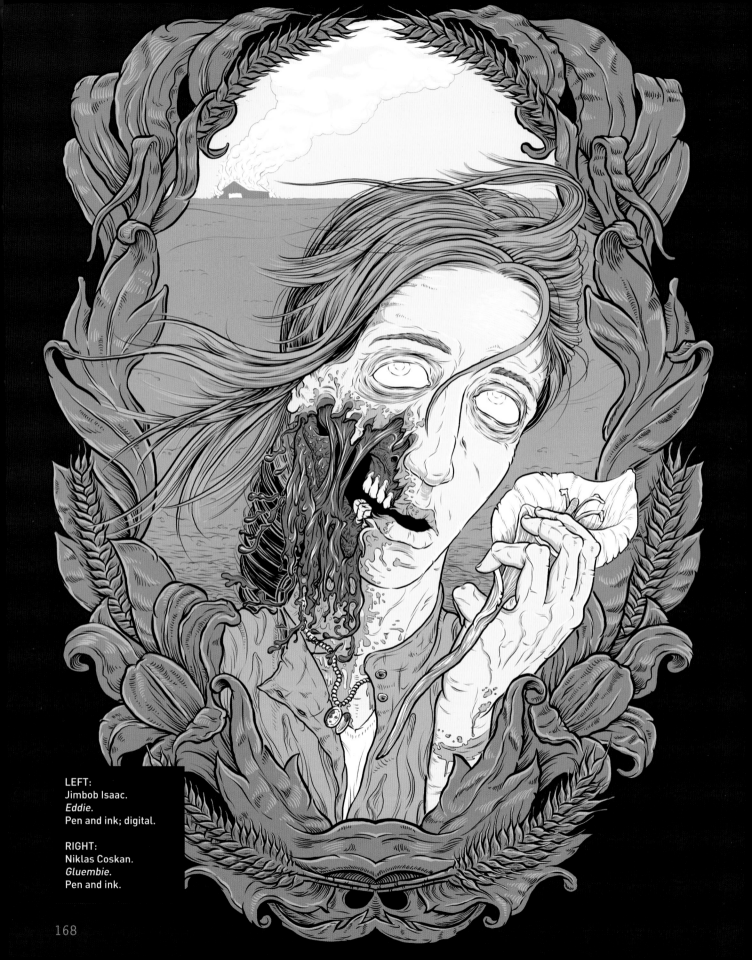

LEFT:
Jimbob Isaac.
Eddie.
Pen and ink; digital.

RIGHT:
Niklas Coskan.
Gluembie.
Pen and ink.

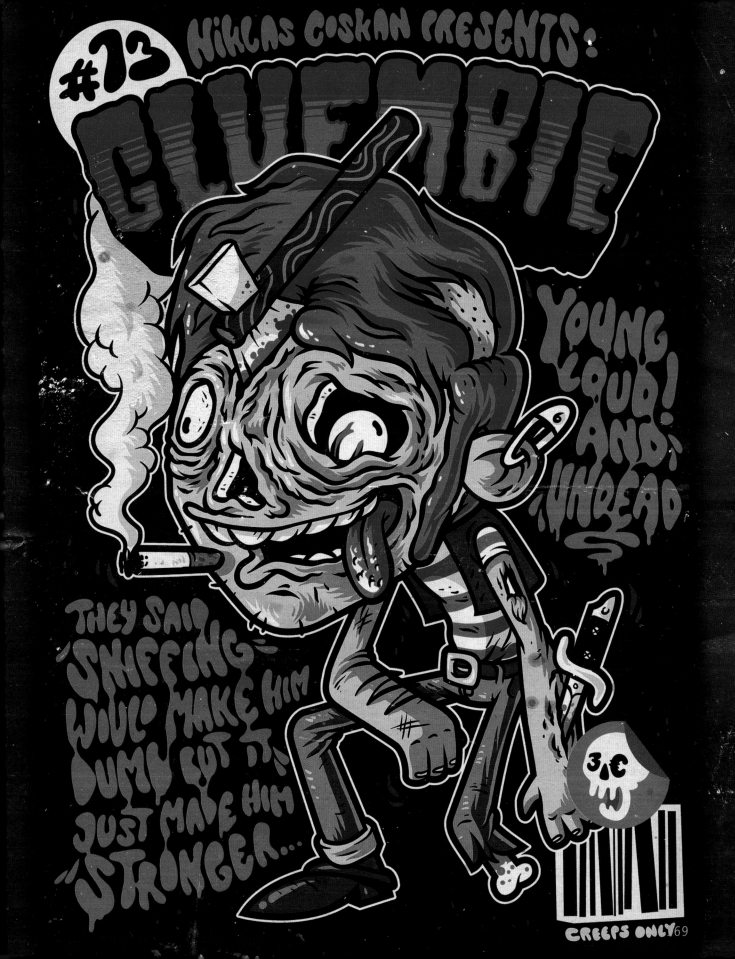

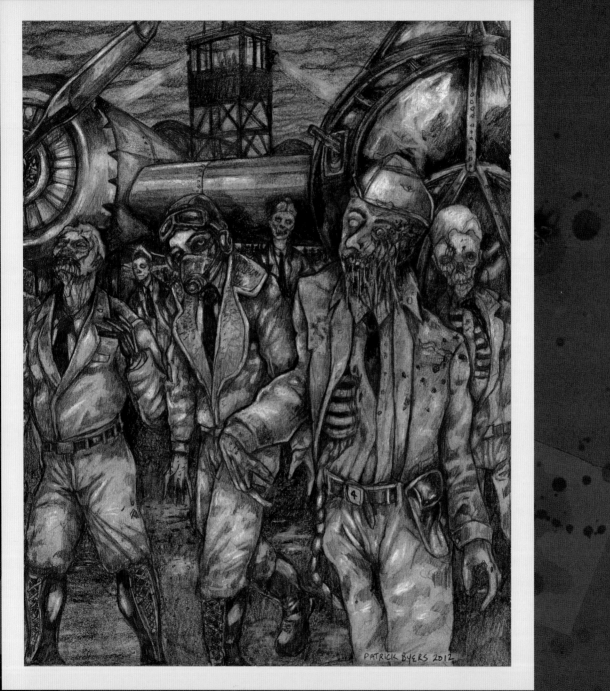
PATRICK BYERS 2012

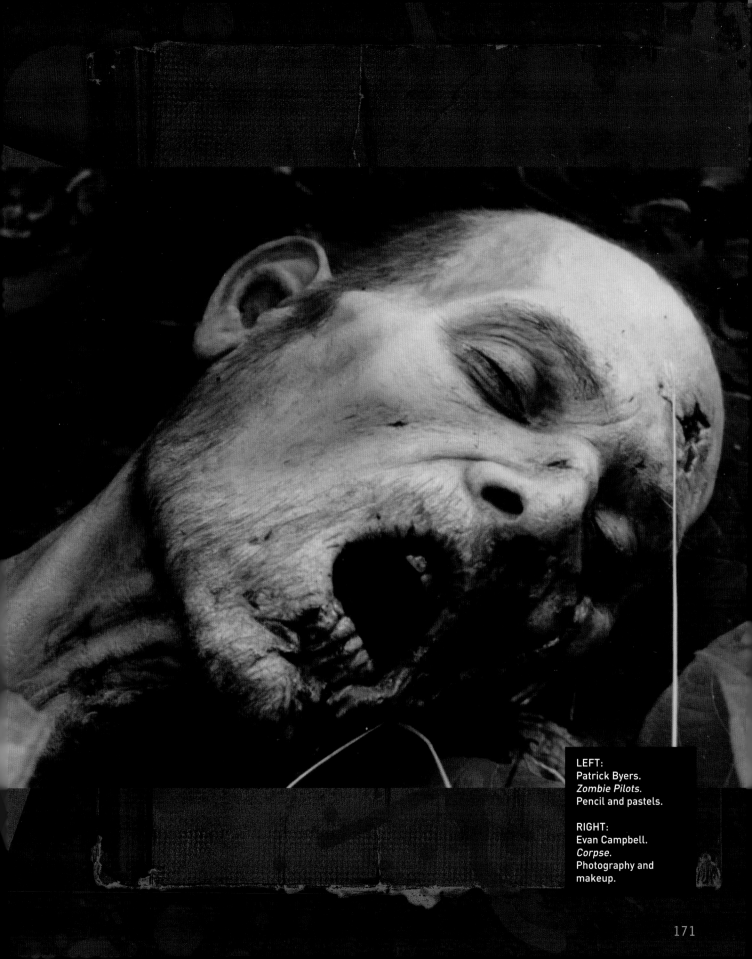

LEFT:
Patrick Byers.
Zombie Pilots.
Pencil and pastels.

RIGHT:
Evan Campbell.
Corpse.
Photography and
makeup.

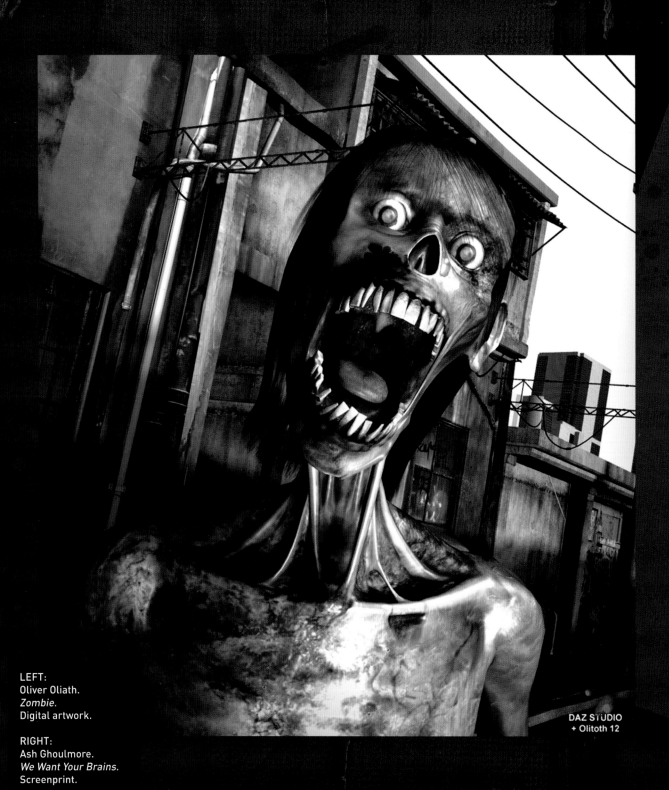

LEFT:
Oliver Oliath.
Zombie.
Digital artwork.

RIGHT:
Ash Ghoulmore.
We Want Your Brains.
Screenprint.

DAZ STUDIO
+ Olitoth 12

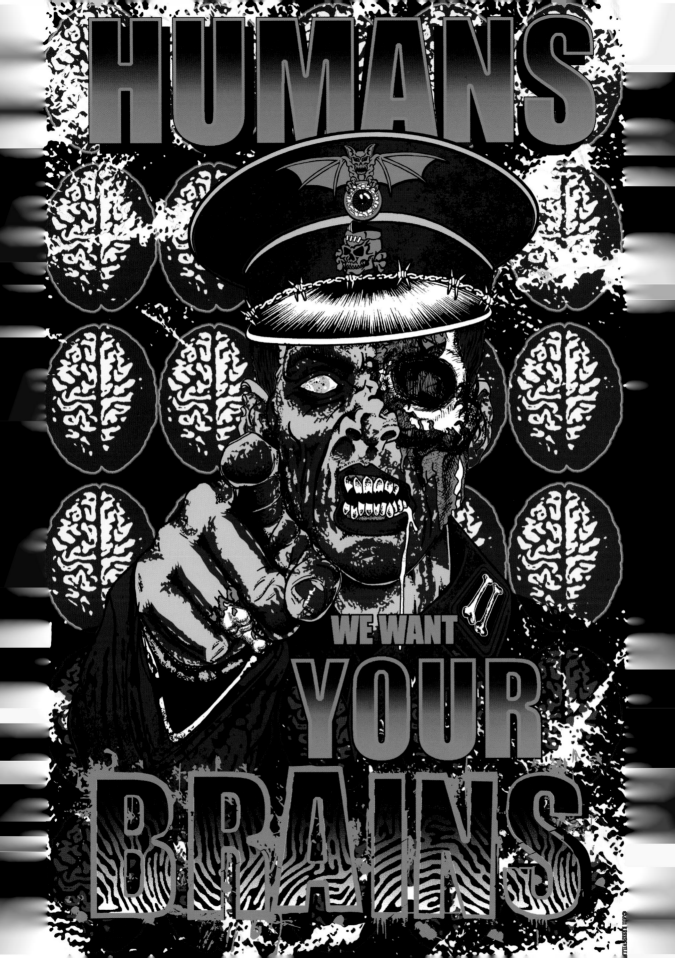

T:
o Fisher.
eam of Lips.
cil, pen and ink.

HT:
d Hartman.
mpblood.
an ink; digital.

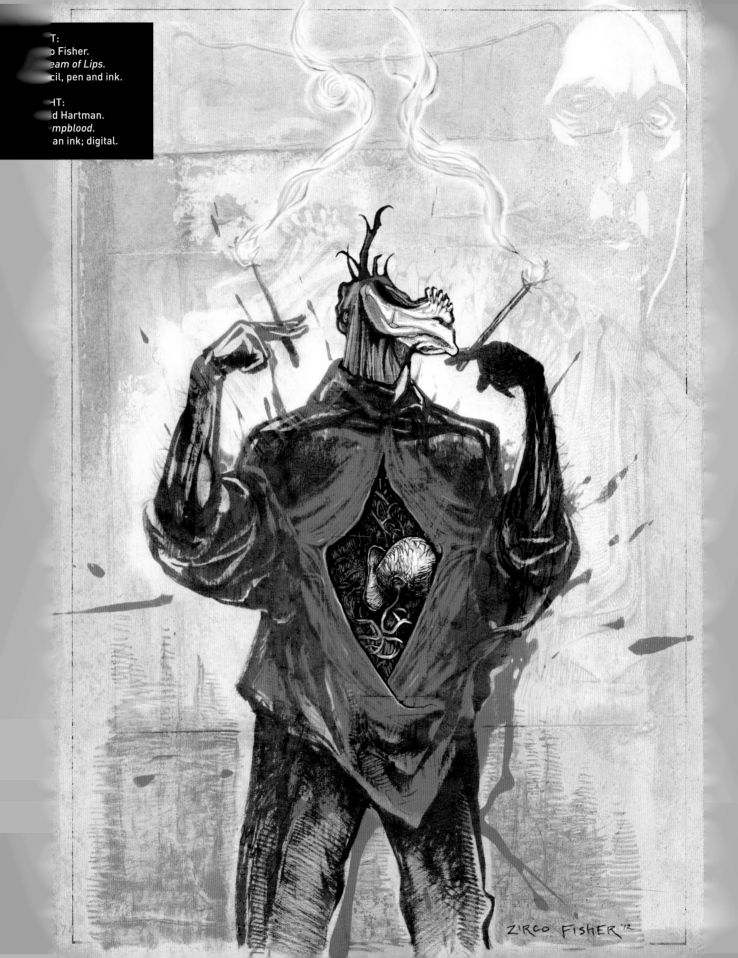

ZIRCO FISHER '12

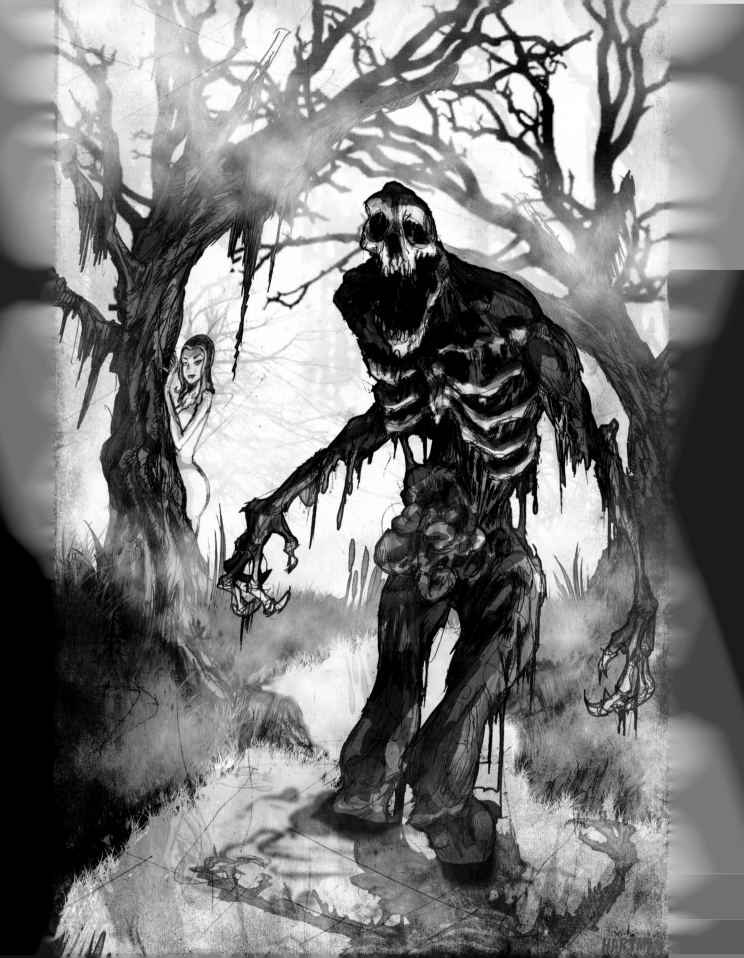

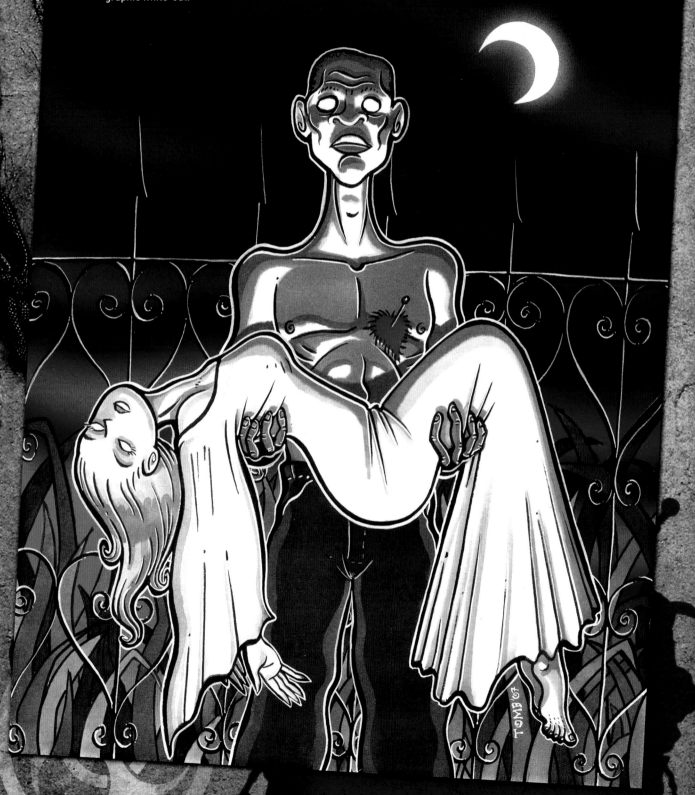

BELOW:
Tom Bagley.
I Really Care For You.
Ink, magic markers,
airbrush ink and
graphic white-out.

QUARANTINE

RIGHT:
Nick Percival.
Savini Zombie.
Pen and ink; digital.

"I COULD EASILY KILL YOU NOW, BUT I'M DETERMINED TO HAVE YOUR BRAIN!"

SP SECRET

LEFT:
Rachel Reyes
Quarantine.
Photography and
digital.

RIGHT:
Jim Cole.
*One to the Head
(Propaganda).*
Digital artwork.

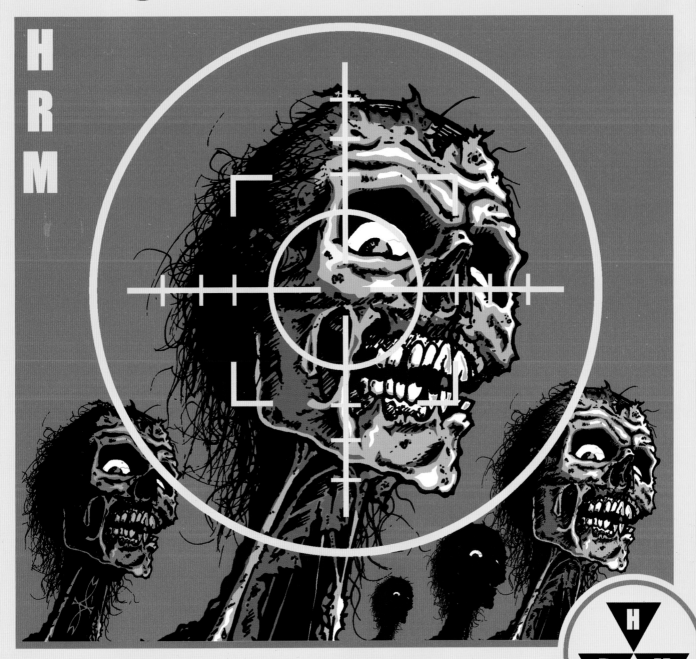

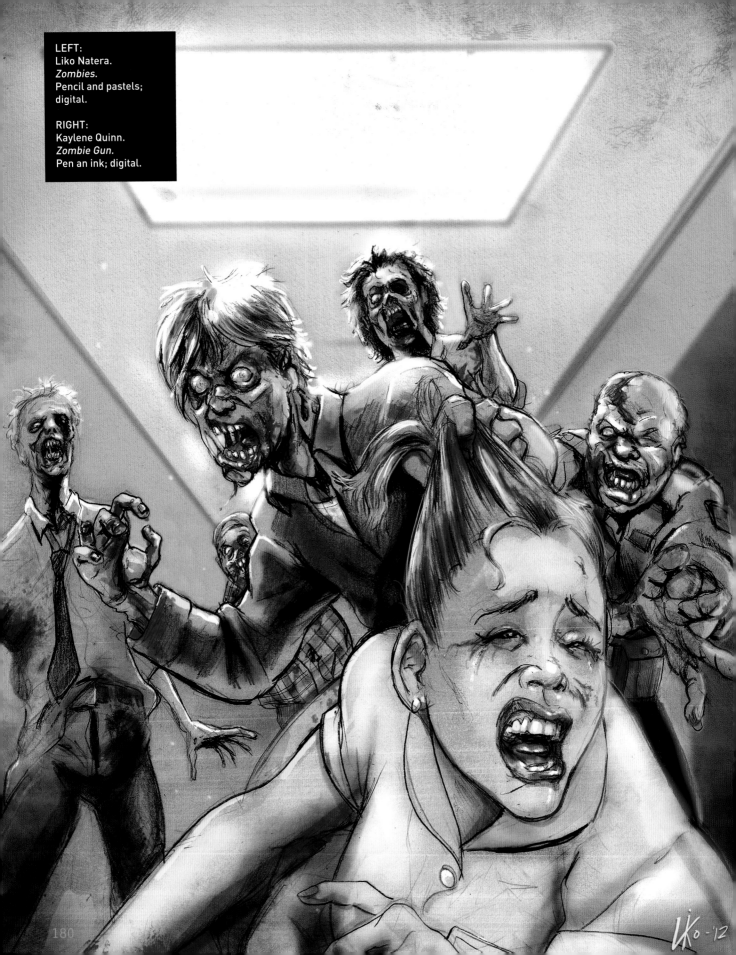

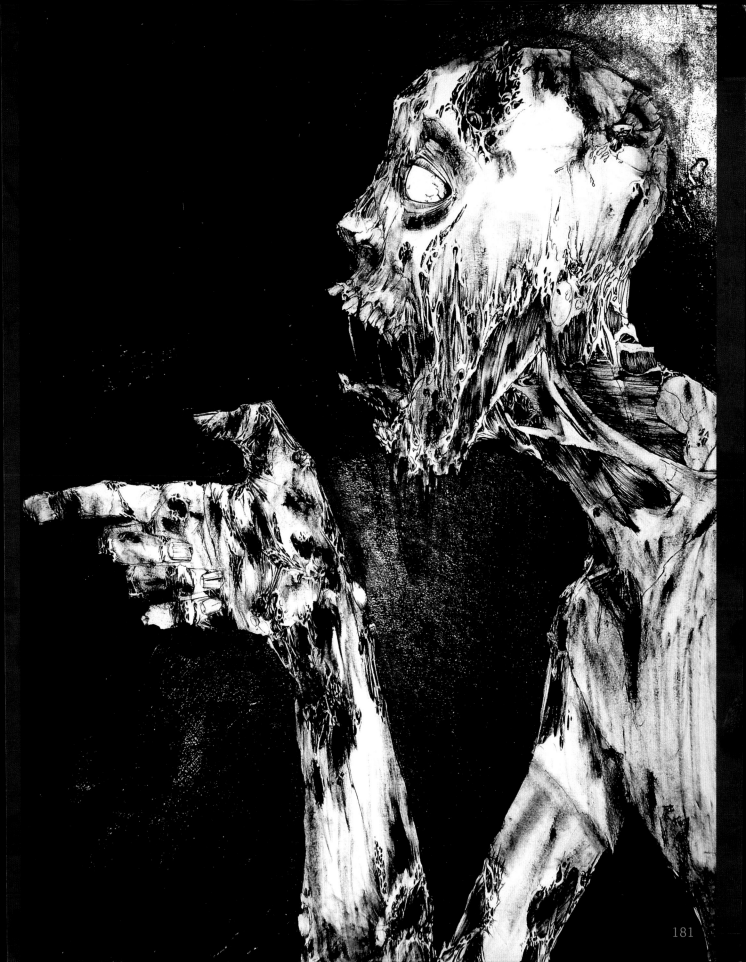

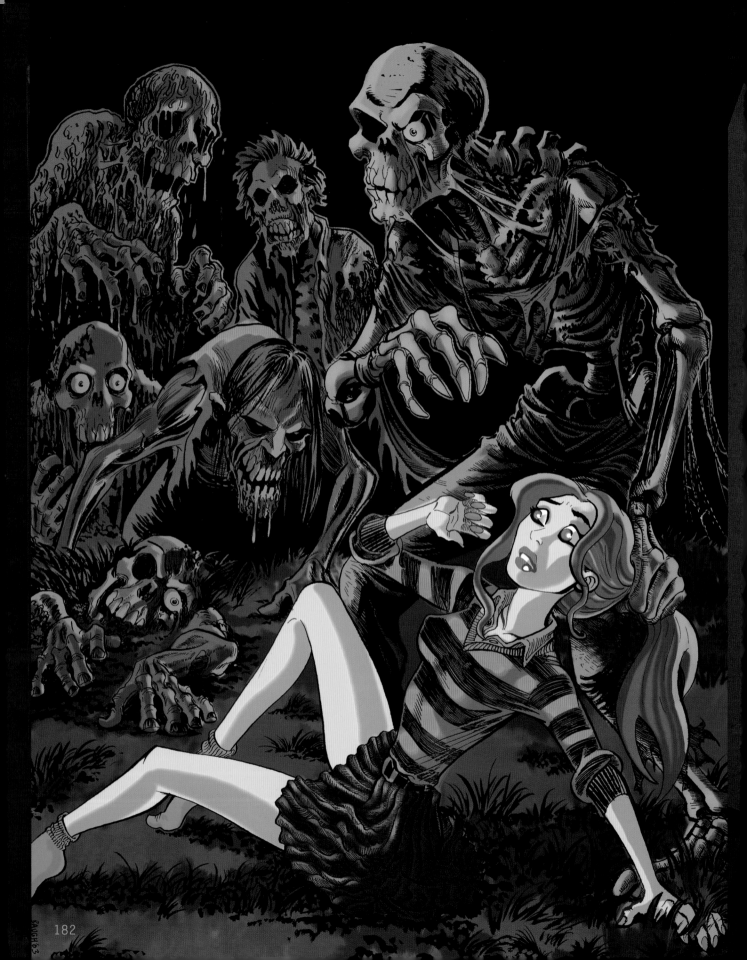

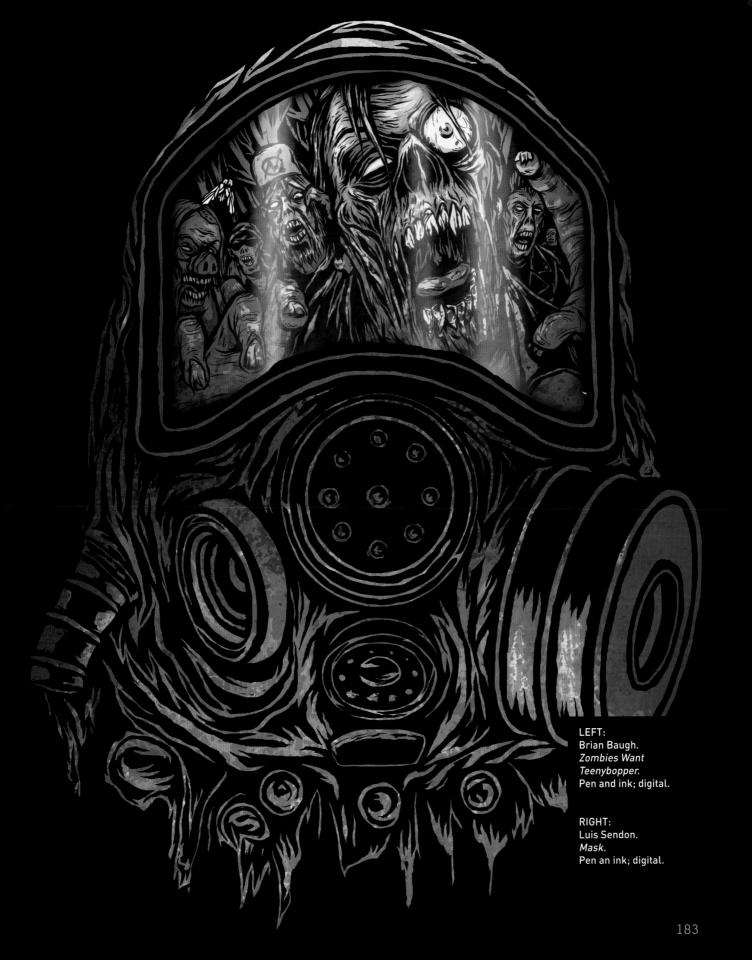

LEFT:
Brian Baugh.
Zombies Want Teenybopper.
Pen and ink; digital.

RIGHT:
Luis Sendon.
Mask.
Pen an ink; digital.

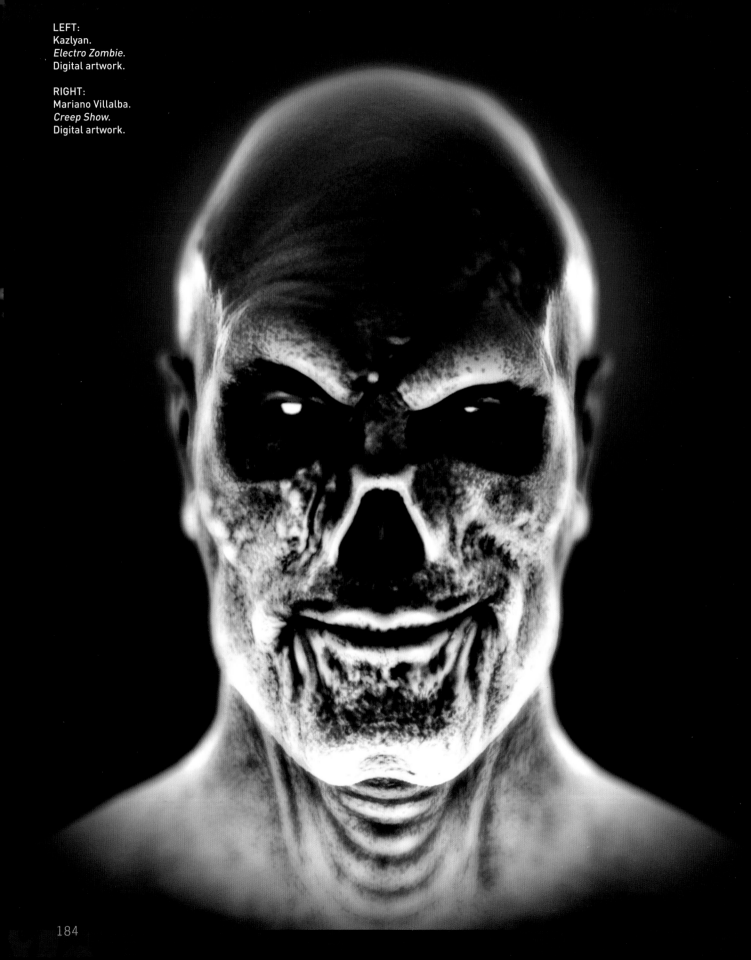

LEFT:
Kazlyan.
Electro Zombie.
Digital artwork.

RIGHT:
Mariano Villalba.
Creep Show.
Digital artwork.

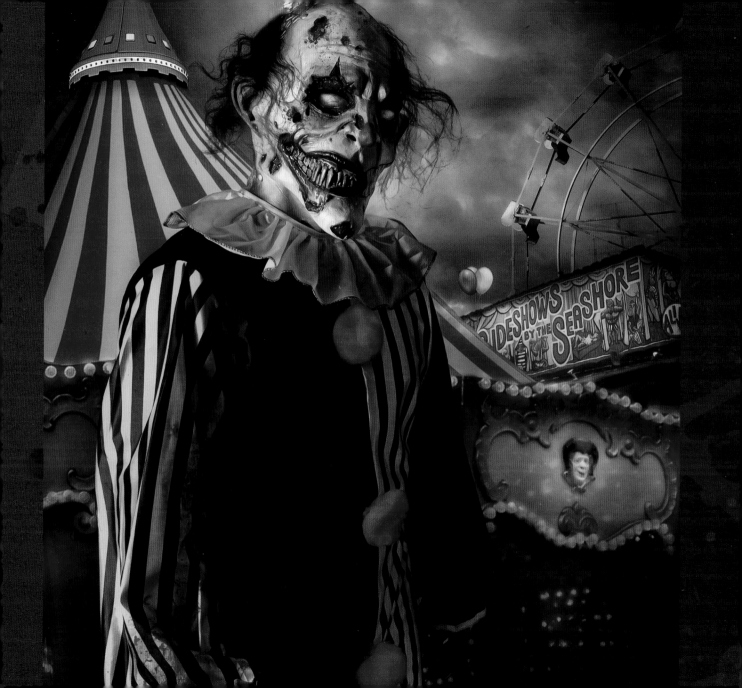

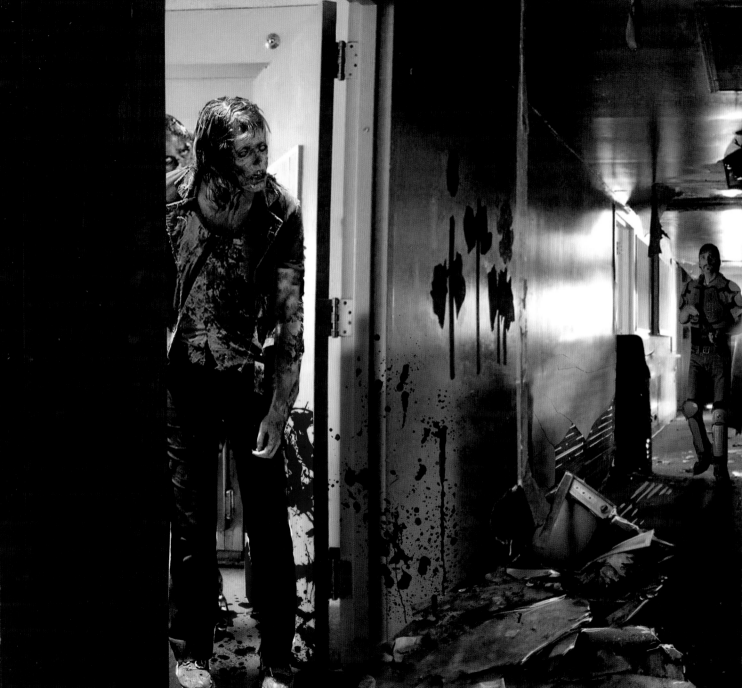

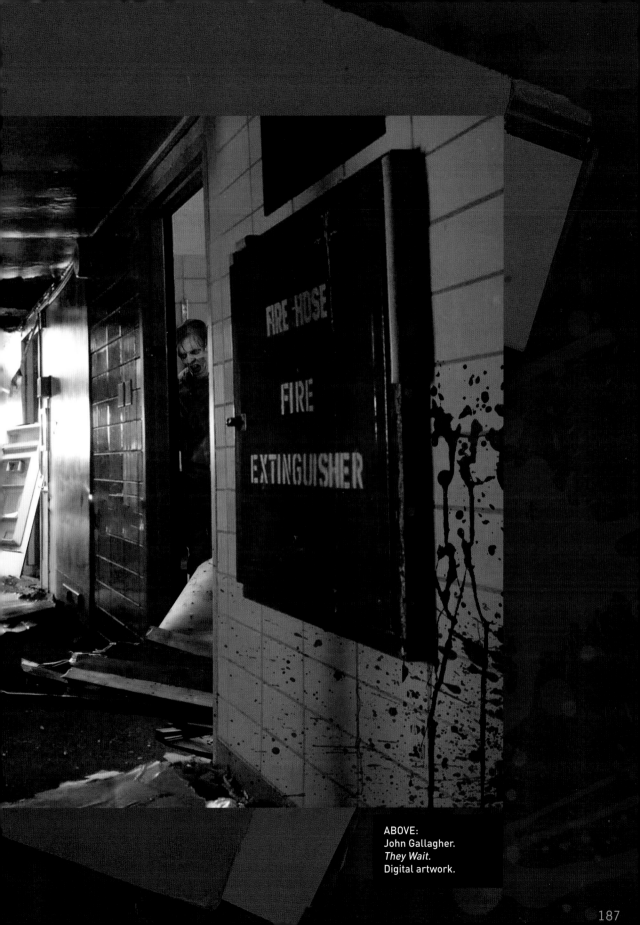

ABOVE:
John Gallagher.
They Wait.
Digital artwork.

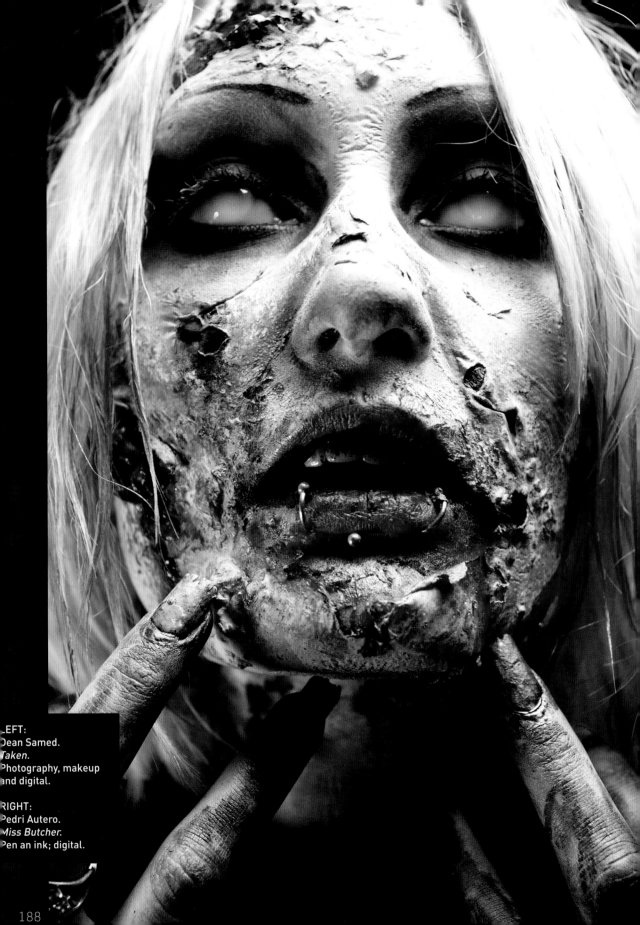

LEFT:
Dean Samed.
Taken.
Photography, makeup
and digital.

RIGHT:
Pedri Autero.
Miss Butcher.
Pen an ink; digital.

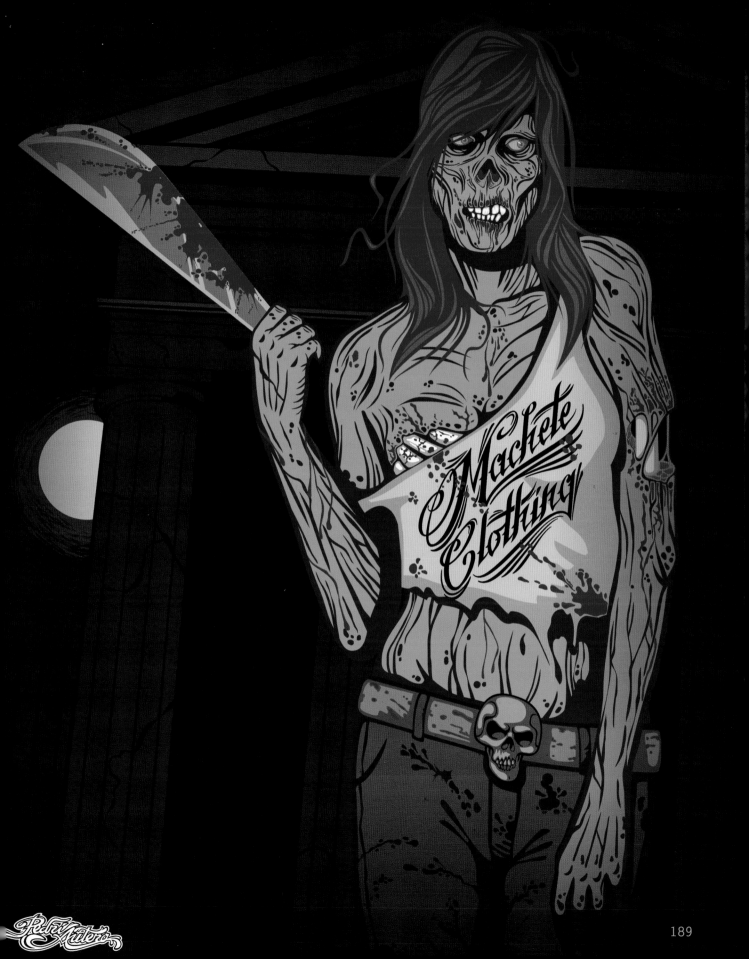

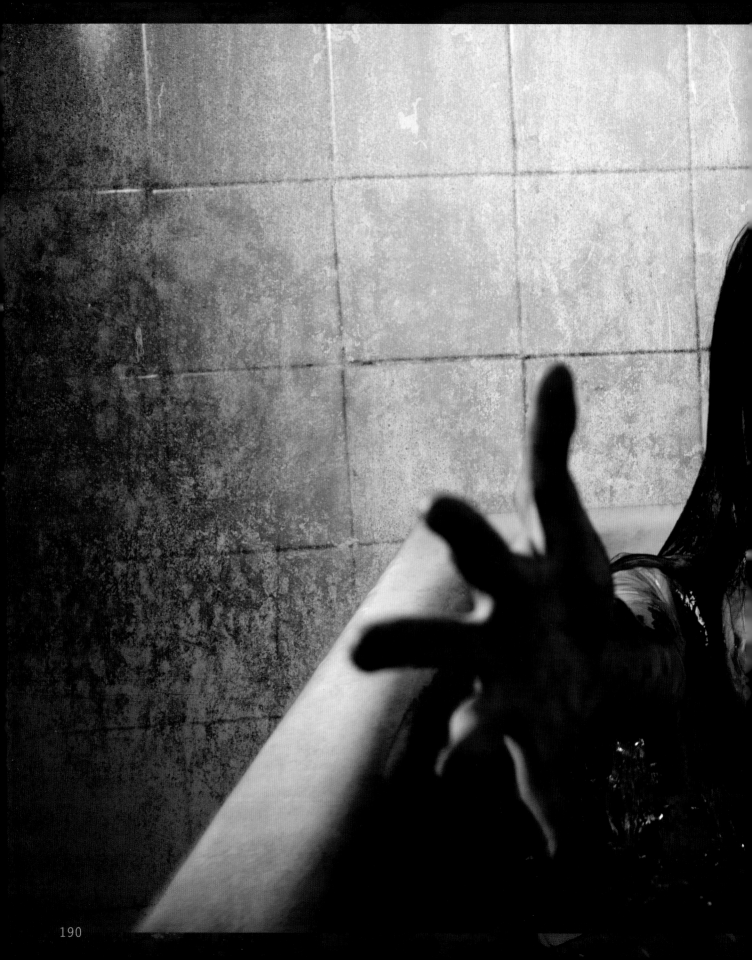

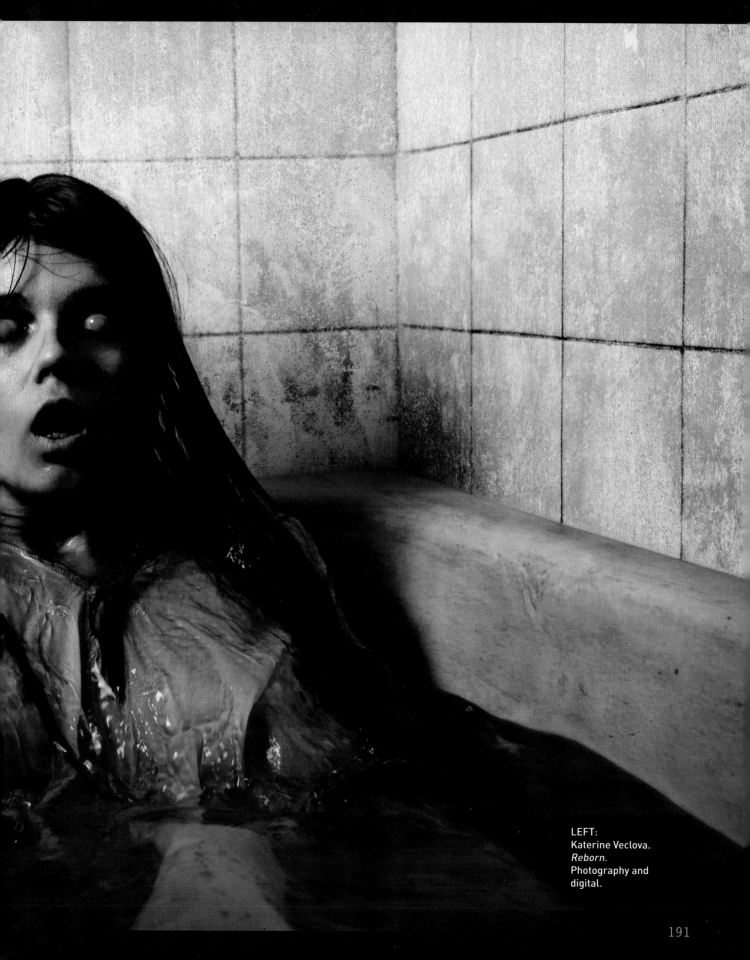

LEFT:
Katerine Veclova.
Reborn.
Photography and
digital.

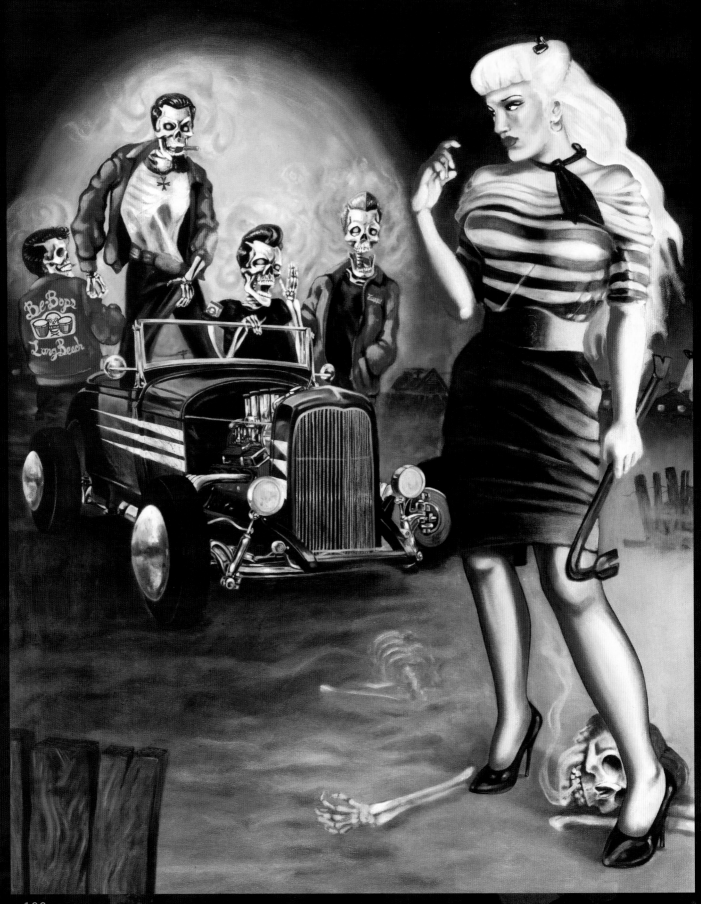

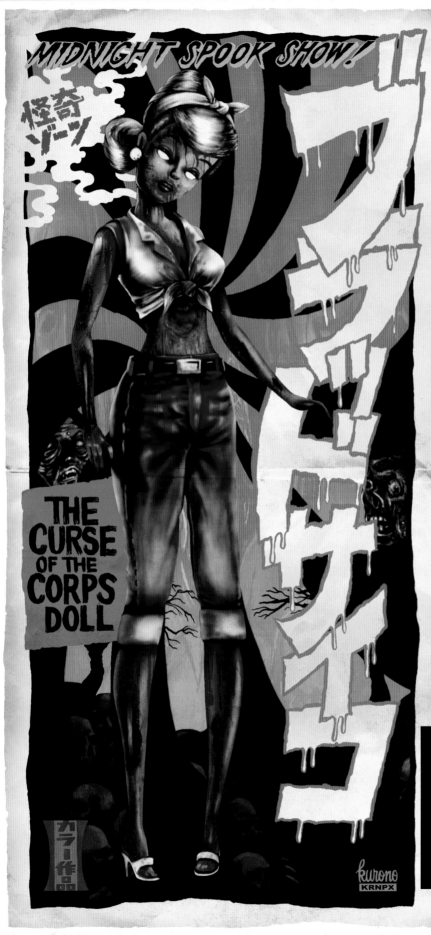

MIDNIGHT SPOOK SHOW!

怪奇ゾーツ

THE
CURSE
OF THE
CORPS
DOLL

kurono
KRNPX

LEFT:
Sara Ray.
Zombie Trouble.
Oil.

RIGHT:
Atsushi Kurono
(KRNPX).
*The Curse of the Corps
Doll.*
Digital artwork.

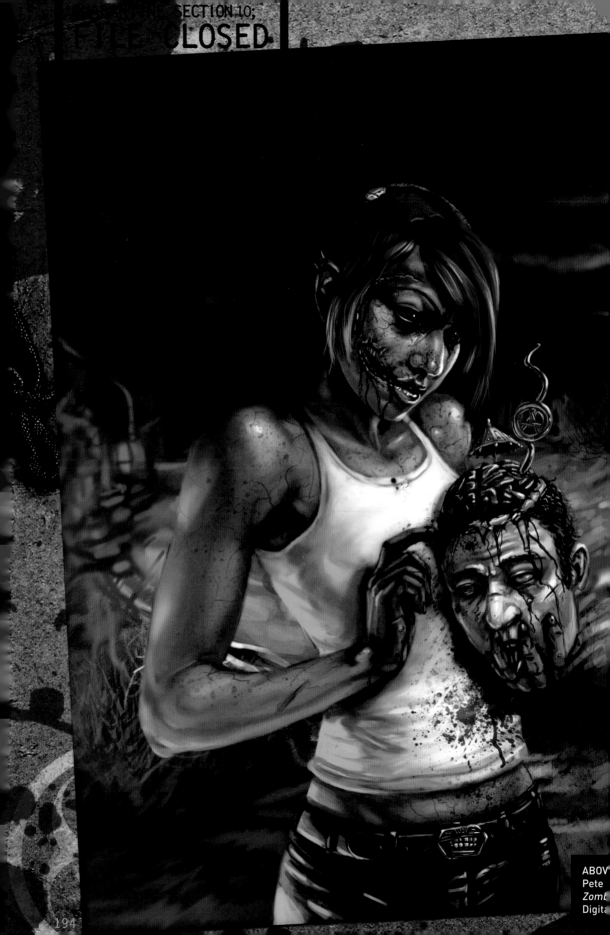

ABOV
Pete
Zomb
Digita

OVERRUN

ABOVE:
April McGuire.
In a Heartbeat.
Digital artwork.

TOP
SECRET

"THE GOOD NEWS IS
THAT YOUR DATES
ARE HERE, THE
BAD NEWS IS
THAT THEY'RE DEAD."

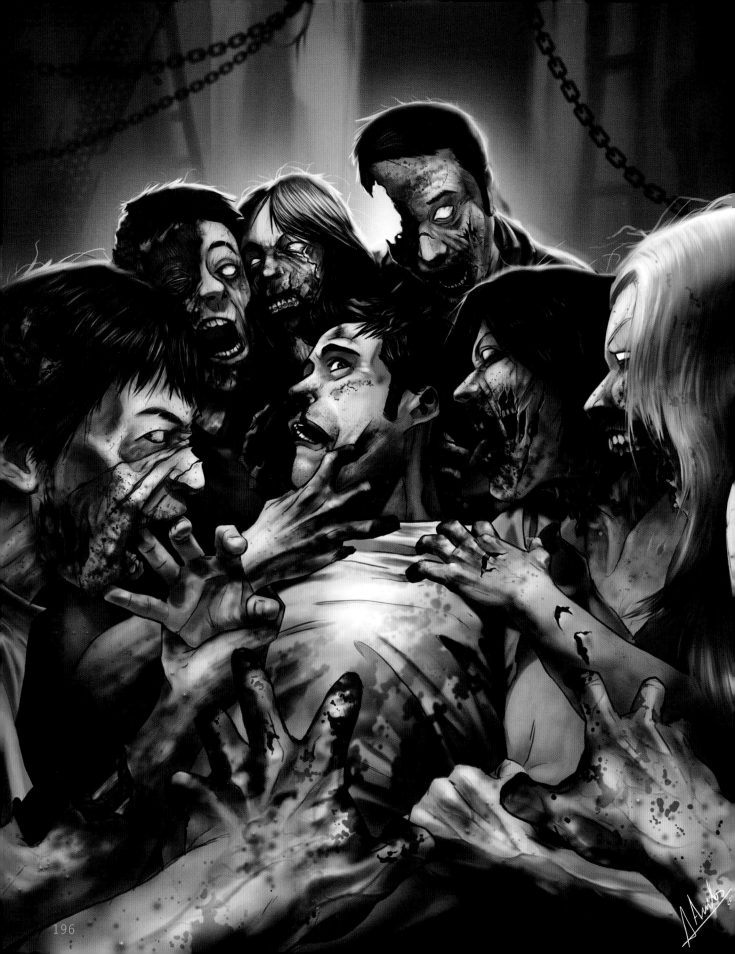

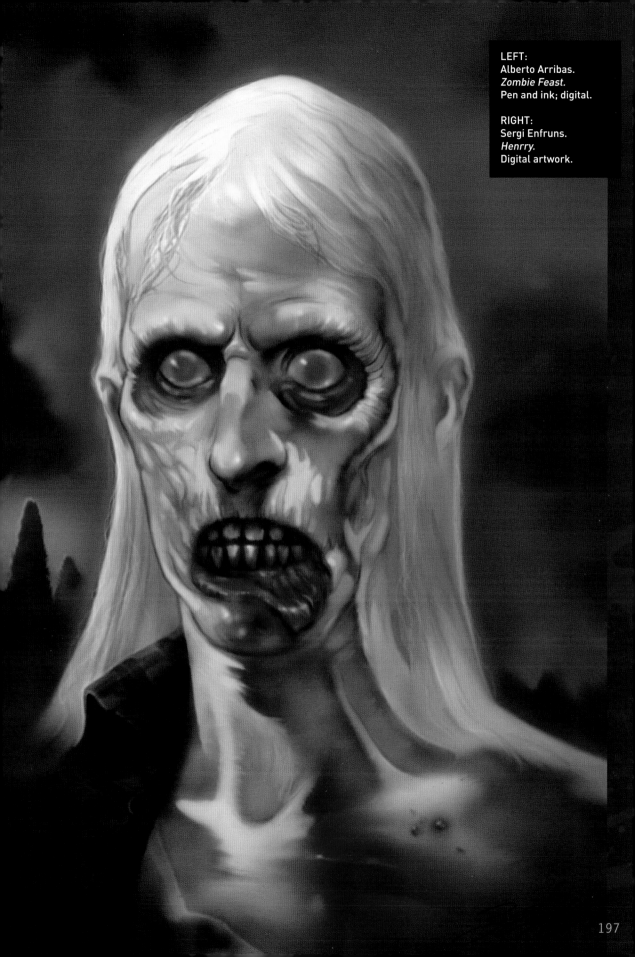

LEFT:
Alberto Arribas.
Zombie Feast.
Pen and ink; digital.

RIGHT:
Sergi Enfruns.
Henrry.
Digital artwork.

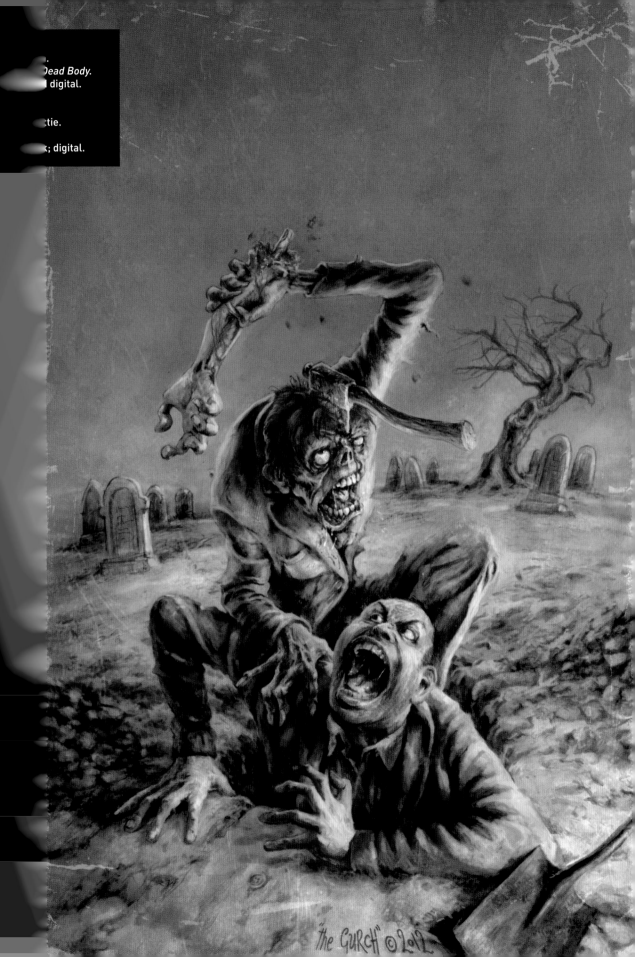

.
Dead Body.
digital.

tie.

; digital.

"the GURCH" © 2012

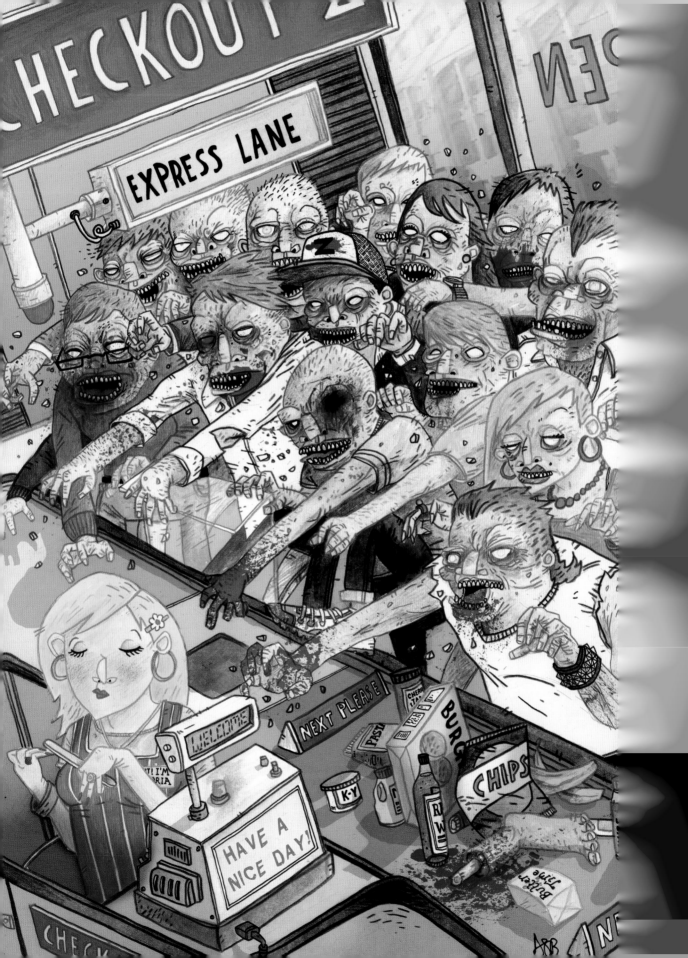

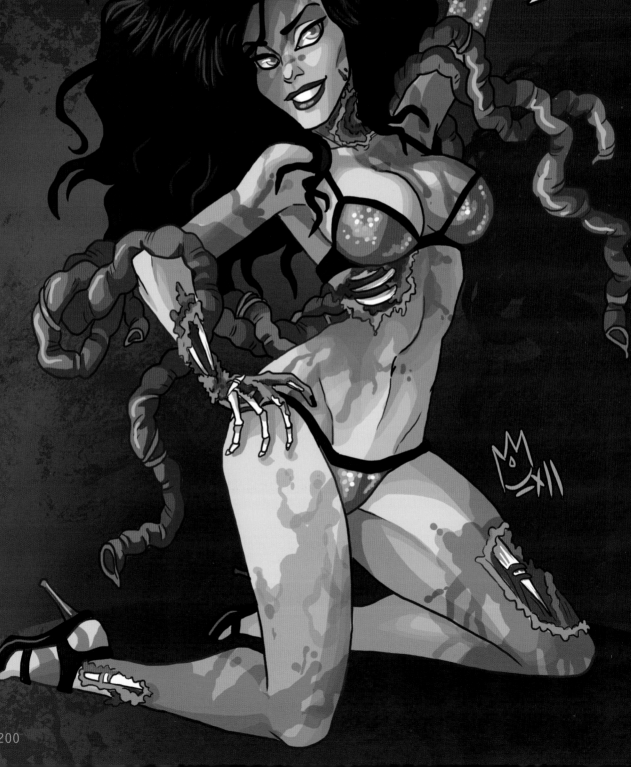

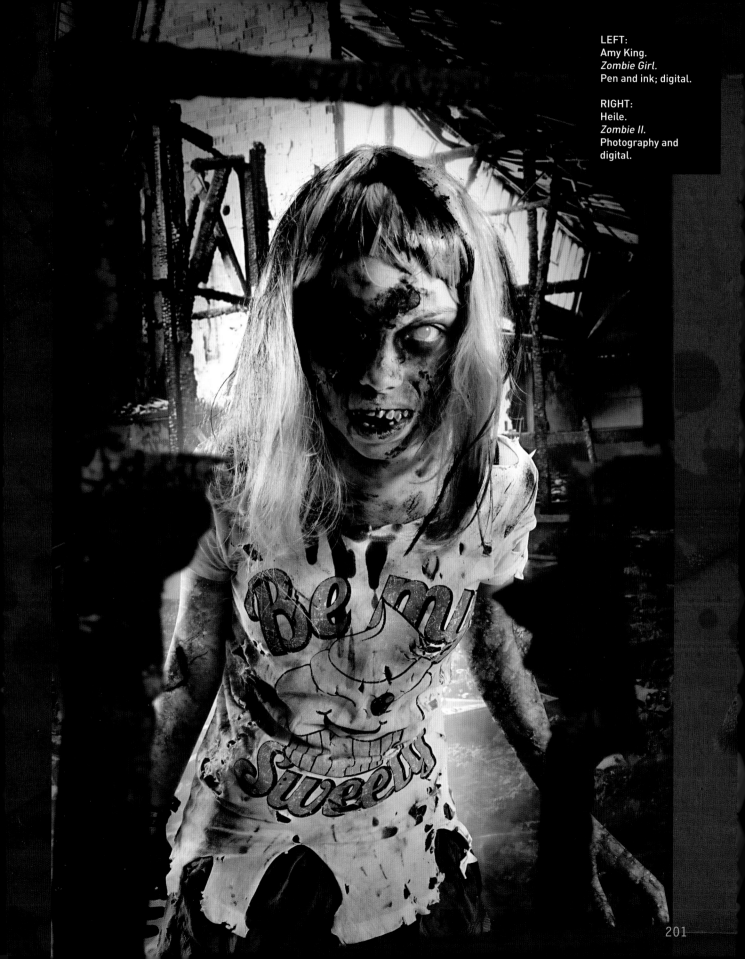

LEFT:
Amy King.
Zombie Girl.
Pen and ink; digital.

RIGHT:
Heile.
Zombie II.
Photography and
digital.

201

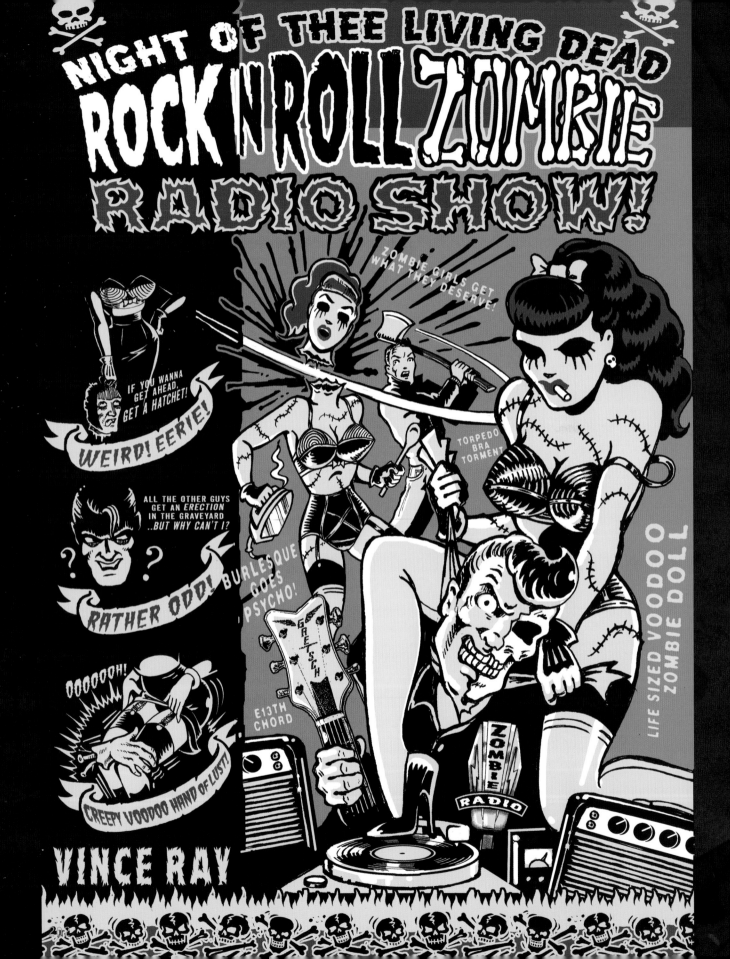

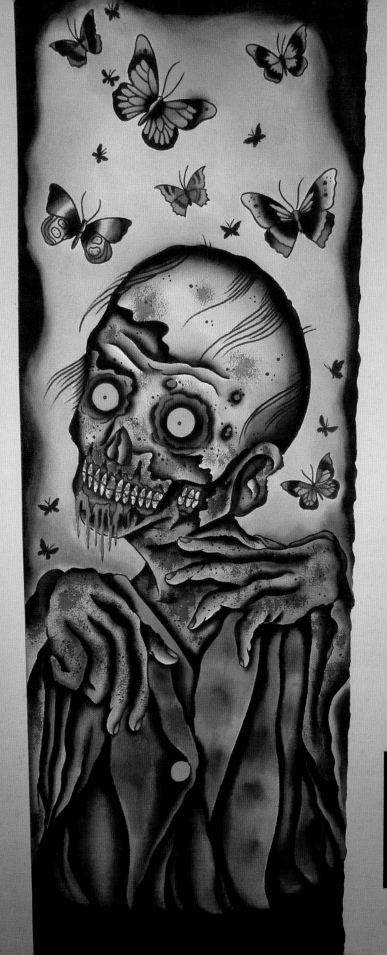

LEFT:
Vince Ray.
Zombie Poster.
Screenprint.

RIGHT:
Phil Kyle.
Skate Zombie.
Pen and watercolour.

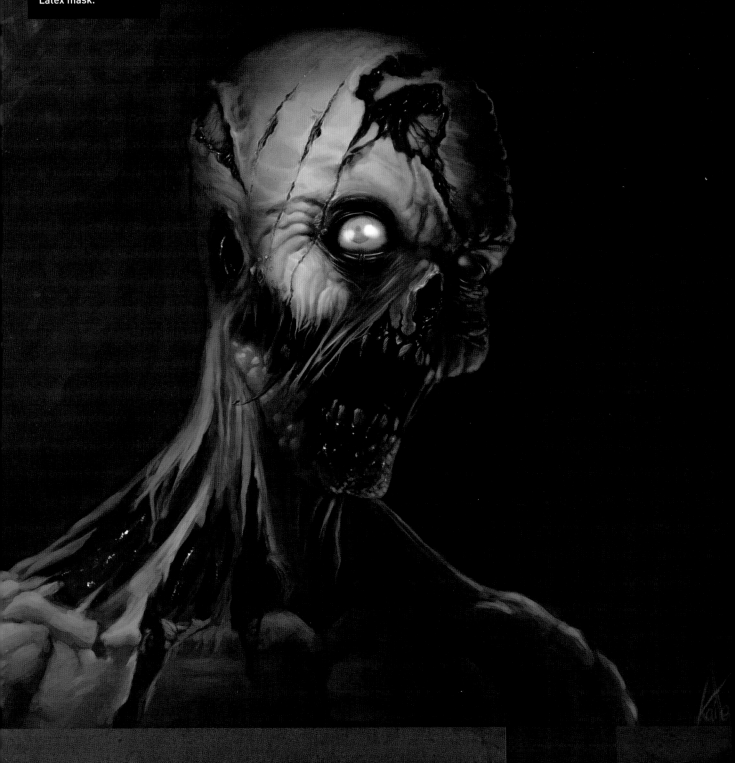

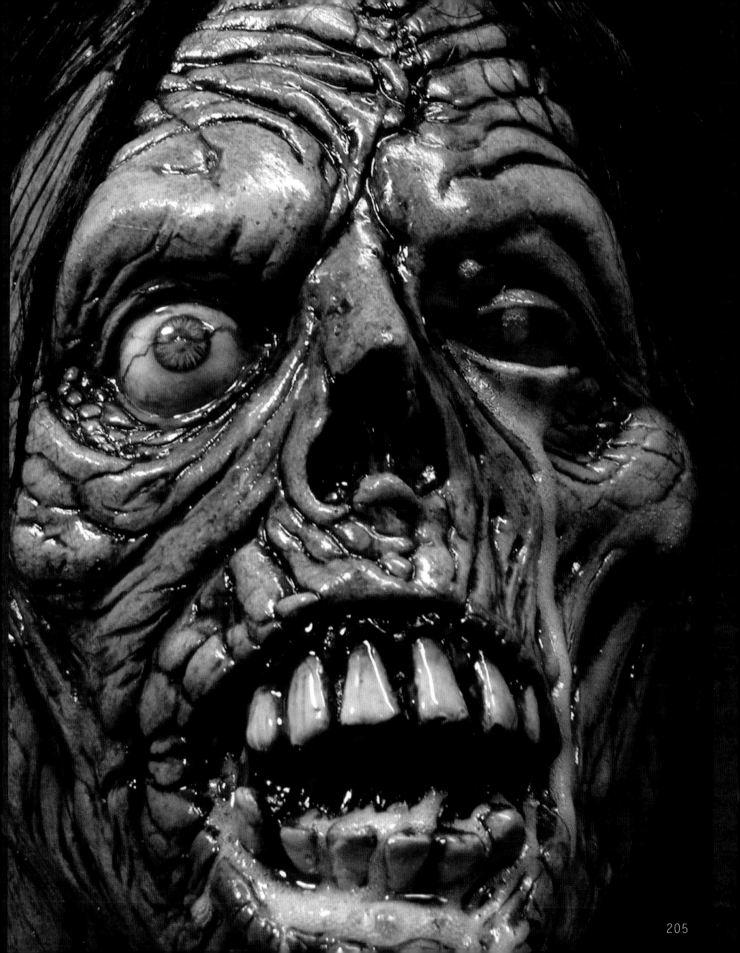

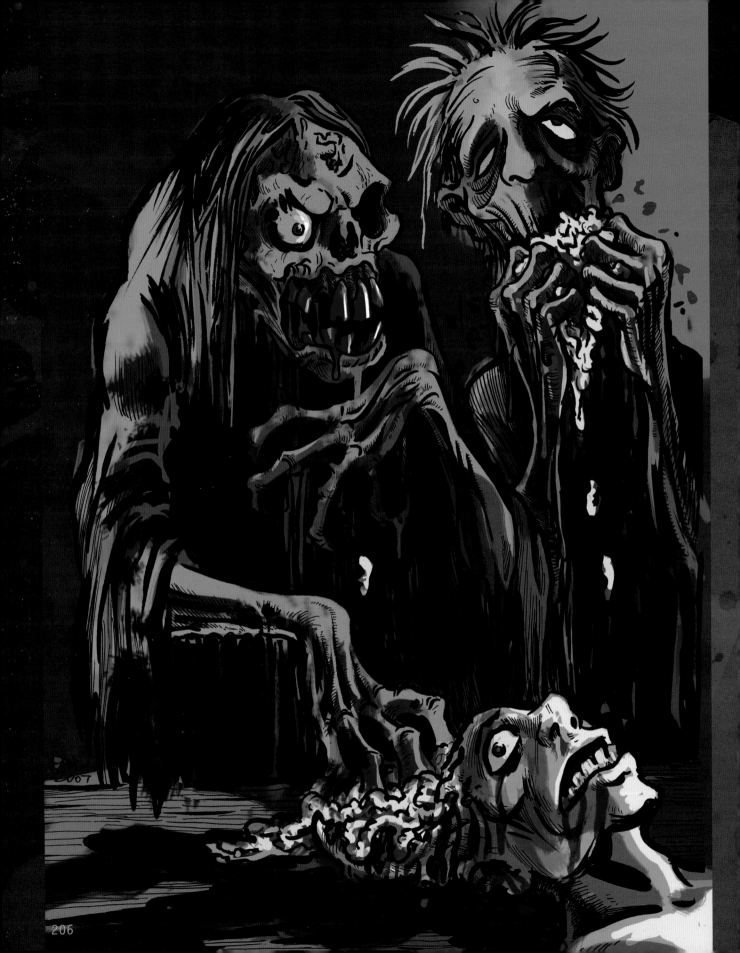

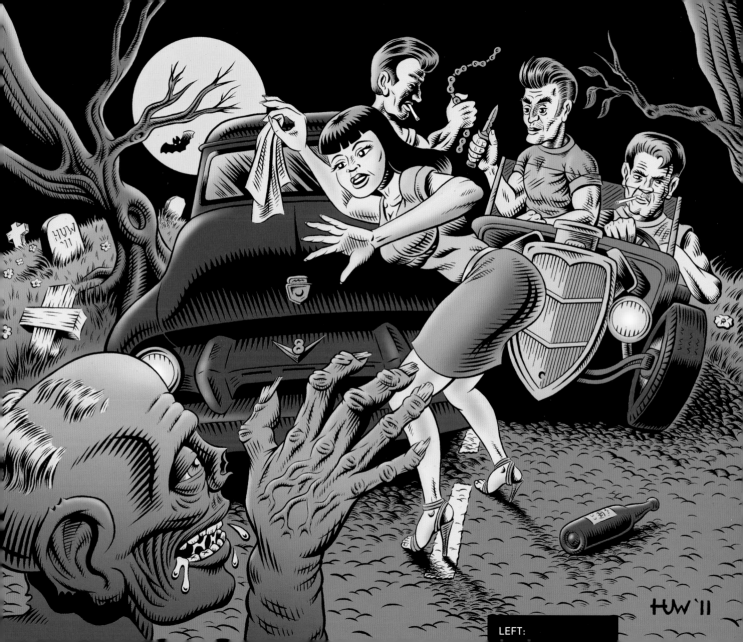

LEFT:

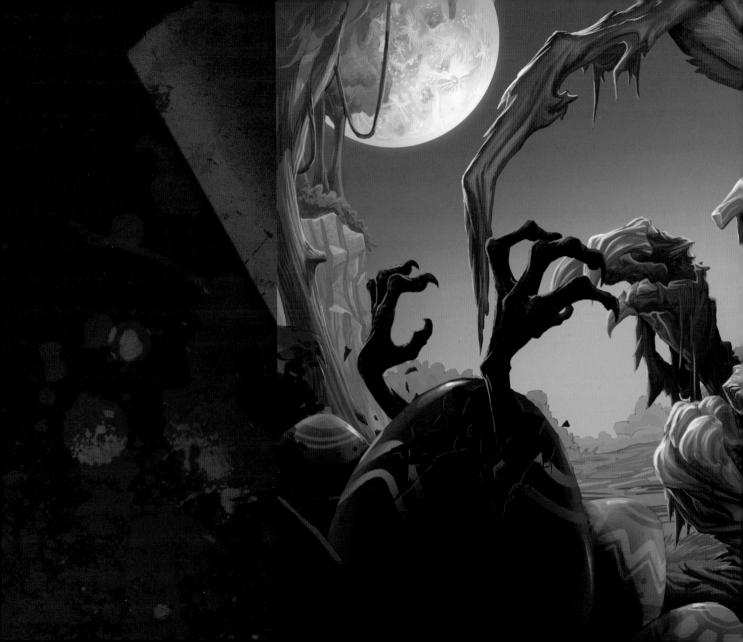

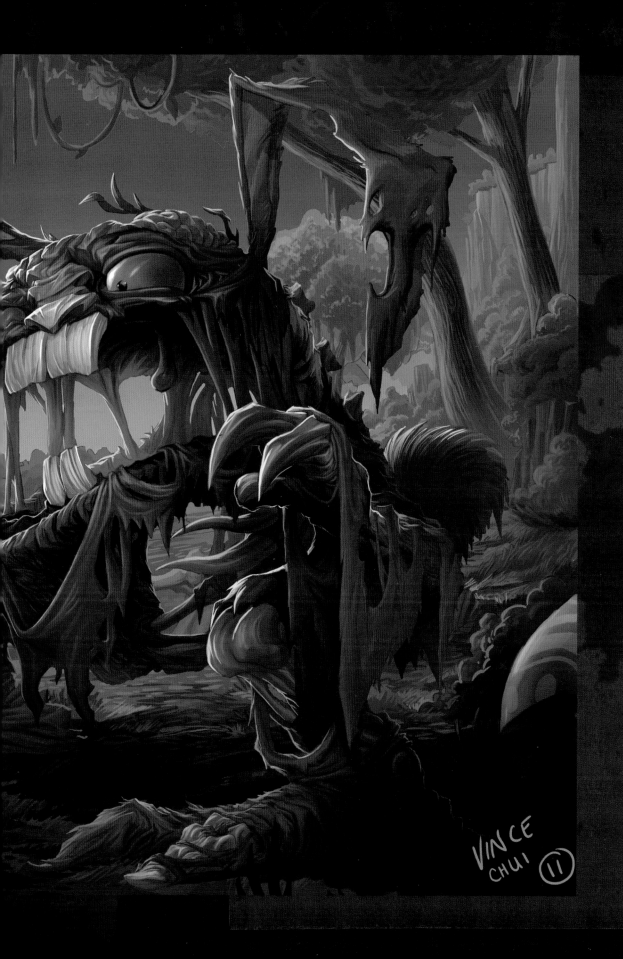

VINCE
CHUI (11)

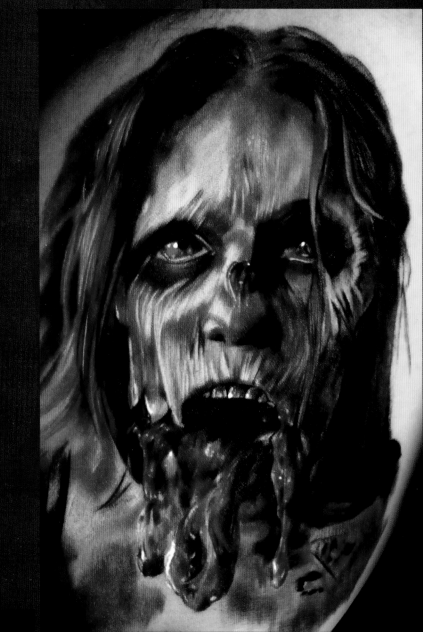

LEFT:

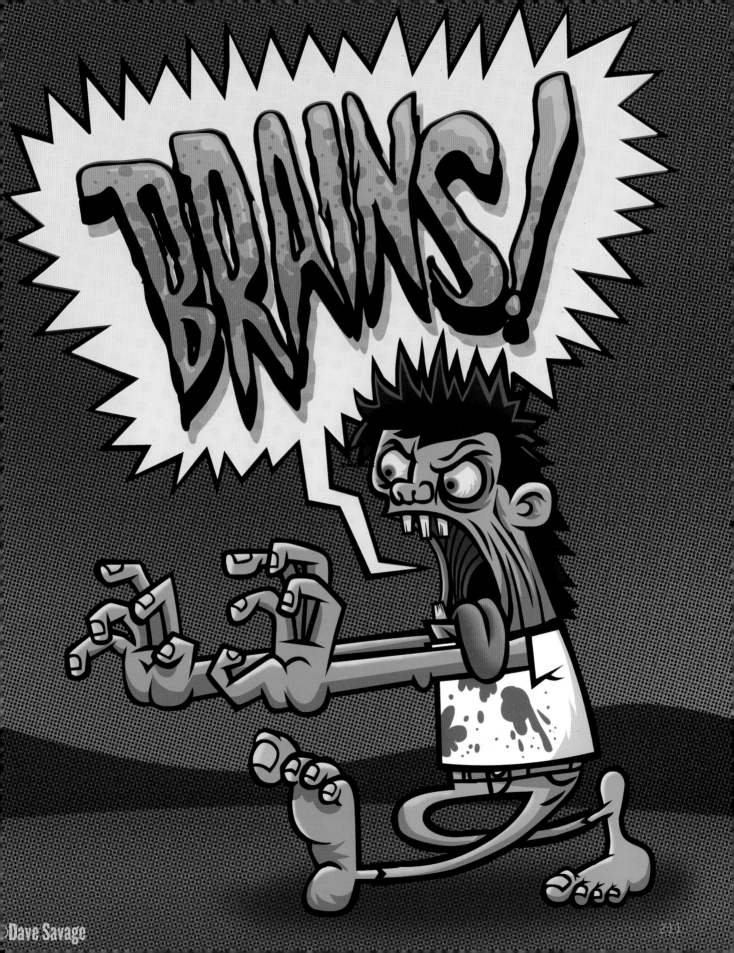

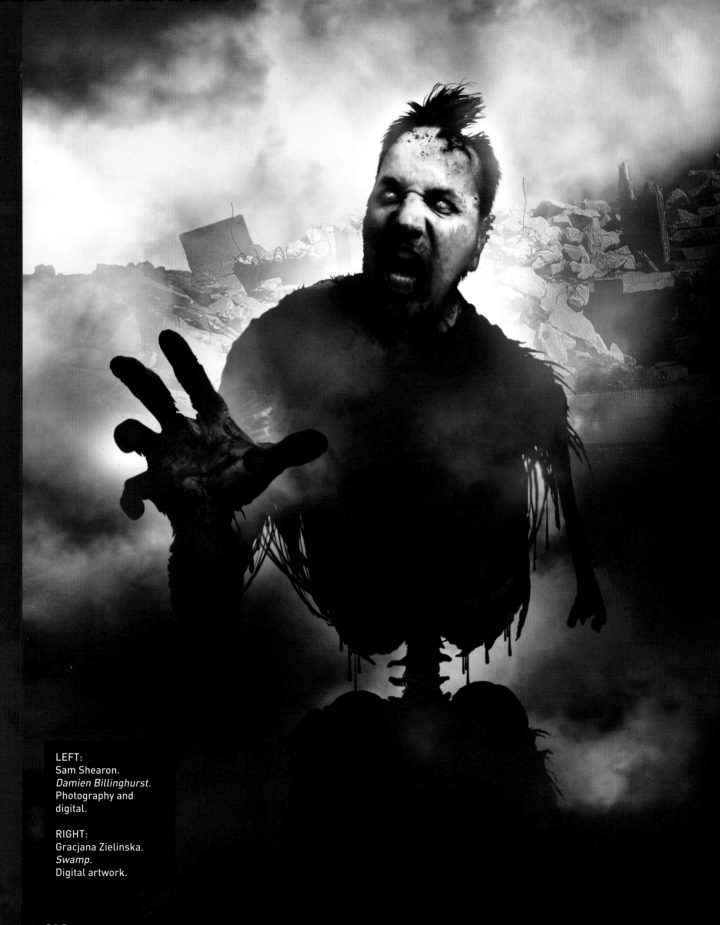

LEFT:
Sam Shearon.
Damien Billinghurst.
Photography and
digital.

RIGHT:
Gracjana Zielinska.
Swamp.
Digital artwork.

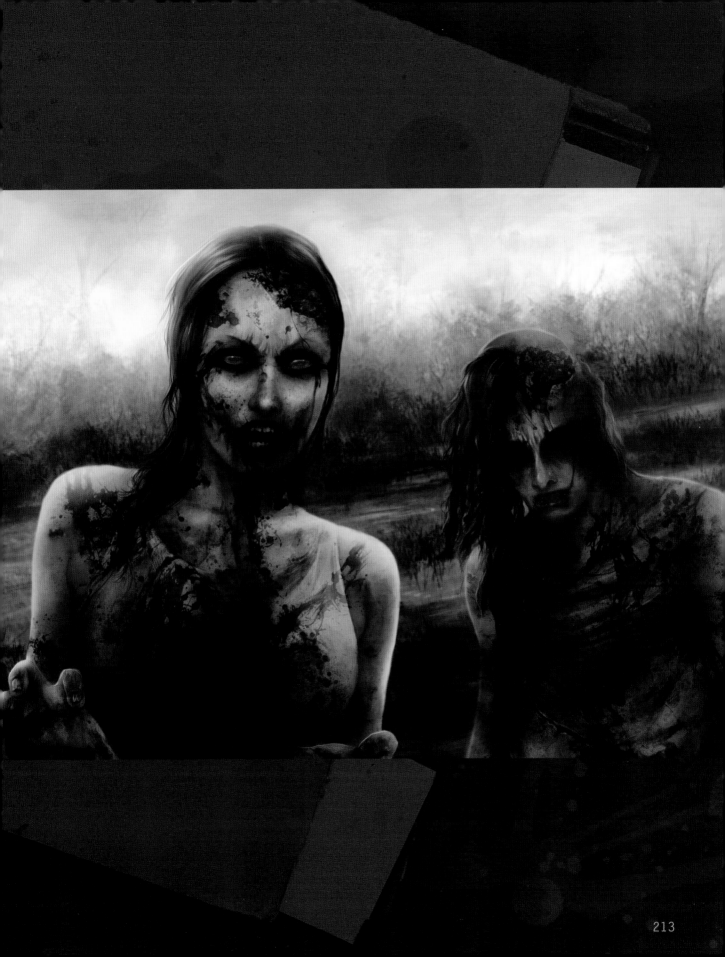

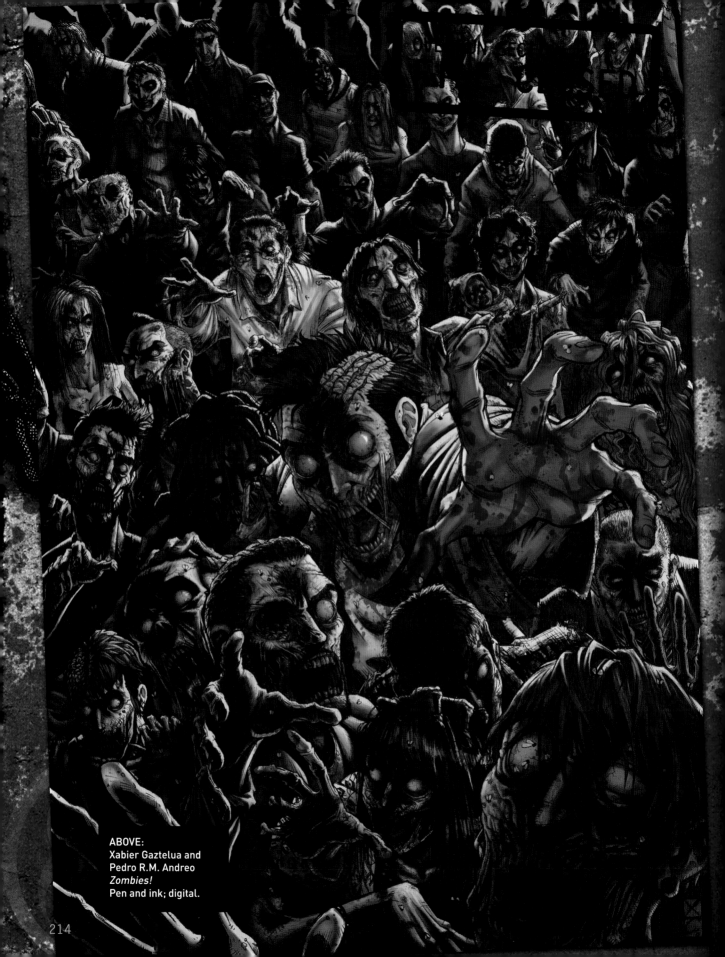

ABOVE:
Xabier Gaztelua and
Pedro R.M. Andreo
Zombies!
Pen and ink; digital.

214

APOCALYPSE

"WHAT DO YOU MEAN THERE'S NO GOVERNMENT? THERE'S ALWAYS A GOVERNMENT, THEY'RE IN A BUNKER OR A PLANE SOMEWHERE!"

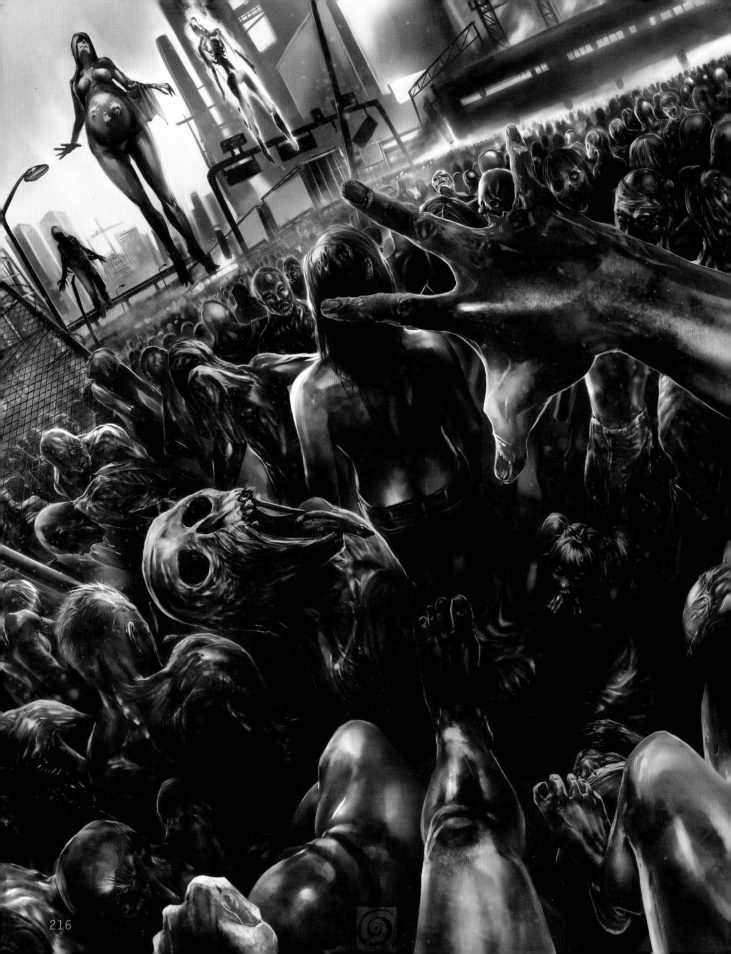

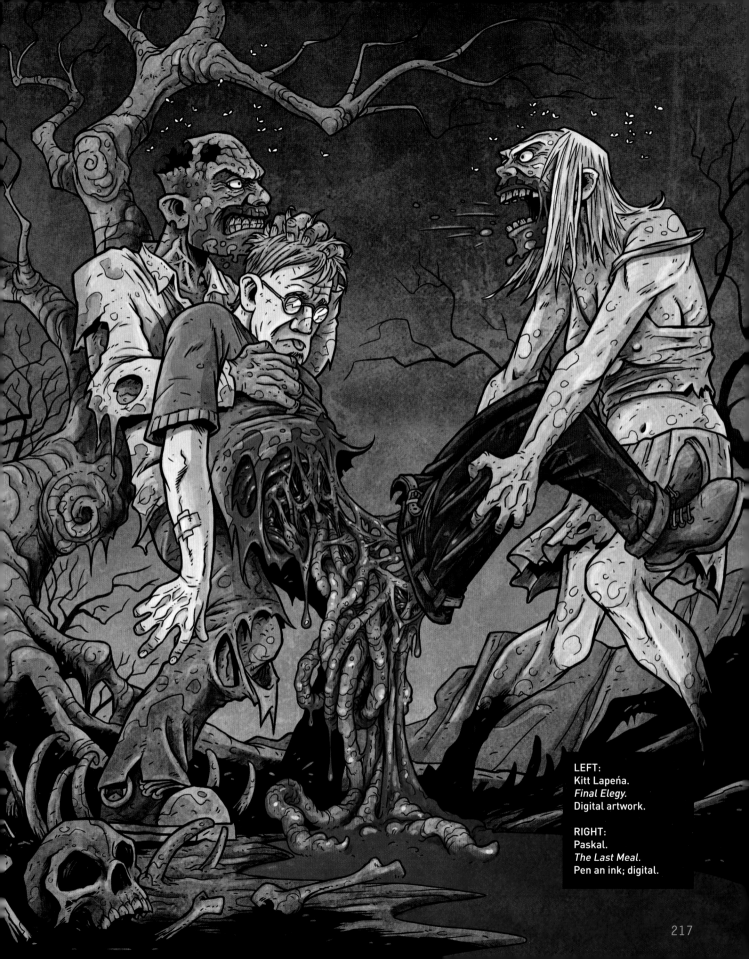

LEFT:
Kitt Lapeña.
Final Elegy.
Digital artwork.

RIGHT:
Paskal.
The Last Meal.
Pen an ink; digital.

217

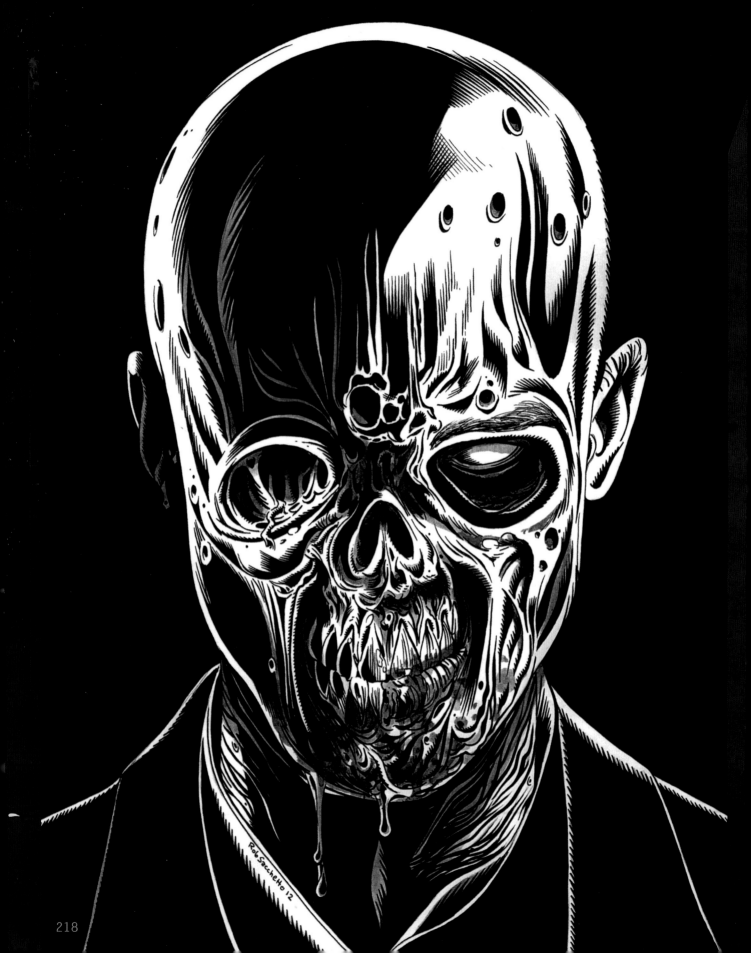

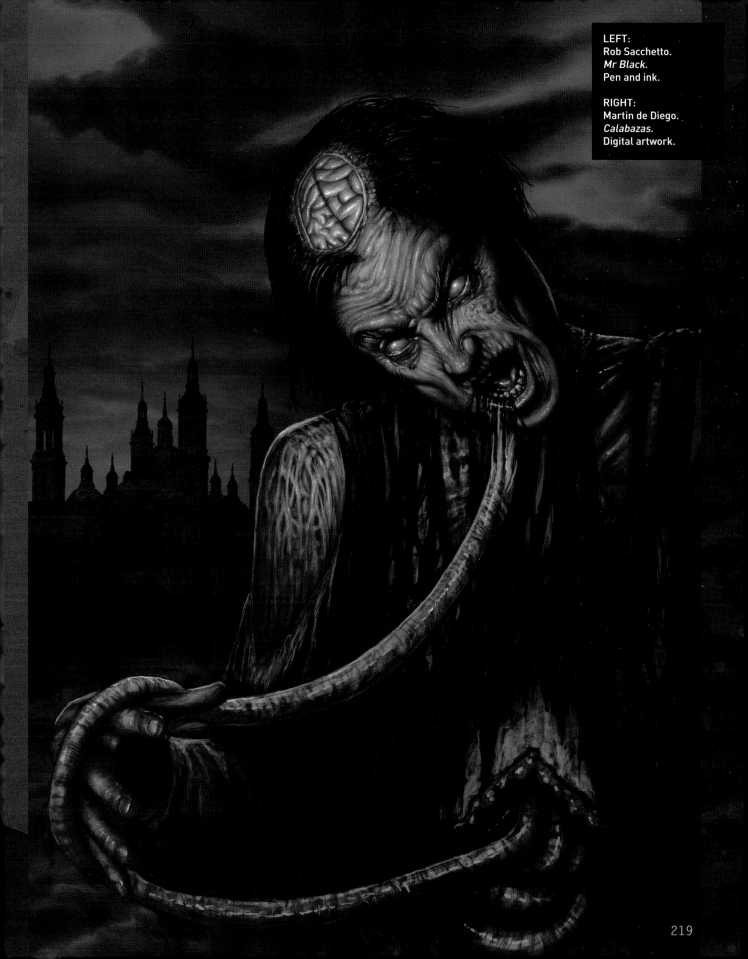

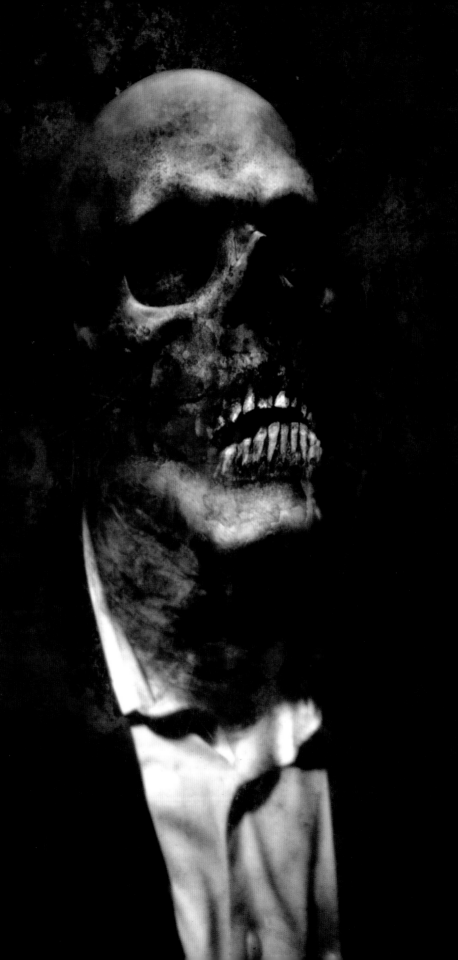

LEFT:
John Branham.
Wormface.
Digital artwork.

RIGHT:
Alex Quintero.
Slime Zombie.
Digital Artwork

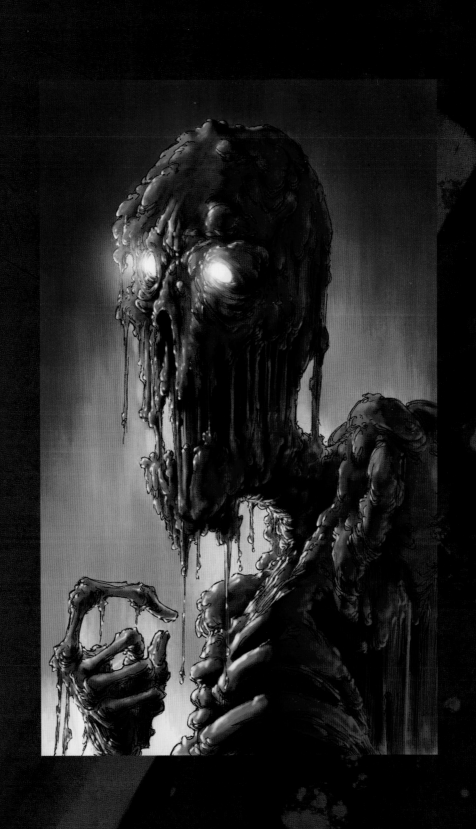

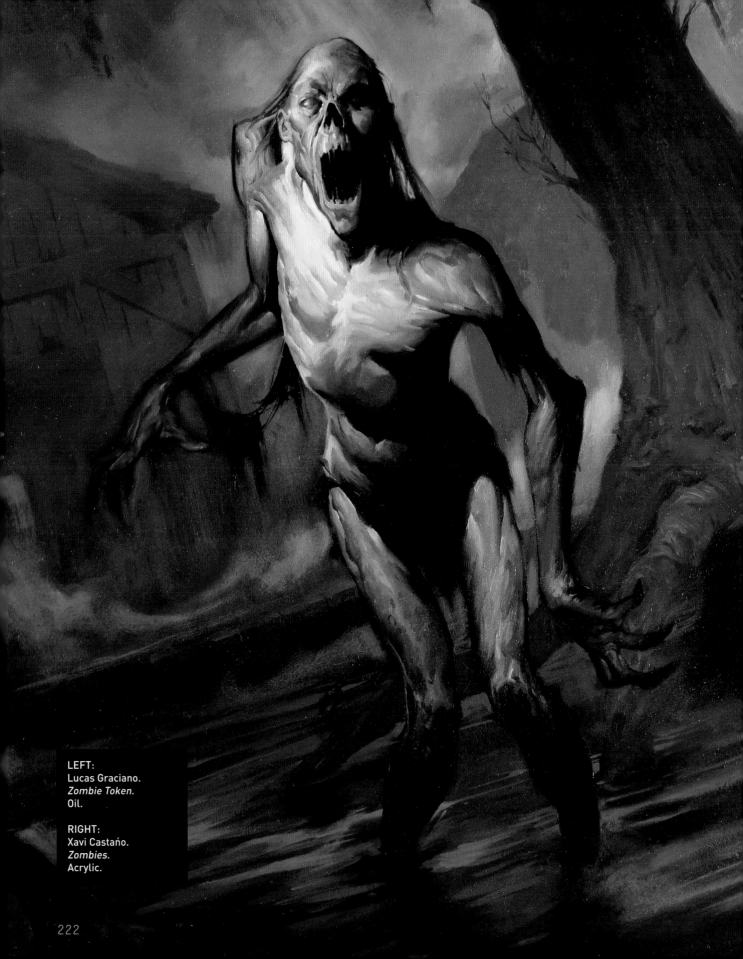

LEFT:
Lucas Graciano.
Zombie Token.
Oil.

RIGHT:
Xavi Castaño.
Zombies.
Acrylic.

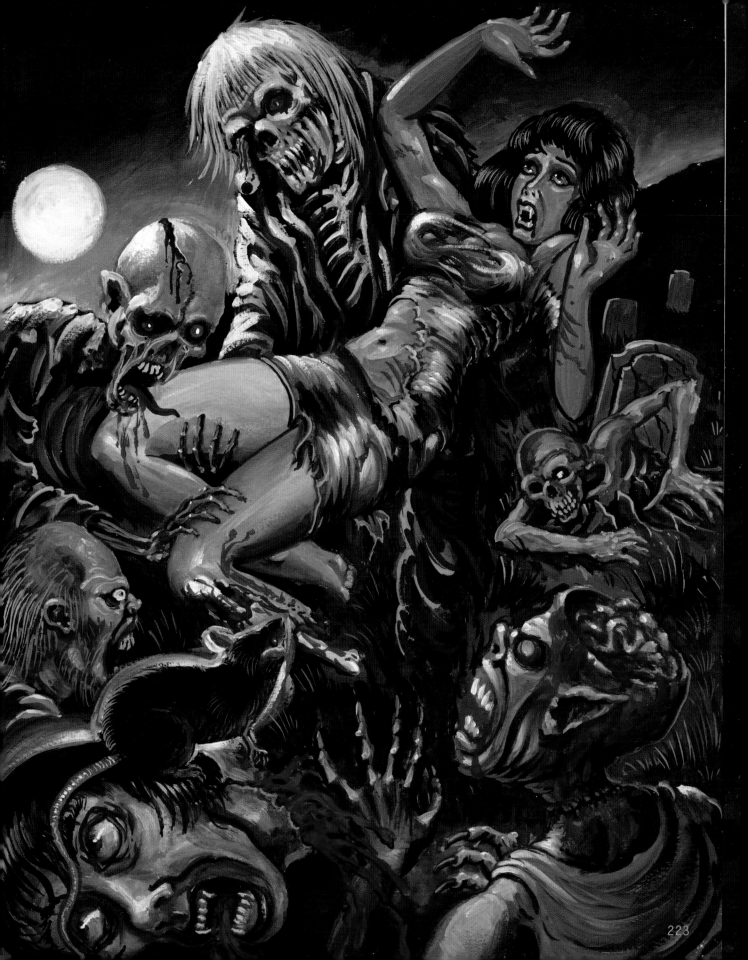

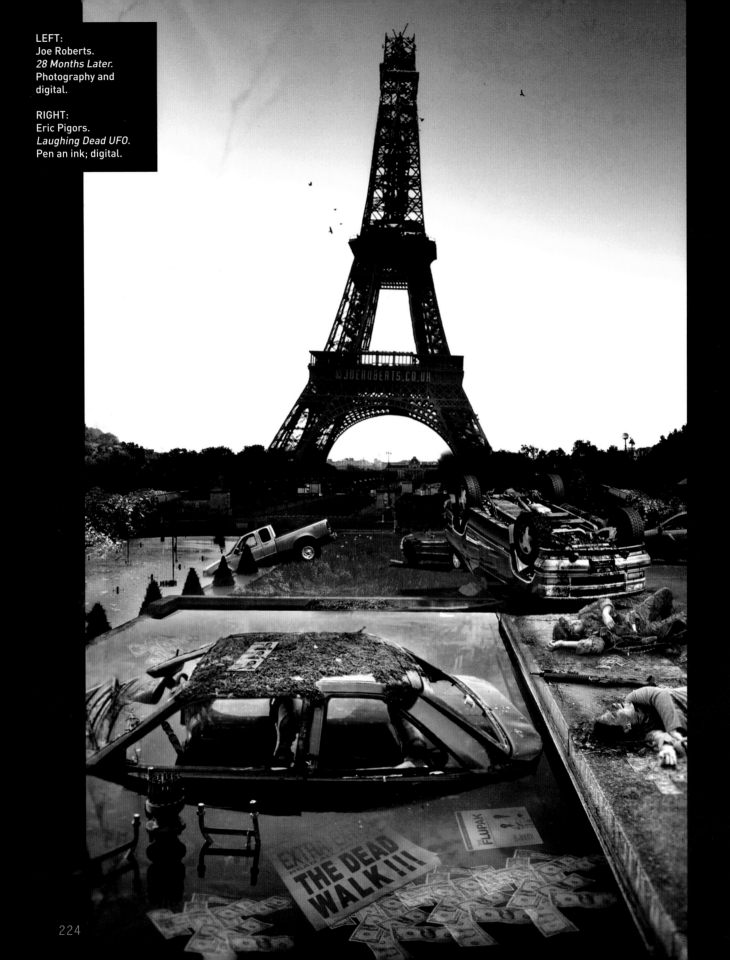

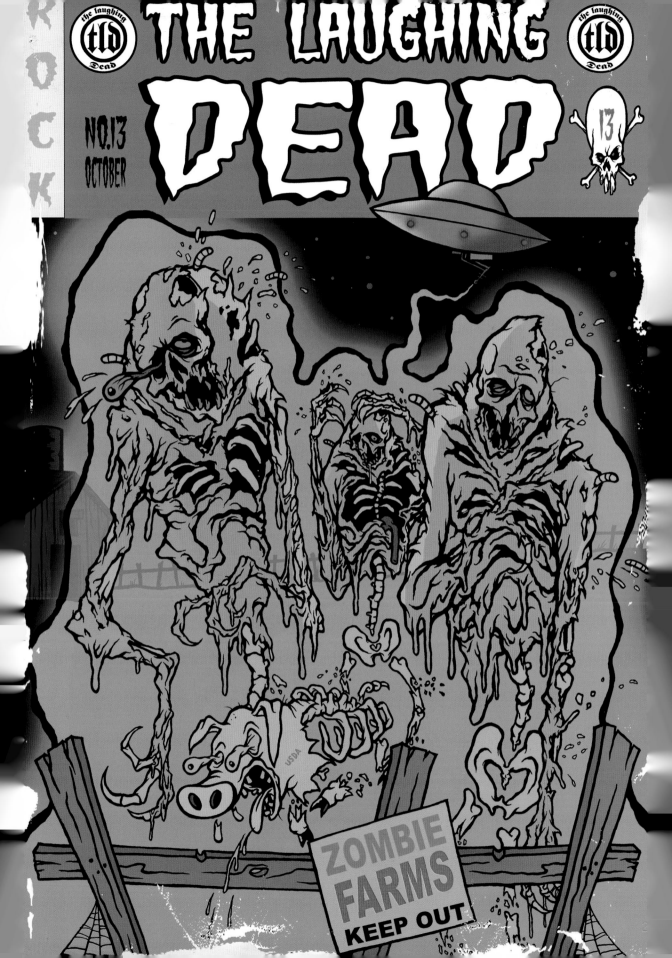

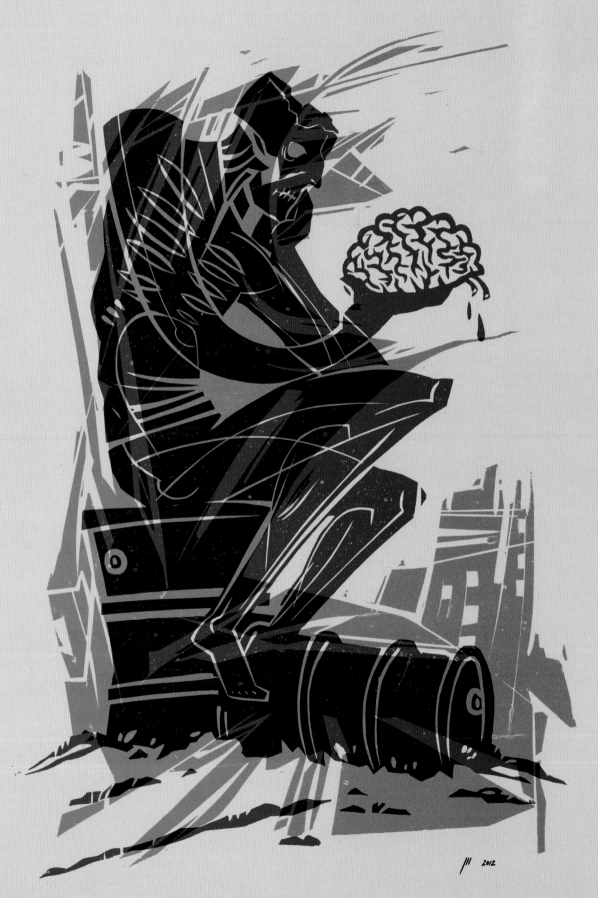

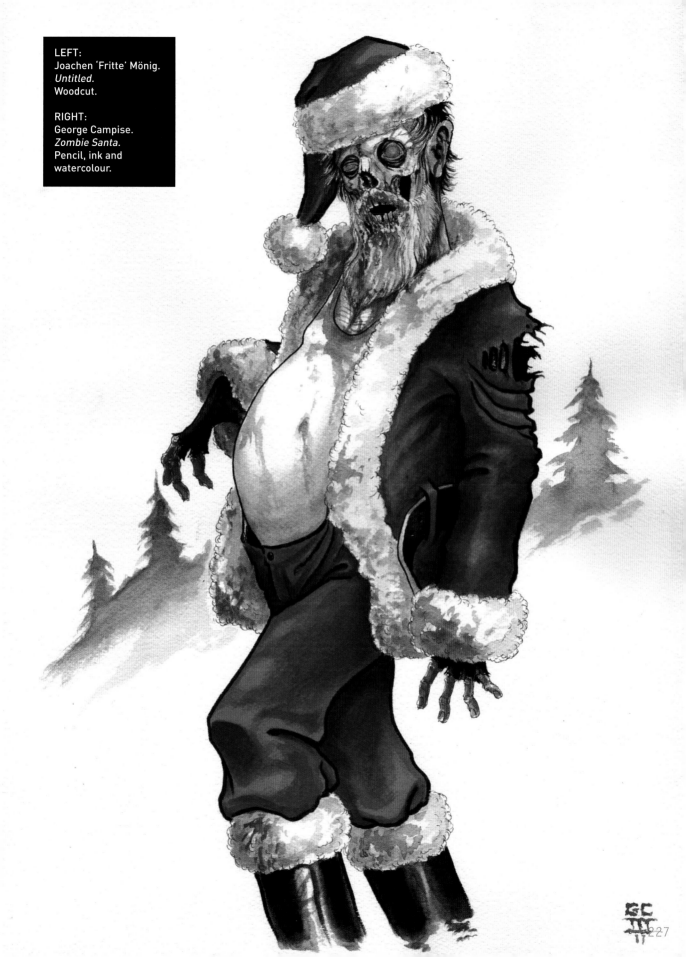

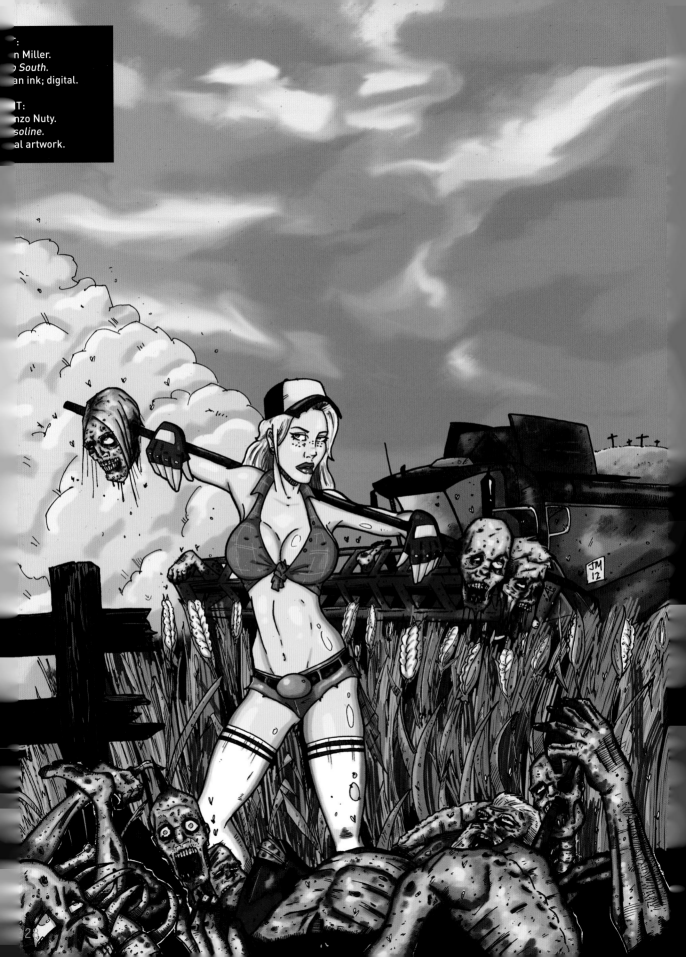

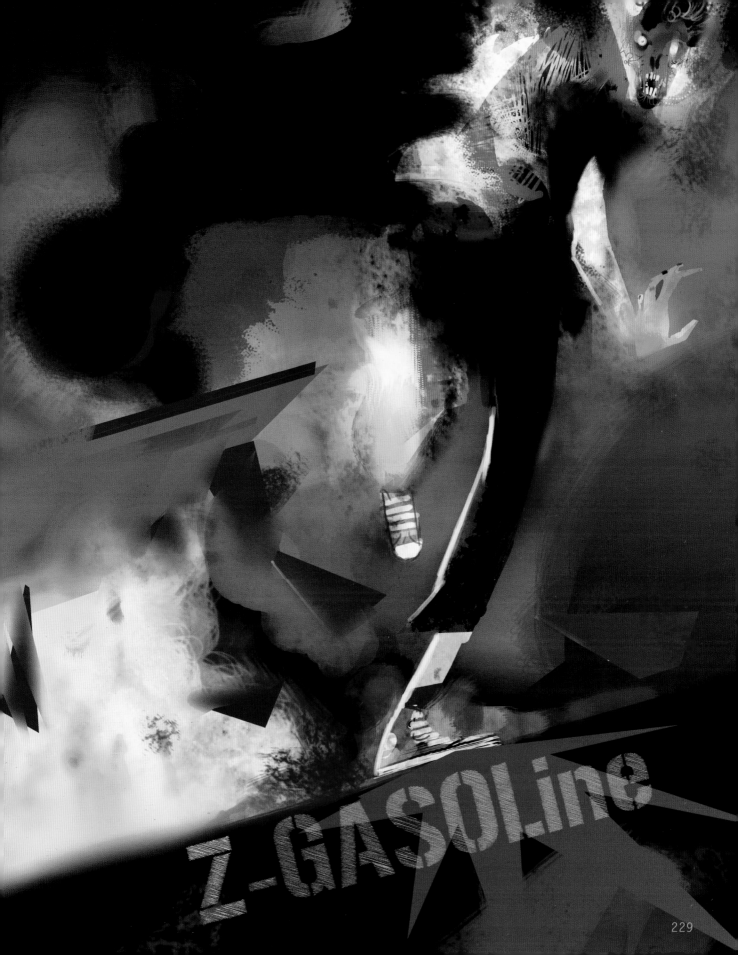

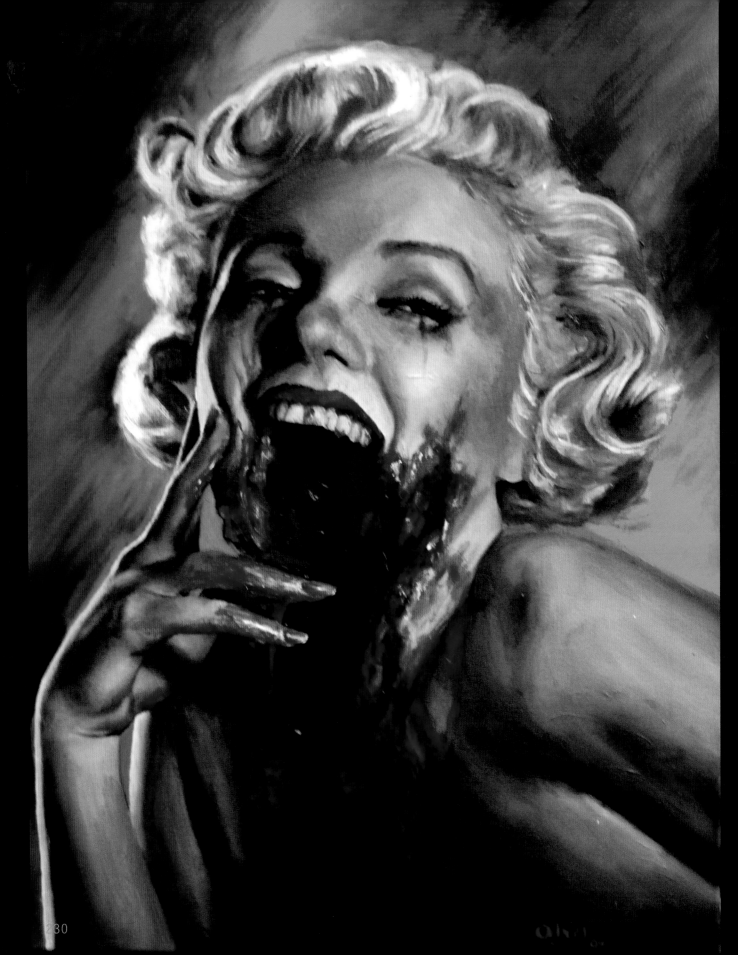

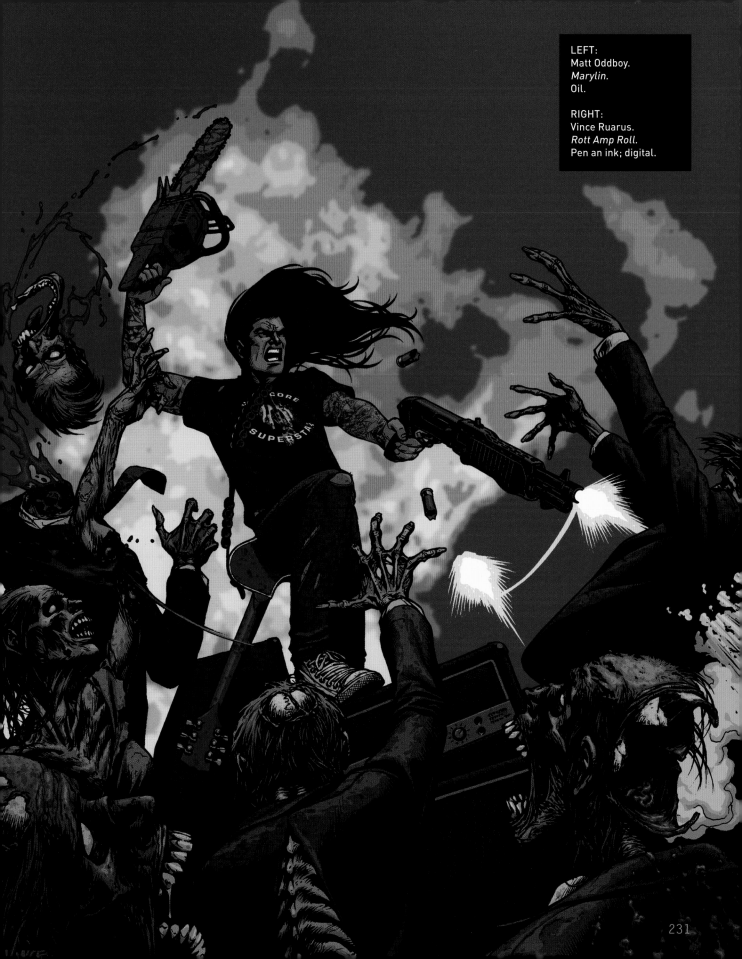

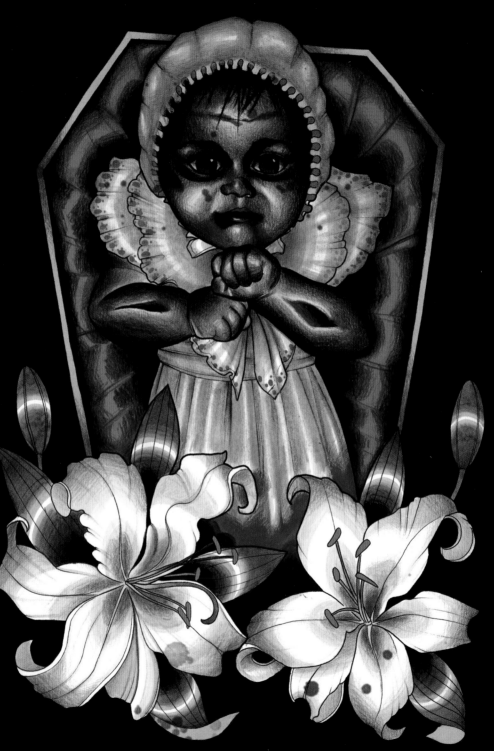

ABOVE:
Inma Alted.
Baby Zombie.
Pen and ink; digital.

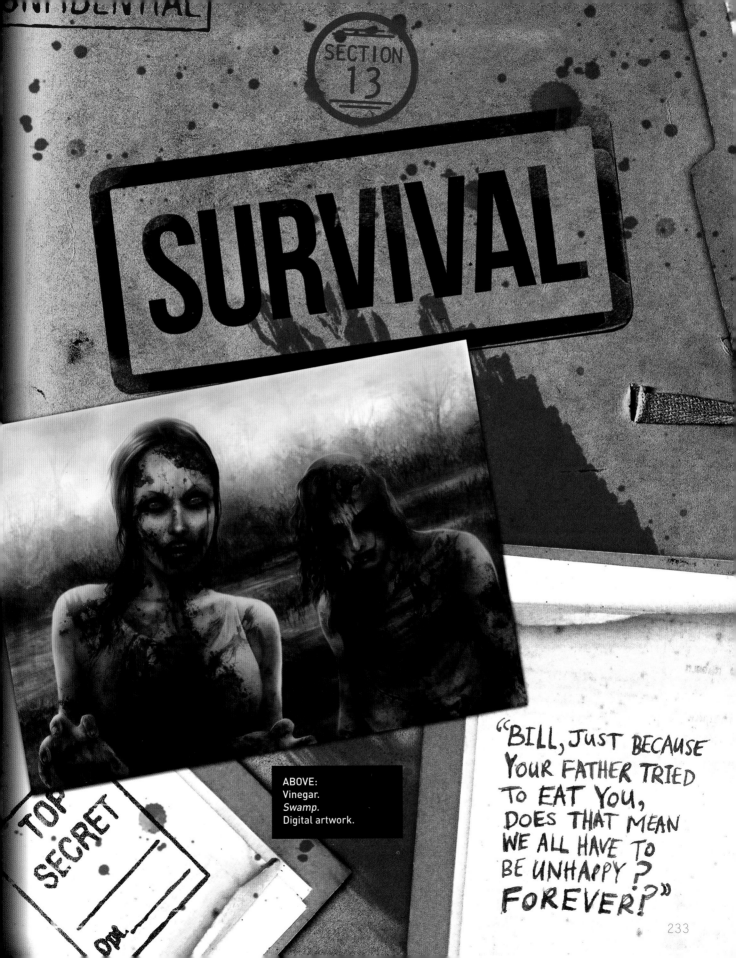

SURVIVAL

ABOVE:
Vinegar.
Swamp.
Digital artwork.

TOP
SECRET

"BILL, JUST BECAUSE
YOUR FATHER TRIED
TO EAT YOU,
DOES THAT MEAN
WE ALL HAVE TO
BE UNHAPPY?
FOREVER!"

RIGHT:
Jason Edmiston.
Zombie Prom.
Acrylic.

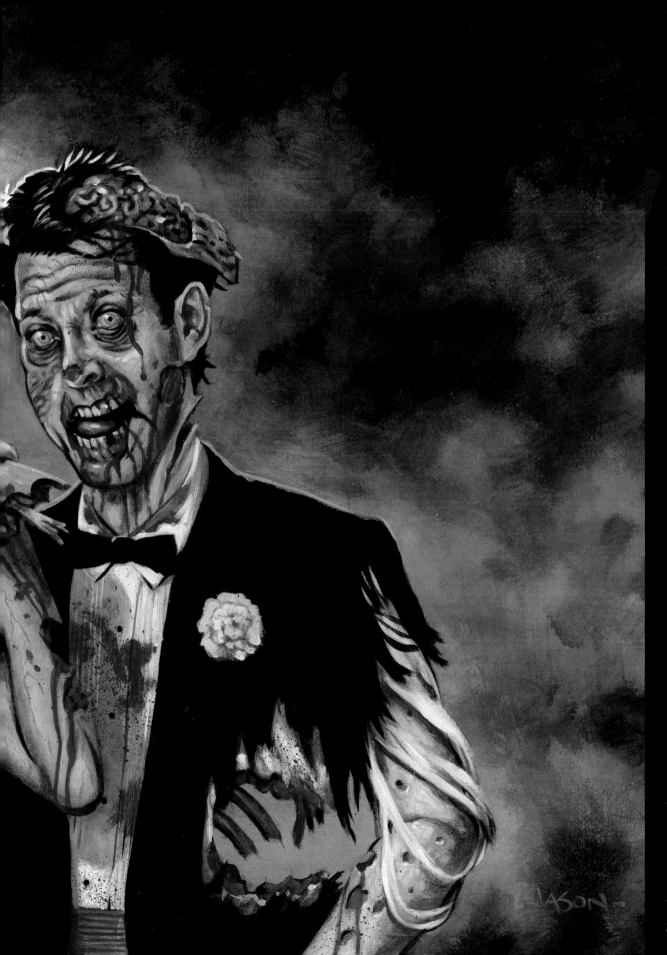

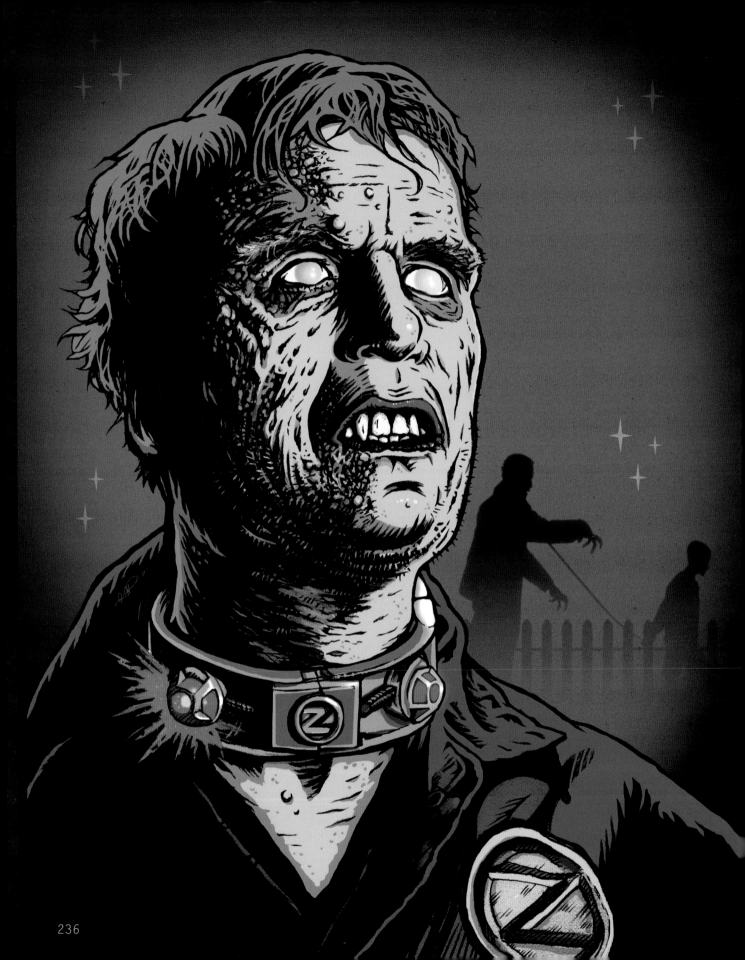

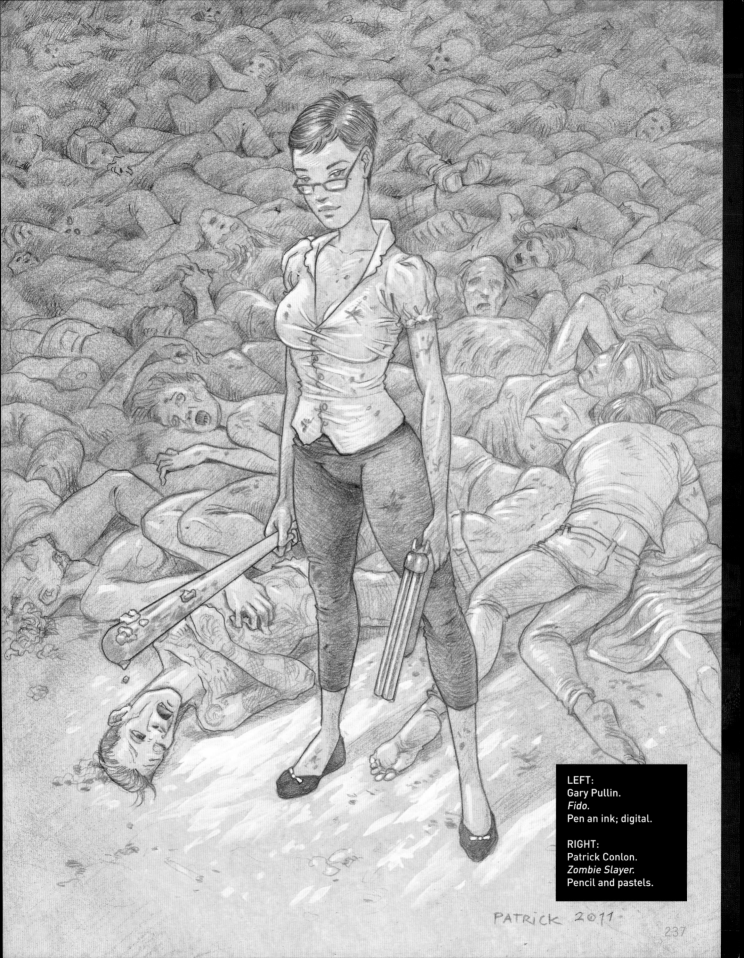

LEFT:
Gary Pullin.
Fido.
Pen an ink; digital.

RIGHT:
Patrick Conlon.
Zombie Slayer.
Pencil and pastels.

PATRICK 2011·

237

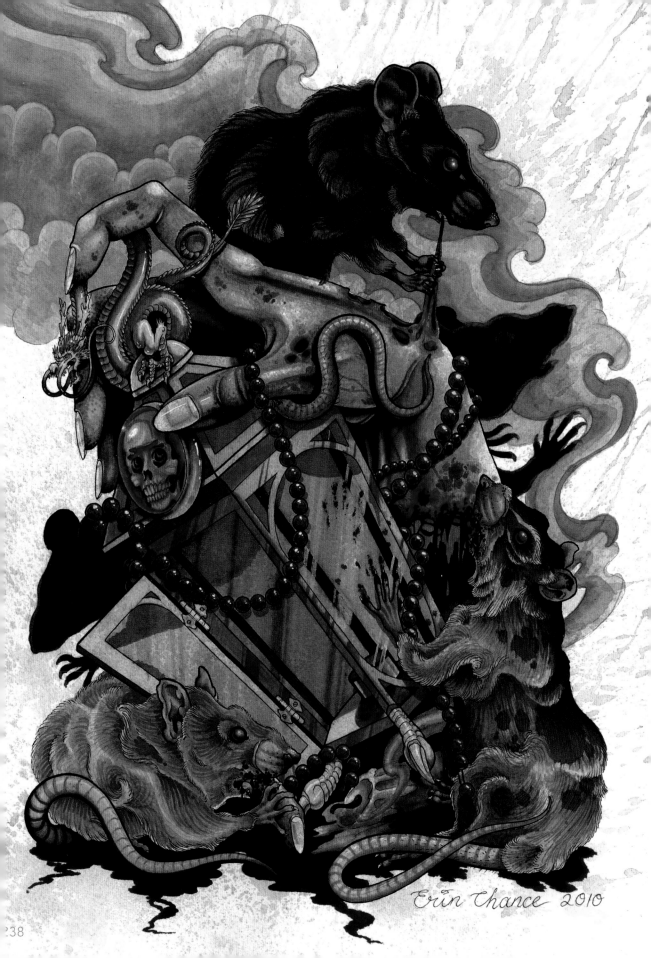

Erin Chance 2010

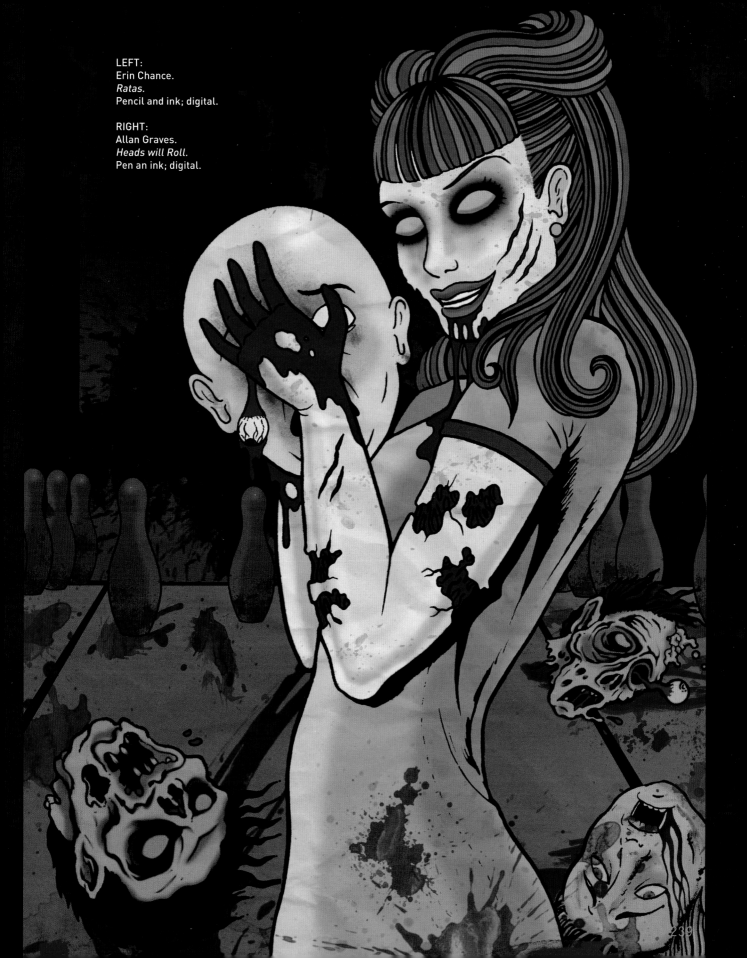

LEFT:
Erin Chance.
Ratas.
Pencil and ink; digital.

RIGHT:
Allan Graves.
Heads will Roll.
Pen an ink; digital.

239

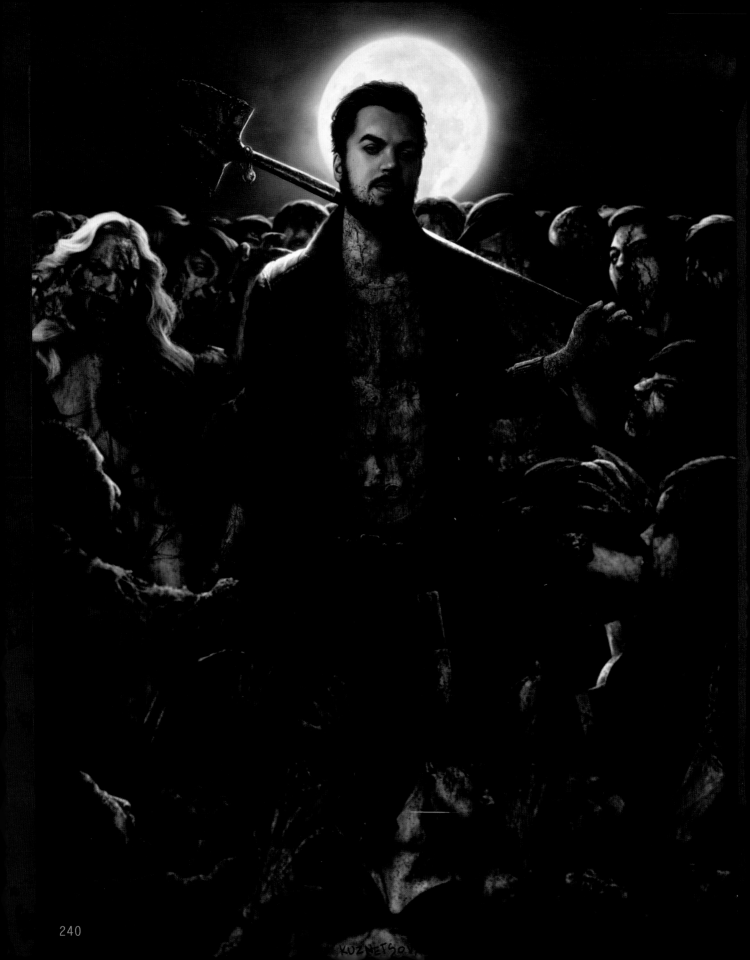

KUZNETSOV

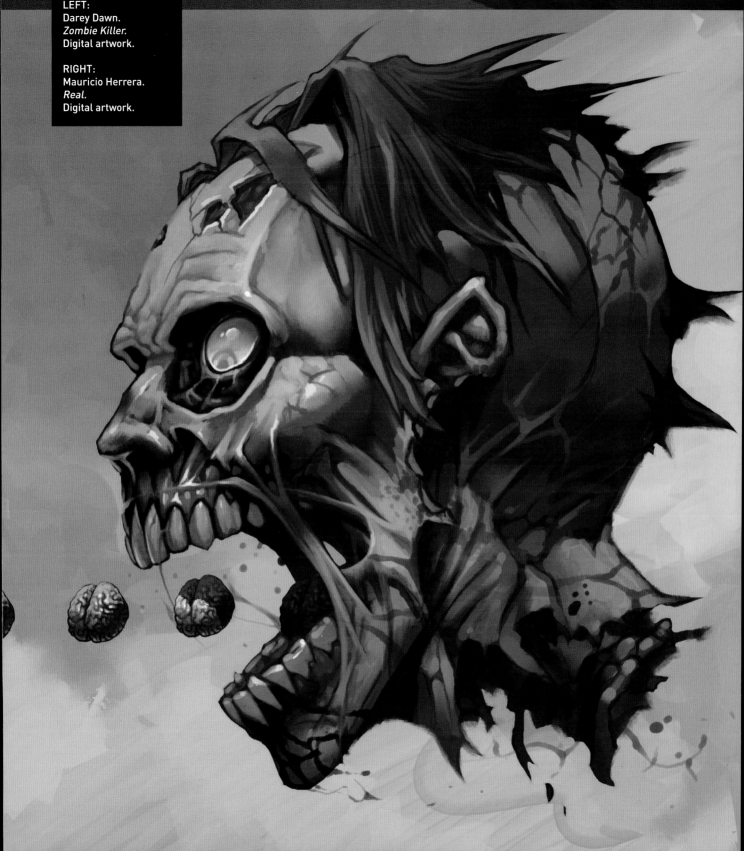

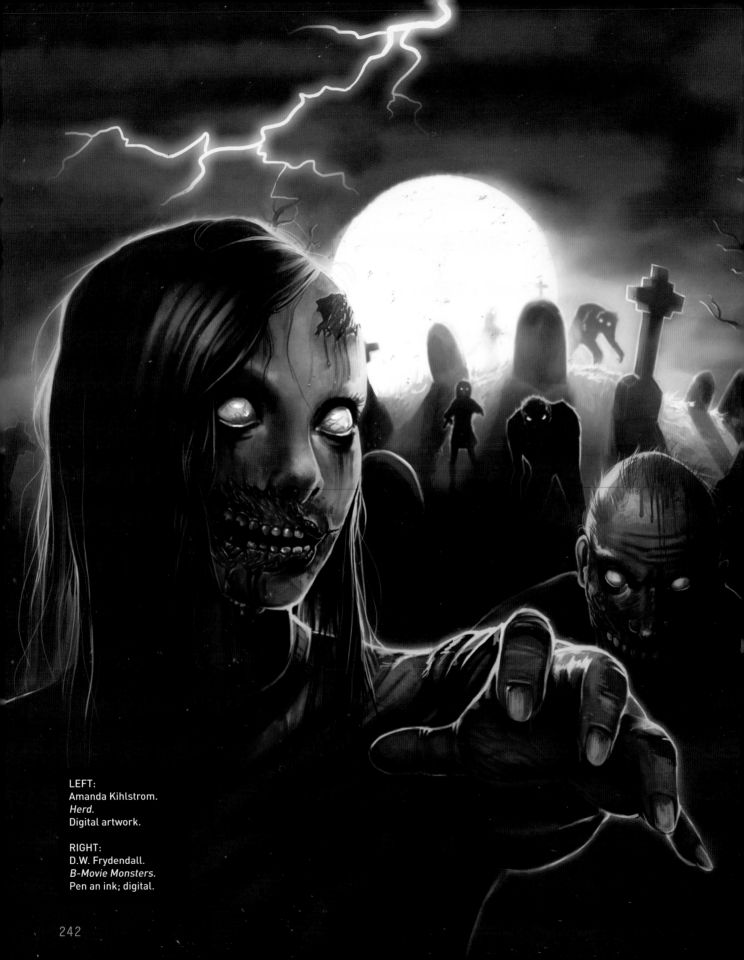

LEFT:
Amanda Kihlstrom.
Herd.
Digital artwork.

RIGHT:
D.W. Frydendall.
B-Movie Monsters.
Pen an ink; digital.

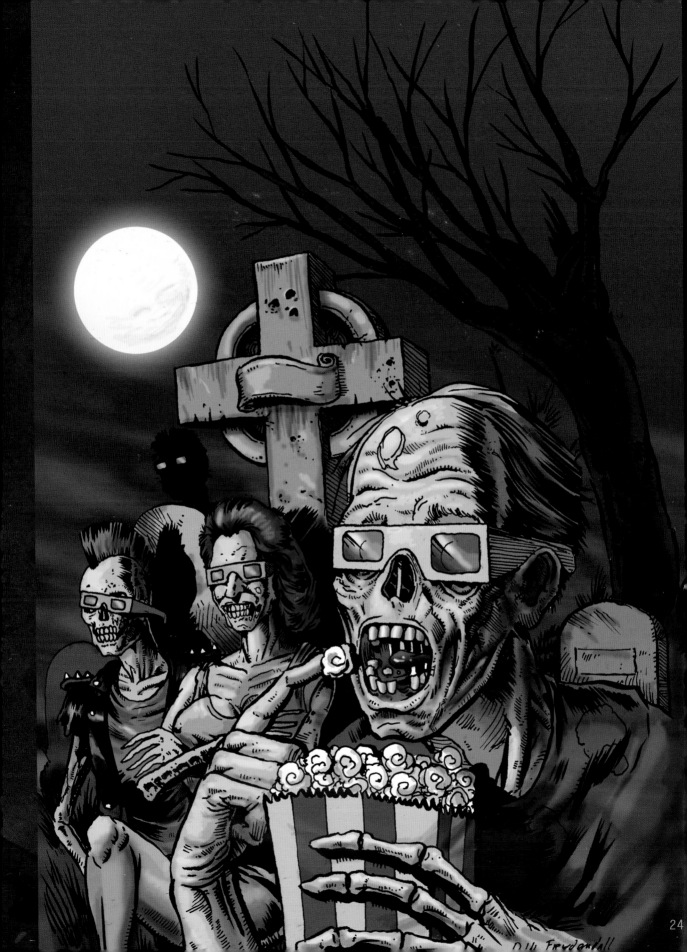

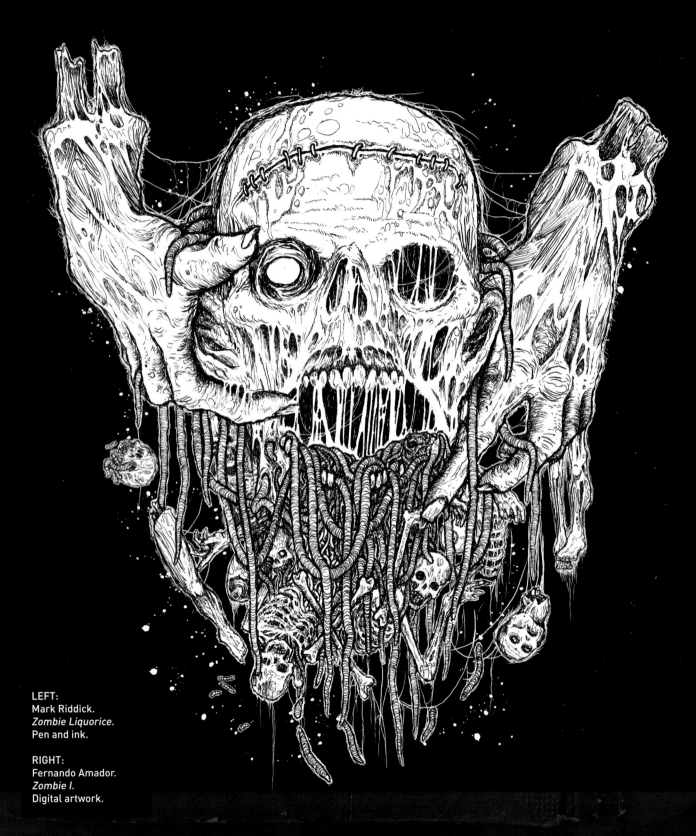

LEFT:
Mark Riddick.
Zombie Liquorice.
Pen and ink.

RIGHT:
Fernando Amador.
Zombie I.
Digital artwork.

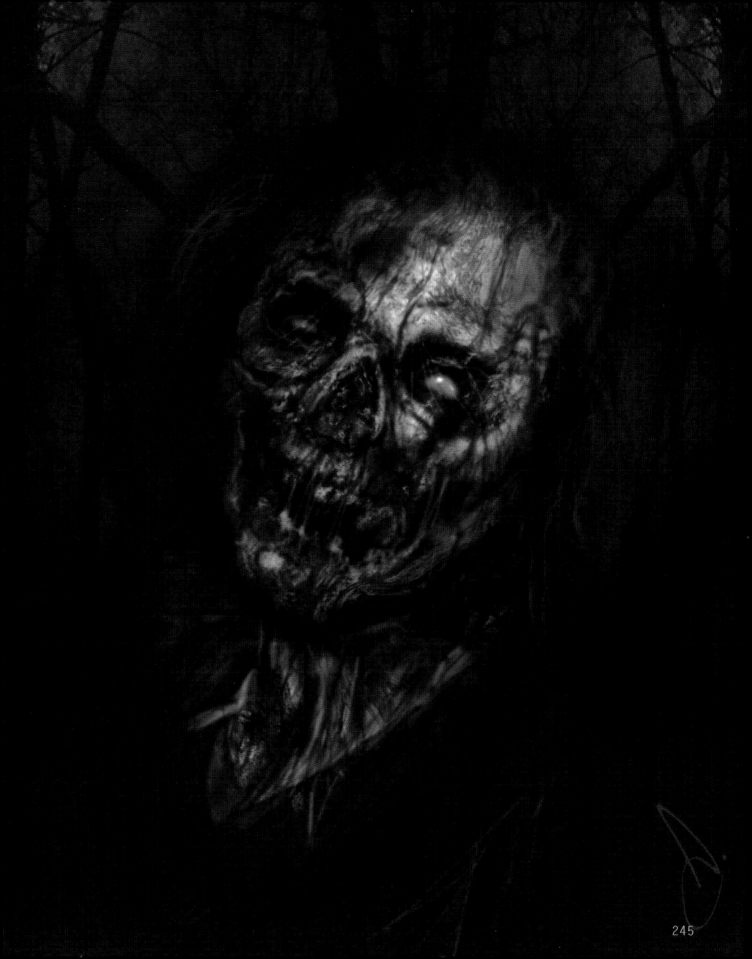

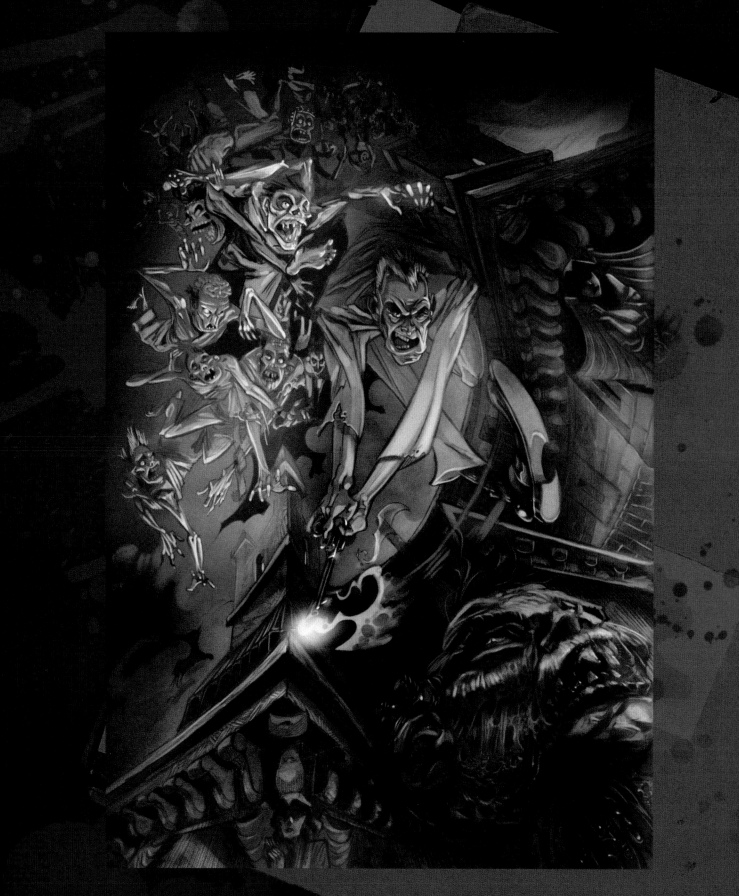

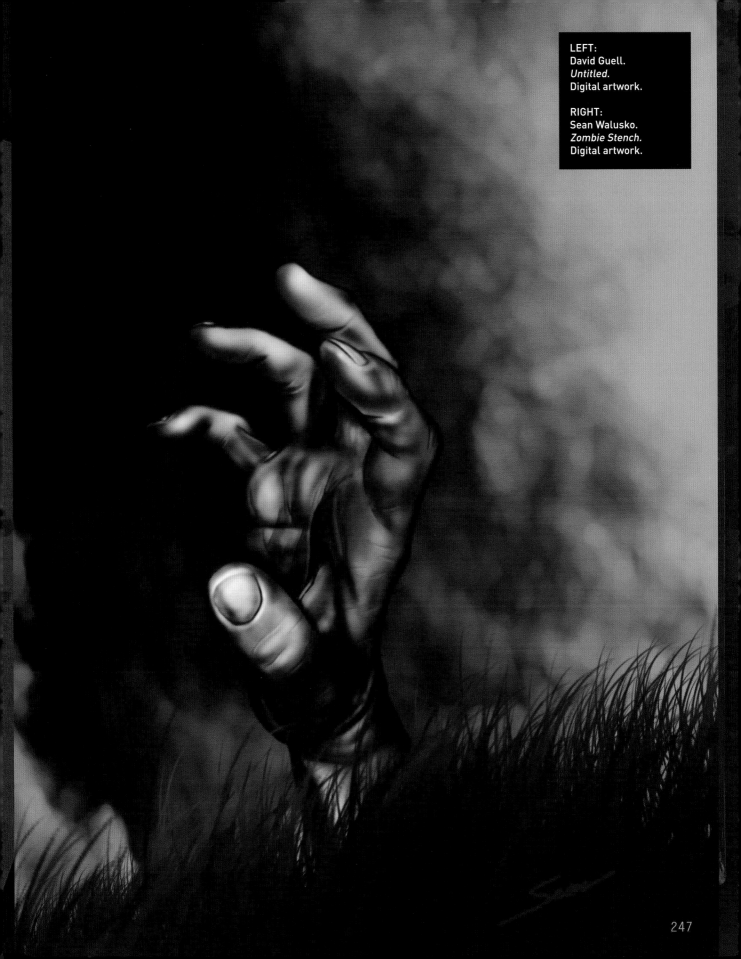

LEFT:
David Guell.
Untitled.
Digital artwork.

RIGHT:
Sean Walusko.
Zombie Stench.
Digital artwork.

247

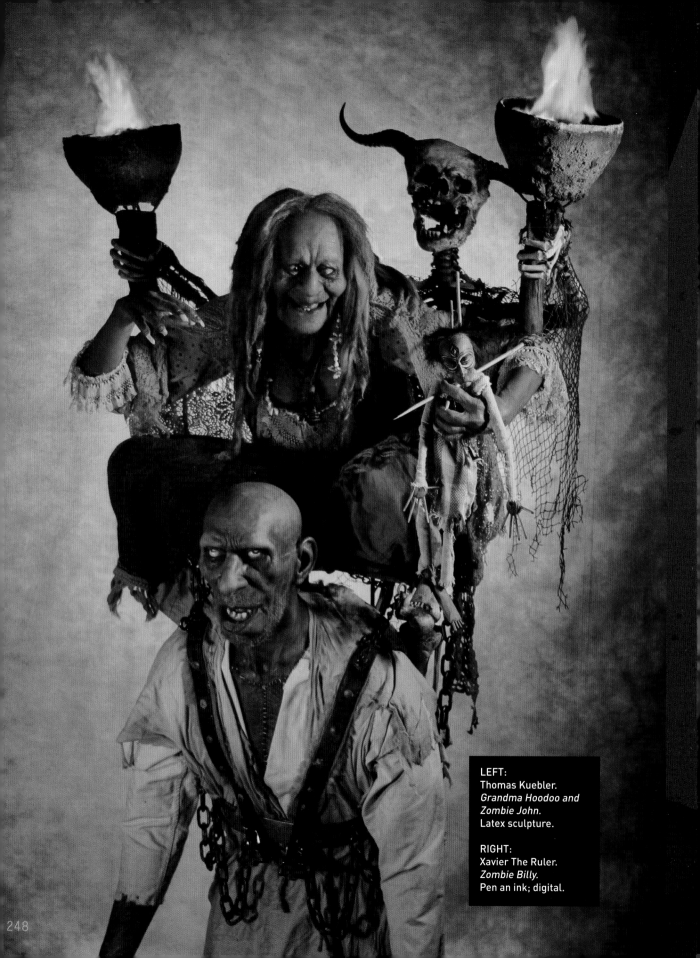

LEFT:
Thomas Kuebler.
Grandma Hoodoo and Zombie John.
Latex sculpture.

RIGHT:
Xavier The Ruler.
Zombie Billy.
Pen an ink; digital.

248

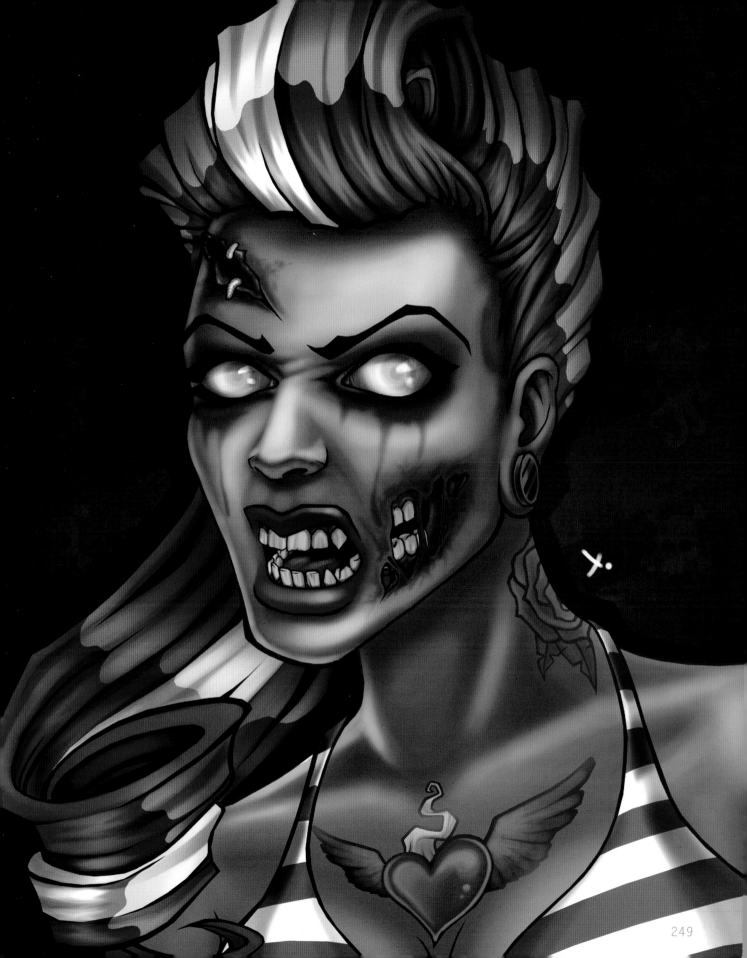

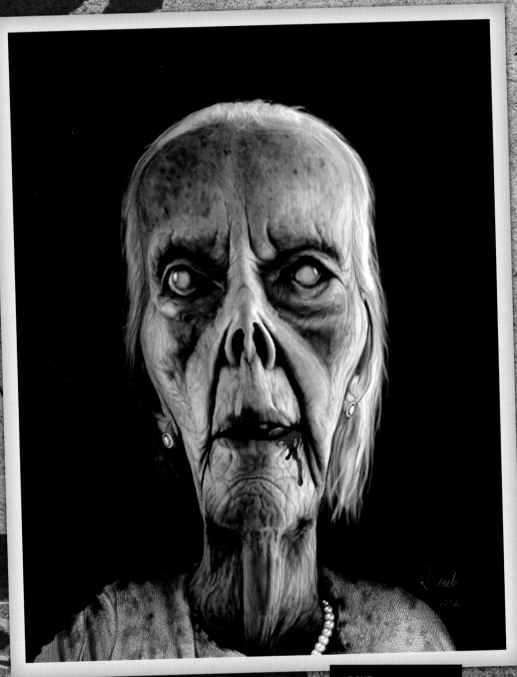

ABOVE:
Ricky Leach.
*Zombie Granny wants
Kisses.*
Digital artwork.

APPENDIX

ARTISTS' CREDITS
CONTACT DETAILS
ACKNOWLEDGEMENTS
AND OTHER STUFF.....

ARTISTS' CREDITS AND CONTACT DETAILS

Additional credits:

The image by Serge Birault on page 86 was originally commissioned by ImagineFX magazine www.imaginefx.com; many thanks Beren!

Future zombie publications:

If you'd like your art to be considered for any future zombie publications from Graffito Books, send us your lo-res examples to zombies@graffbooks.co.uk.

ALLAN GRAVES would like to thank:

Mum and Dad and my family for their everlasting support.
Natalia for keeping up with my monsters and for all her help with this undead task.
All the participating artists: without them this book would not have been possible.
Lee, Shiraz and all the Haunted crew.
Enrique, Lorenzo and Francisco @ Freaks.
George Campise for the awesome cover.
Gerard Losilla for pushing me to keep drawing and to not do any more black faces.
Ian, Jessica Rajs @ gorgeous & gory, Dean Boor @ Shock Horror, Daniel de Leon, Humphrey @ The Cinema Store.
Xavi @ Mondosonoro, MizzHell & Ash @ Kreepsville666, Oskura & Sol @ Monster museum, Jordi @ FNAC, Sergi E
for all the extra jobs, Terry Beezer and Michelle Kerr.
Trickorzine,The Horror section, Zombies and Toys, Zombieseverywhere.
Rue Morgue for eternal inspiration.
All my friends and customers out there that have allowed me to make a living from the horror business.
And you, for buying this book!

Cheers and creeps, Allan.

THE PUBLISHER would particularly like to thank all the remarkable artists from around the world, whose
creativity and genius make this book what it is, Allan Graves for having been such a pleasure to work with, Sam
Ratcliffe for his wit, good humour and brilliant design skills and Stephen Tai and his team in China for the quality
of their print and service.

AND LAST, BUT NOT LEAST, we'd like to acknowledge all those zombie films that have been a big source of
inspiration over the years, in particular (and in no particular order) the following iconic must-see movies, quotes
from which have entered the zombie aficionado's lexicon: *Fido, Creepshow, Dead and Buried, Zombieland,
Undead, 28 Days Later, Re-animator, Return of the Living Dead, Night of the Creeps, Zombie Holocaust, Resident
Evil, Planet Terror* and *Dawn of the Dead.*